IMAGES
of America

TOLLESON

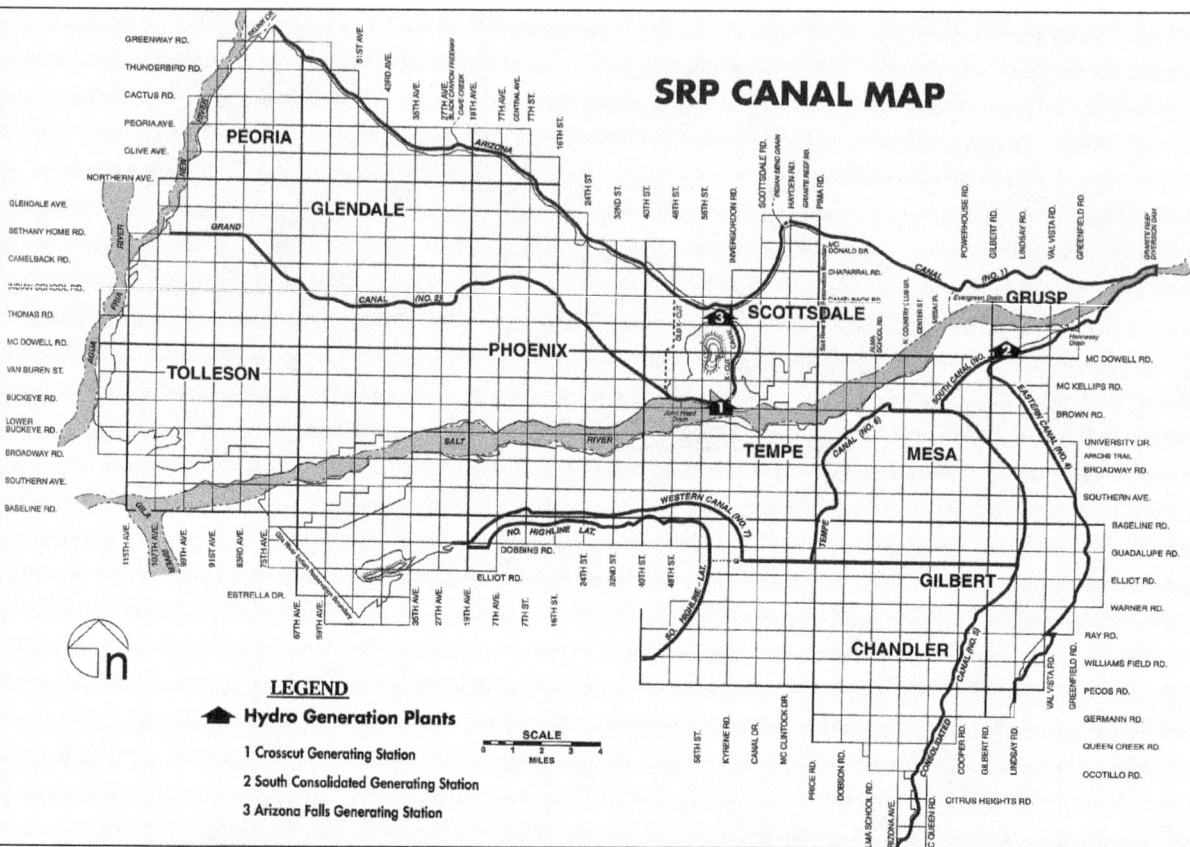

SRP CANAL MAP

GREENWAY RD.
THUNDERBIRD RD.
CACTUS RD.
PEORIA AVE.
OLIVE AVE.
NORTHERN AVE.
GLENDALE AVE.
BETHANY HOME RD.
CAMELBACK RD.
INDIAN SCHOOL RD.
THOMAS RD.
MC DOWELL RD.
VAN BUREN ST.
BUCKEYE RD.
LOWER BUCKEYE RD.
BROADWAY RD.
SOUTHERN AVE.
BASELINE RD.

PEORIA
GLENDALE
PHOENIX
TOLLESON
SCOTTSDALE
GRUSP
TEMPE
MESA
GILBERT
CHANDLER

LEGEND

Hydro Generation Plants

1 Crosscut Generating Station
2 South Consolidated Generating Station
3 Arizona Falls Generating Station

SCALE
0 1 2 3 4
MILES

The Salt River Project canal system has supplied valley water since 1903. After Walter Gist Tolleson subdivided his first 40 acres in 1912 to begin a town, most of the southwest valley historically became known as Tolleson. (Salt River Project.)

ON THE COVER: These produce workers, pictured in 1952, labored at packing sheds up and down the Southern Pacific Railroad, helping Tolleson to become "the Vegetable Center of the World."

IMAGES

of America

TOLLESON

Jim Green and Jimmy Ruiz

Arizona Historical Foundation

ARCADIA
PUBLISHING

Published by Arcadia Publishing
Charleston SC, Chicago IL, Portsmouth NH, San Francisco CA

Library of Congress Catalog Card Number: 2007941881

For all general information contact Arcadia Publishing at:
Telephone 843-853-2070
Fax 843-853-0044
E-mail sales@arcadiapublishing.com
For customer service and orders:
Toll-Free 1-888-313-2665

Visit us on the Internet at www.arcadiapublishing.com

To Maria Socorro Arrieta Ruiz, a Tolleson native. Maria was born in a small house at the corner of Lateral 22 (Ninety-first Avenue) and Adams Street on April 1, 1946. She died at her Ninety-fifth Avenue home 55 years later. Maria was a registered nurse, a wife, mother, daughter, and grandmother. Her life epitomizes the commitment to town and family that has continued to be the foundation of the Tolleson community.

CONTENTS

ACKNOWLEDGMENTS

In the preparation of this pictorial history of Tolleson, the authors discovered that each image and each family is a book within itself. Jack and Gloria Villa gave us great photographs and information regarding their extended families, and Jack offered tremendous help in editing. Joy Burton shared materials she had collected for a similar book. The Diaz, Hernandez, Chavira, Alcocer, Lopez, and Medrano families all shared their connections with Tolleson's history.

We must thank Victor Flores and Catherine May of the Salt River Project for allowing us access to the organization's archives. Thanks go to the Tolleson City Library and city management teams. Another round of thanks goes to Jose Figueroa for his technical support and to Thelma Green for her memories, which we referenced often. We are grateful to Grace Shelton, Barbara Hudson, Elsie Busse, Rod and Nellie Rodriquez, Virginia Vanlandingham, Jackie Diaz, Fae Veronin, Carmen Florez, Jarrie Holliday, Ophelia Villa-Navarro, Barbie and B. Bryant, Bonnie Pendergast, and the Veterans of Foreign Wars, who all shared their numerous artifacts. If not cited otherwise, all photographs belong to Jim Ruiz.

Our gratitude goes to Arcadia Publishing and especially to our editor, Jared Jackson, who showed us patience and guidance in our preparation.

Finally, we must thank all the citizens of Tolleson. Their undying spirit and love for community continue to keep Walter Gist's vision of Tolleson alive.

INTRODUCTION

On a comfortable November day in 1867, Jack Swilling, a South Carolina native, rode his mount southeast across the desert from his homestead on the upper Hassayampa and toward the U.S. military camp not far from the confluence of the Verde and Salt Rivers. The gold seeker, soldier, farmer, and entrepreneur looked at the vast desert lying before him. History does not tell us the intent of his trip, but it does record the momentous results of that journey. He was possibly heading his friend John Y. T. Smith's camp, which lay west of Camp McDowell. With the military camp commander, perhaps he was planning to discuss the Apache situation and his mail run from Prescott to the villages along the Gila. History does record the results of his actions after he stopped at the north end of the White Tank Mountains to admire the vast stretch of desert that cradled the meandering Salt River.

Maybe he stopped his horse at the granite tanks always holding a catch of cool water before he moved down into the valley. He could have crossed the dry Agua Fria and the New River heading across virgin desert, but chances are he followed the well-worn Hohokam trails south toward the Gila, then along the Salt River through the valley on his way to his destination. As he rode, he no doubt noticed lush growths of cane and willow, cottonwood, paloverde, and mesquite. Small fields of corn, hay, and sorghum were being farmed by some Native Americans along the riverbanks. *The wild grasses for feed could be profitable*, he surely thought. He was amazed, though, by the number of ancient ruins he passed, and he especially wondered about the long lines of creosote, greasewood, and desert bushes—some running for miles—that seemed to follow a pattern across the land as they led from the river.

By March 1868, the Swilling Irrigation and Canal Company and the Swilling ditch had become realities. The desert lands through which Jack Swilling rode would grow into the vast irrigated farm fields of the Salt River Valley. These farms would produce enough vegetables, fruit, grain, and cattle to feed much of the nation. It was man's vision, but it was water that brought the desert to bountiful life. Small agricultural communities soon turned into towns and cities and metropolitan spreads. In the west valley sprang up Glendale, Peoria, Alhambra, Buckeye, and Coldwater, and at the very center of this mecca of prosperity lay the community that would become known as the Vegetable Center of the World.

The town, founded by another South Carolina native in 1912—the same year Arizona gained statehood—would thrive as the heart of over 100 square miles of the most productive farmland in the country. Today it lies 11 miles from downtown Phoenix; 11 from the center of Glendale; 13 from Luke Air Force Base; 10 from Litchfield Park, adjacent to Avondale; and 10 from Laveen. For decades, much of the southwest valley, from the Agua Fria River to Lateral 17 (Fifty-first Avenue) and from Glendale Avenue to south of the Salt River, has been known as Tolleson.

This book presents a pictorial history of that area and of the community that rose from the desert floor to become one of the foremost west valley cities. The Tolleson area is a place where history has made its mark through the assimilation of a number of nationalities: Hispanic, Anglo European, Russian, African American, Japanese, and Native American, among others. It is an area

of art and culture, of service and convenience. It is a place to live, to raise a family, to work, and to retire. The schools, hospitals, entertainment centers, sports facilities, shops, freeways, public transportation, and jobs in the area could never have been dreamed of by the two prominent gentlemen from South Carolina.

The history of the Tolleson area continues to unfold. Most of the farm fields are gone, having been replaced by urban sprawl, but the history of the people continues. From the time of the first inhabitants of this desert valley over 10,000 years ago to the ancient Hohokam civilization that so mysteriously disappeared sometime in the 13th century, the Arizona desert and its rivers have prevailed. Hopefully, this pictorial record will help preserve a part of that heritage for generations to come.

One

THE HISTORY

FROM THE ANCIENTS TO
THE MEN FROM SOUTH CAROLINA

The first inhabitants of the Salt River Valley settled around 8,000 BCE. Here they discovered a vast, fertile land with abundant water, wildlife, and diverse weather. Today archeologists have little information about these mysterious people; however, a magnitude of information exists regarding the civilizations that followed. For more than 1,500 years, a highly skilled society inhabited and prospered in this fecund valley of several rivers. They disappeared in the middle of the 15th century, leaving scattered remnants across the land.

By the 16th century, Spanish explorers left Pimeria Alta, the vast wilderness to the north. Next came the *Mexica* searching for new lands. Trappers, gold hunters, and colonizers followed, all seeking the "pot of gold" just beyond the purple mountains. The Mexican-American War of 1849 and the Civil War of 1860 to 1865 helped encourage Anglo-European settlement.

On October 23, 1907, a young man named Roy Hughes Tolleson arrived in Arizona seeking a fresh-air cure for his severe inflammatory rheumatism. Walter Gist Tolleson, his father, came in January 1908 and purchased a 160-acre dairy ranch homestead just west of Phoenix for his family. For $16,000 in 1910, he bought a remote 160-acre farm on the southwest corner of Lateral 22 between the Old Yuma Road and the Buckeye Short Line Railroad. The land had irrigation, and a new dam was under construction 80 miles upriver. In 1912, the year of Arizona's statehood, Walter Gist Tolleson decided to subdivide 40 acres of his farmland, thus giving birth to a town.

On his way from Wickenburg across the Salt River Valley in 1867, Jack Swilling saw Pima Indians (*Akimal O'otham*) using water from their canals to irrigate small fields and care for their crops. At the time, he could not have known that the ancient Native Americans' canal system traversed hundreds of miles throughout the valley. Today much of the ancient system has been destroyed by modernity. (Tolleson Public Library.)

During the 200 years before the American colonies claimed independence, the Southwest created a new culture. In the 17th, 18th, and 19th centuries, Hispanics with Spanish and Native American heritage migrated to the uncharted lands, settling in the north Sonoran Desert only to find a harsh life with untold challenges. They are the ancestors of today's Mexican American community. (Tolleson Public Library.)

10

History records the life of Jack Swilling with great accolades as well as vicious scorn. To some, the man was a hero, a fighter, a leader, and a friend. To others, he registered as a scoundrel, an addict, a drunk, and a common criminal. One thing in his character, though, looms large: the man was a visionary. Today the Salt River Valley testifies to that. (Salt River Project.)

The 1870s and 1880s saw much turmoil in citizens' attempts to bring water to a thirsty valley. At one time, 11 canal companies incorporated. The Grand Canal Company filed papers on June 20, 1878, and eventually supplied most of the water to farmers west and southwest of Phoenix from their Grand Canal, which continues to serve southwest valley farmers' needs today. (Salt River Project.)

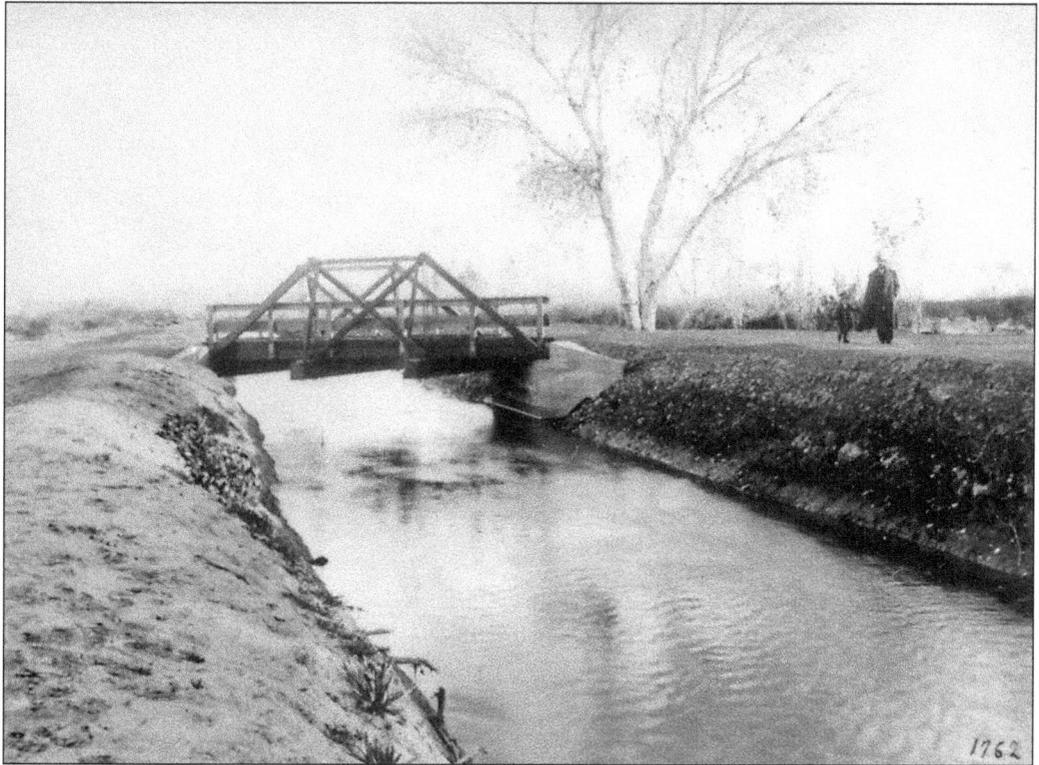

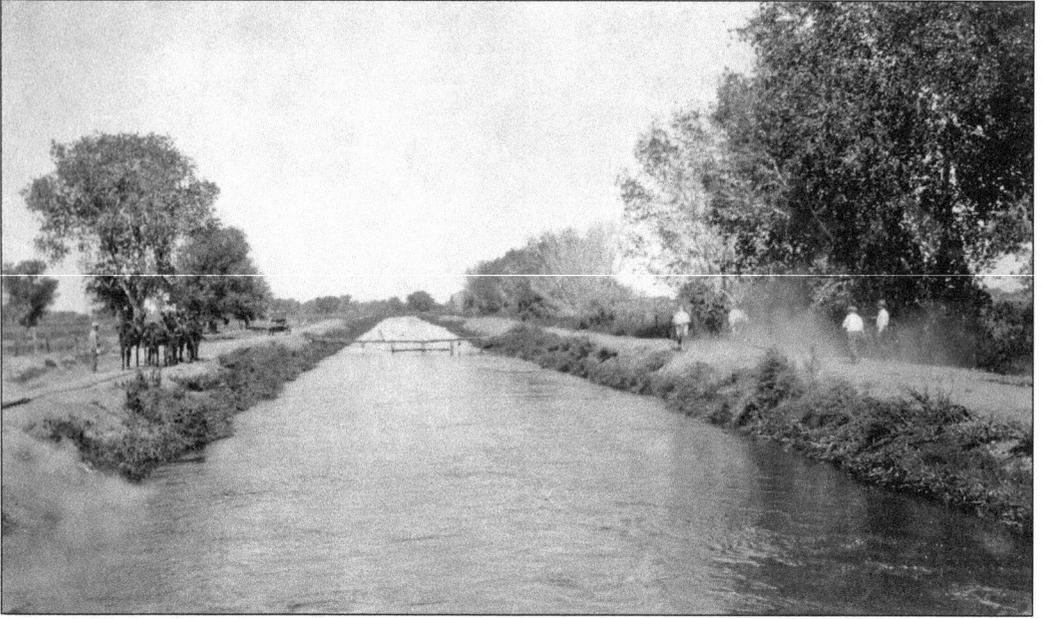

The Grand Canal, completed in 1878, spanned the east side of the valley to the Agua Fria River and covered approximately 20,000 acres, according to reporter Patrick Hamilton, who printed the information in a Phoenix paper in 1886. By 1887, three north-side canals—the Salt River, the Maricopa, and the Grand—had joined forces under one company to fight the water problems that had arisen across the valley. (Salt River Project.)

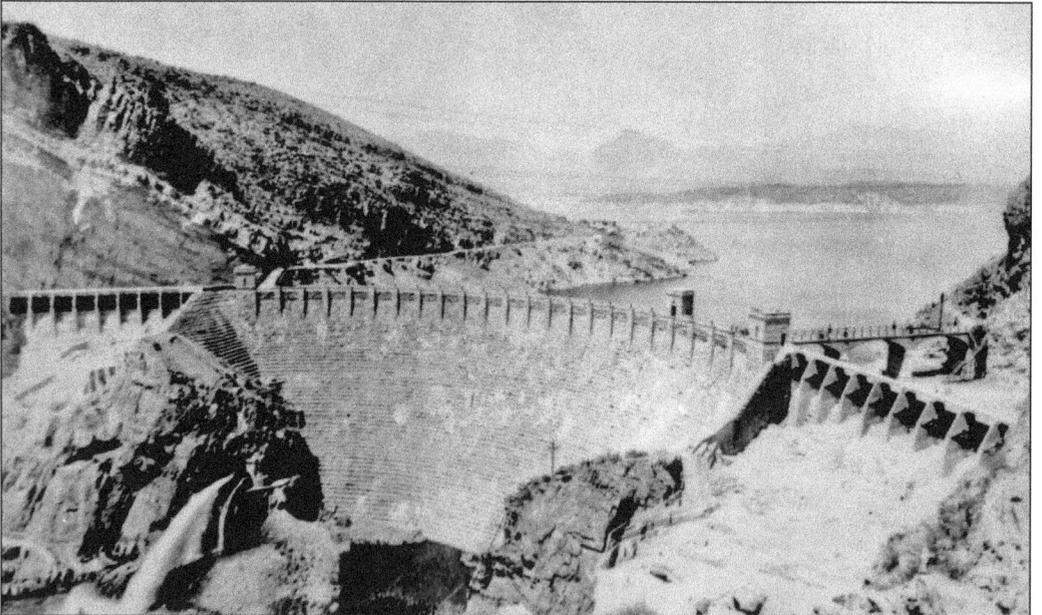

In 1902, the National Reclamation Act signed by Theodore Roosevelt gave the Salt River Valley citizens a chance to fulfill their dreams. Tonto Dam (later named Theodore Roosevelt Dam) at last provided water storage and a degree of control, allowing proper irrigation to thousands of acres year round. Completed in 1911, it was the world's largest masonry dam, and the resulting Roosevelt Lake became the largest manmade lake in the world. (Salt River Project.)

On March 18, 1911, a "car carrying Mr. Roosevelt rounded the point, giving him the first view of mighty Roosevelt Dam. A salute of eleven guns reverberated through the canyon. Five minutes later, the car appeared on the crest of Roosevelt Hill" (*Arizona Highways*, April 1961). The valley finally had a ready and manageable source of water. In 1959, an act of Congress officially named the dam after Pres. Theodore Roosevelt. (Salt River Project.)

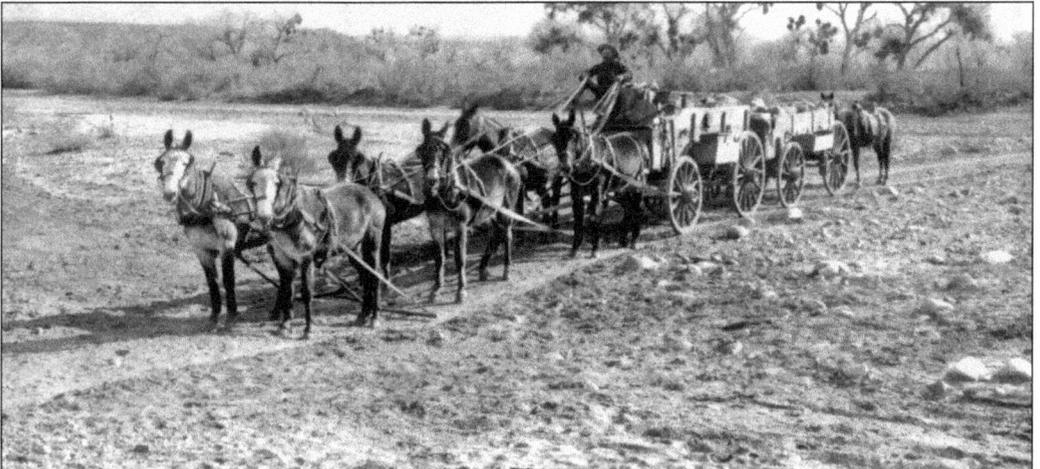

Walter Gist Tolleson discovered a remote farm for sale about 11 miles from Central and Washington Streets in Phoenix in 1910. Still standing on the property were the adobe remains of the Ten Mile Store on the corner of Lateral 22 and the Old Yuma Road. This 1904 photograph shows the way freight moved across the desert on this old road. The need expired with the coming of the Arizona Eastern Railroad. (Salt River Project.)

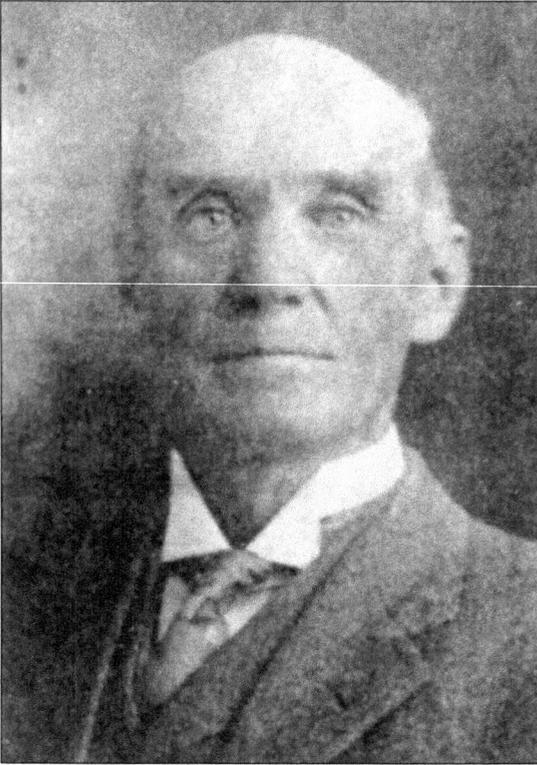

No record exists of Walter Gist Tolleson meeting President Roosevelt; however, he was a man much like the president. "Daddy Pop," as his family called him, ran the town. "He dressed in a coat, tie, white shirt and a flat straw hat. And Sunday afternoons he would pull his sleeves up at the garters, pull the hat over his eyes, and go to sleep on his canvas chair." (Leon Tolleson, *Arizona Republic*, May 22, 1986.)

Susan Alethea Hughes Tolleson, the family matriarch, moved with Walter and her family from Gaffney, South Carolina, to a college town named Spartanburg in 1892. They had seven children. Arriving in Phoenix in 1908, the couple purchased a ranch on Nineteenth Avenue a mile and a half south of the capitol, and started a home.

In 1912, shortly after Walter Gist Tolleson subdivided his 40 acres, he built a general merchandise store on the corner of Monroe Street and First Drive, which is now Ninety-first Drive. (In 1956, when Tolleson's status changed from town to city, street names were aligned with the valley grid. Thus, First Avenue became Ninety-first Avenue, First Drive became Ninety-first Drive, and so on—an avenue and a drive to each two blocks.) Walter's brother Leon became the first postmaster on July 14, 1913, with the establishment of a rural route operating out of Walter's general merchandise store. The post office later moved to Lateral 22 and Yuma Road (Ninety-first Avenue and Van Buren Street). Walter also built the first lumberyard in the area.

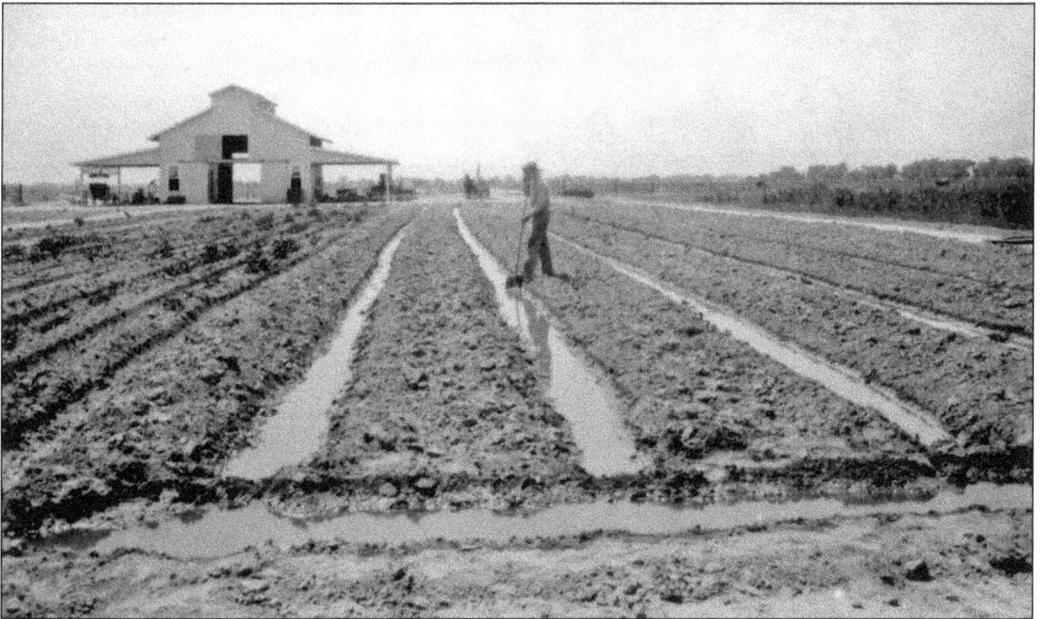

With Roosevelt Dam to provide water to the valley, farmers found success, expanding their investments to improved farms and ranches. An attempt at scheduled irrigation had come with the formation of the Salt River Valley Water Users Association in 1903, but the new dam assured consistency. This early farm in the Tolleson area is the result of the land owners' cooperation. (Salt River Project.)

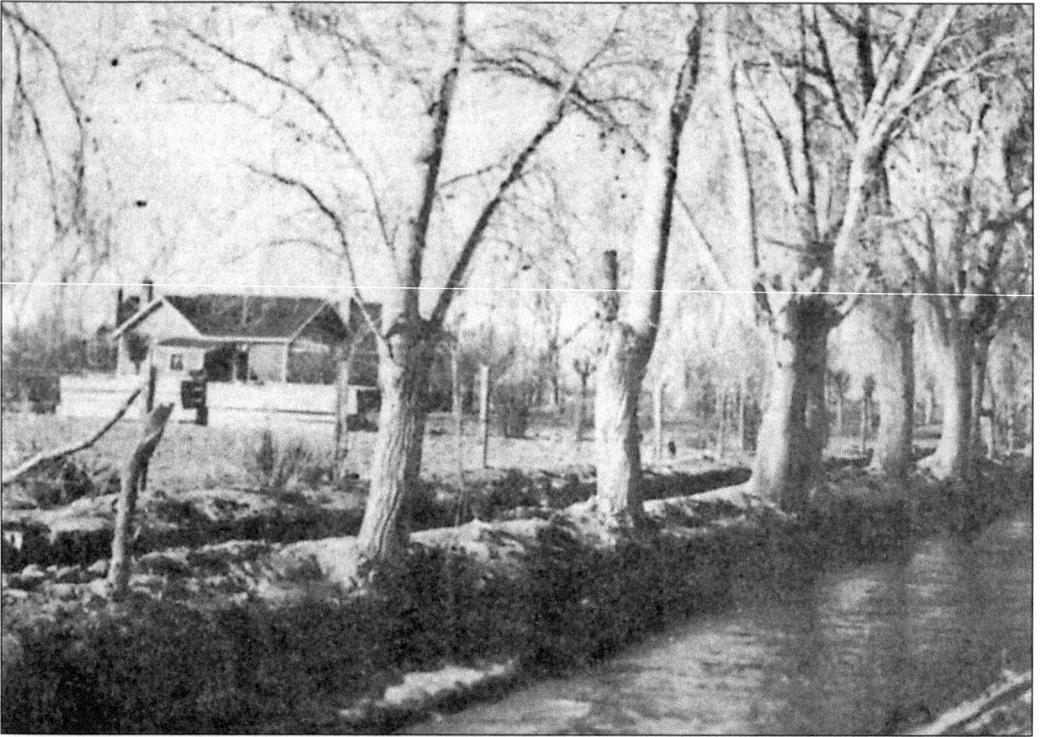

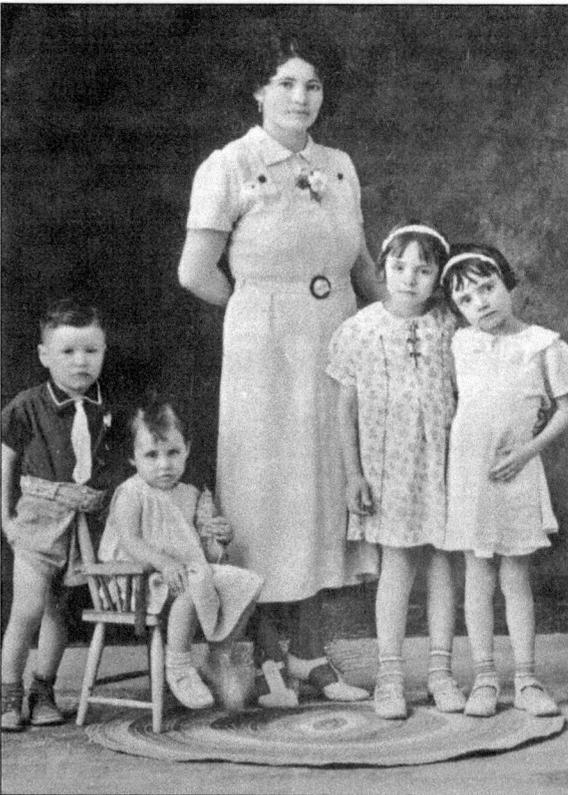

In 1903, T. T. Hedger's family moved from Kentucky to 360 acres 12 miles from Phoenix on West Christy Road (McDowell Road). A year later, T. T. brought his remaining family to live on this ranch in the West—quite different from what he had known in Lexington. Three years later, Katharine Louise was born. Katharine Louise Hedger Lamar became Tolleson's longtime city librarian, church mentor, and civic leader. (Barbara Hudson.)

With the success of farming and ranching even in the unforgiving Sonora, families of all social classes moved to the area. This 1937 photograph of Catalina Tarango and four of her seven children is an example of the sociological connections that took the southwest valley into the 20th century. A new generation would emerge and grow into a modern community culture with deep Hispanic roots. (Jackie Diaz.)

Two

THE PEOPLE
A MELTING POT OF REASONS

Walter Gist and Susan Alethea Tolleson decided to divide some property into lots. Walter was a businessman, a druggist, a developer, and a rancher by trade, and he had all the skills for land speculation. In 1912, Walter publicized his endeavor in the *Arizona Republican*; he would provide free train rides plus lunch for outside citizens to make the 11-mile trip and inspect his land. Over 80 lots were sold by auctioneer B. W. Getsinger, with the average price settling around $50. As an incentive, $5 gold pieces were awarded as prizes, and a brass band played to the crowd. Soon buyers pitched their tents on staked lots.

In the 1920s, Charles J. Baden, a northern landowner, subdivided a portion of his property. More tents and buildings began to appear. Mainly Hispanic families settled on the north side, while southern lots were purchased by Anglo Europeans. Soon after the farms were irrigated, churches and schools were organized. Tolleson was beginning to take shape.

Japanese families in the Issei community came in the early 1900s. In 1911, Russian immigrants came fleeing pressures from the czar. In 1929, the Kiichi Sagawa family started the first Japanese Christian Sunday school in Tolleson. Children from the extreme northwestern section of the Gila River Indian Reservation attended Tolleson schools. By the 1930s, Hindu farmers were selling products to surrounding customers. German, Lebanese, Syrian, and African American workers found jobs, farmed, or ranched in the area. Navajos worked alongside Filipinos and Mexican nationals in the Bracero program. Tolleson had become a southwest valley cultural milieu.

One of the first lots sold by Charles Baden on Polk Street went to Francisco Aguilar in 1928. Aguilar bought materials from Baden, as well as from Tolleson's lumberyard, and built a home for his family. His daughter later married into the Clemente Villa family. Others in this subdivision soon included the Barrazas, Mandurragas, Perezes, Gonzaleses, Chaviras, Fuenteses, Noriegas, Undianos, Rodriquezes, and the Lopezes. (Ophelia Villa-Navarro.)

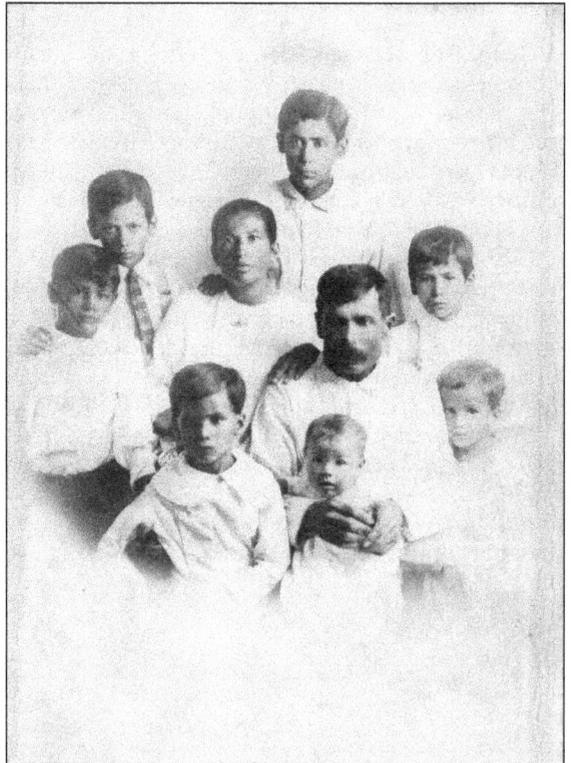

The Clemente Villa family moved to the Tolleson area sometime after 1918. The parents brought 10 children. Jose Maria, the eldest, died of influenza in 1918 and had to be buried along the railroad tracks between Casa Grande and Maricopa. Pictured from left to right are (first row) Bartolo, Francisco, little Manuel; (second row) Alejandro, Vicenta, Jose, Clemente, Clemente Jr.; and (third row) Jose Maria. Not pictured are Rosa and Pedro. (Jack Villa.)

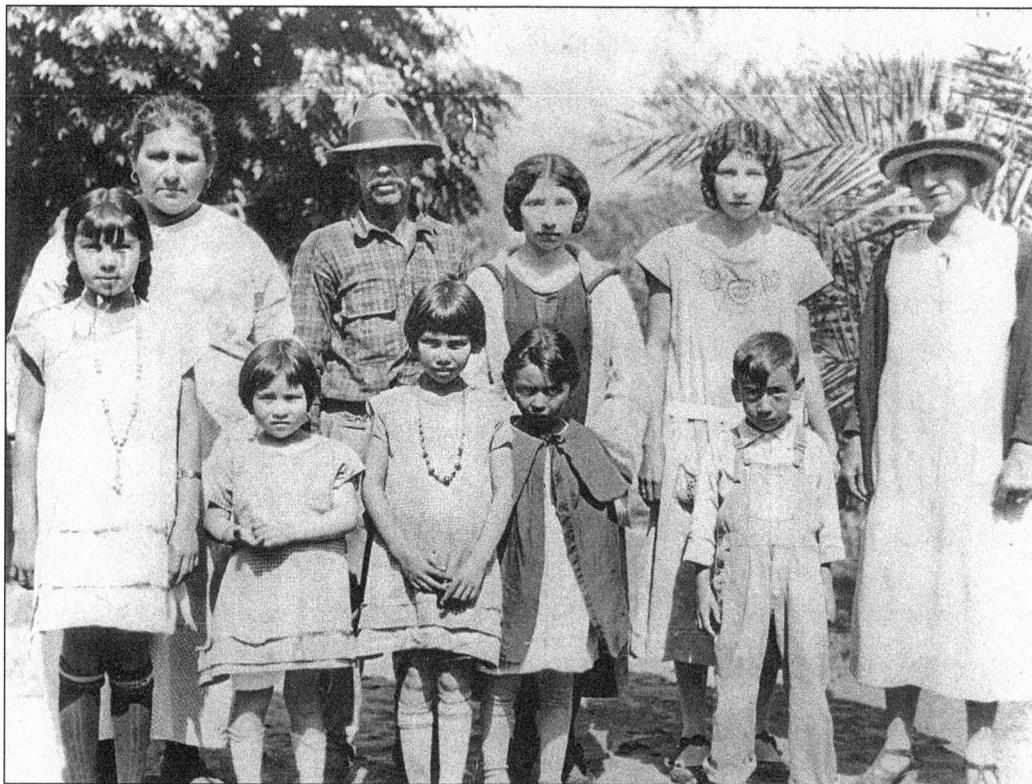

Another founding unit of the community was the Espinoza family. Carlos and Jesusita moved with their children from Tubac to the west valley farming area late in the second decade of the 20th century. Carlos worked on a ranch south of Lower Buckeye Road and raised his children to be hardworking citizens. The family included the following, from left to right: (first row) Carlota, Jesse, Maria, Edna, and Casimiro; (second row) Jesusita, Carlos, Delfina, Carmen, and Soyla. (Jesse Espinoza Lopez.)

Arriving around 1919, the Chavira family worked in the fields until Samuel Sr. became an entrepreneur with his small fruit wagon. When Samuel Sr. died, Maria, who was only nine, helped raise the younger children while the older ones continued their farm labor. Pictured from left to right are the following: (first row) Maria Luisa, Maria, Rodolfo, Samuel Sr., and Evangelina; (second row) Samuel Jr., Luis, and Antonio.

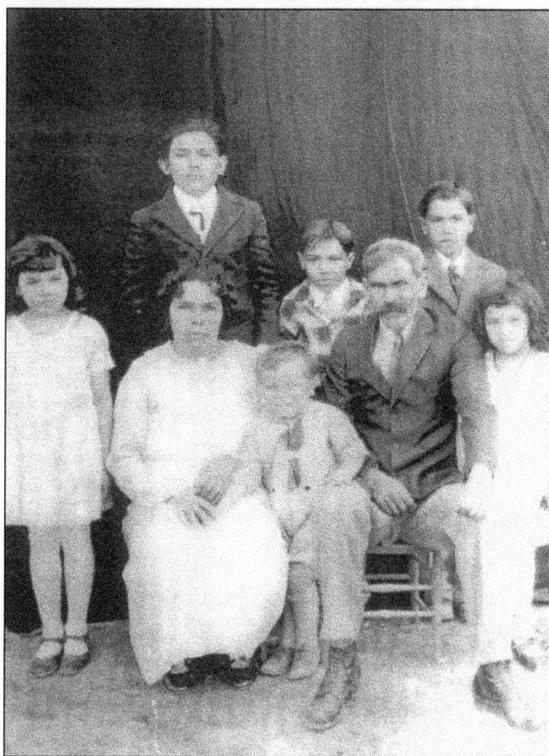

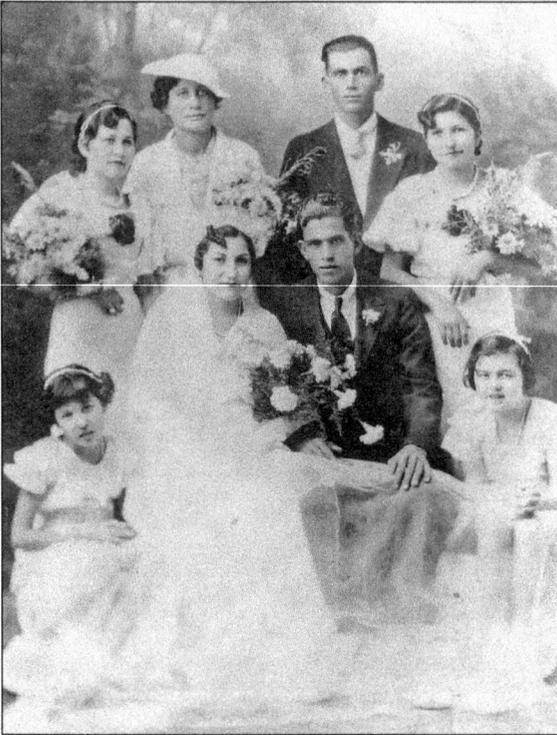

As Walter Gist Tolleson's town prospered at the corner of the Old Yuma Road and Lateral 22, families grew, jobs were created, and immigrants found places to settle. The union of the Villa and Aguilar families, with the marriage of Manuel and Teresa in 1934, is an example of the heritage that has impacted the social, political, and economic facets of the community even to the present. (Ophelia Villa-Navarro.)

In 1895, the Fowler Company provided land for a school on the corner of Lateral 19 and Yuma Road (Sixty-seventh Avenue and Van Buren Street). A small wooden school building called Independence stood at the corner of Lateral 20 and Yuma Road but burned before the company's donation. This photograph shows the first Fowler School. (Fowler School 100 Year Celebration.)

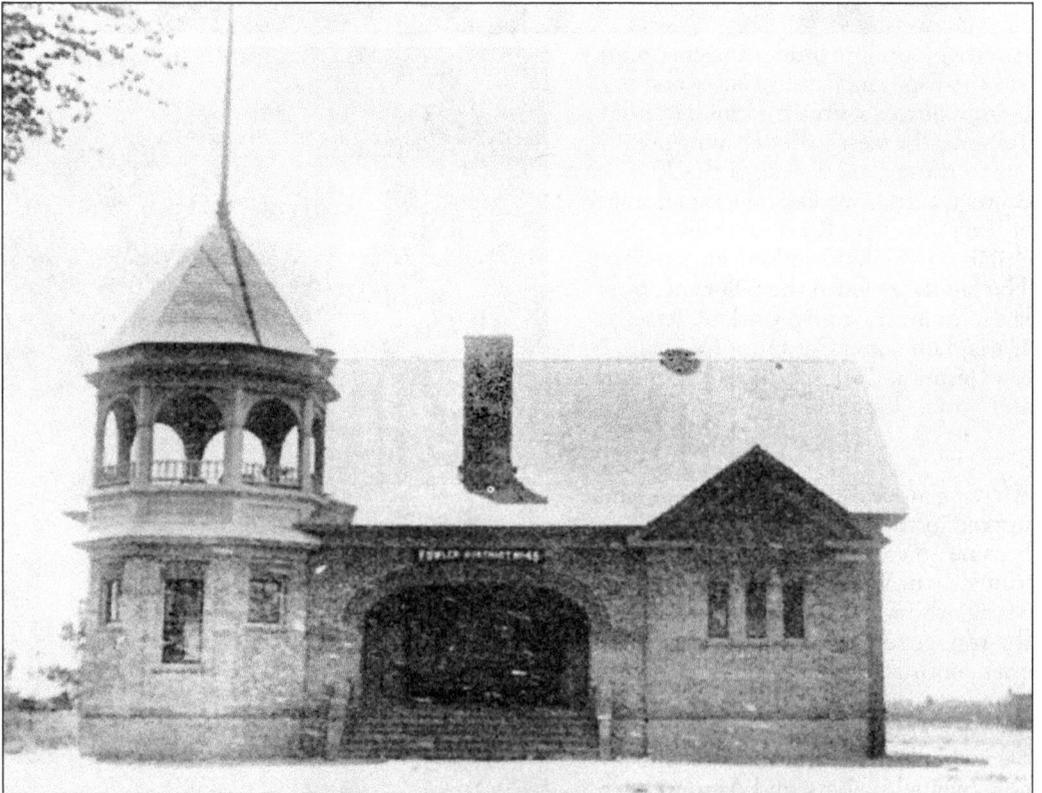

Lucy T. Whyman, Walter's oldest daughter and the widow of Richard C. Wyman, moved to Tolleson with her three children in September 1933 to manage her father's businesses. Walter had become seriously ill while visiting his son in Long Beach, California. In 1937, he subdivided his final 40 acres. His daughter became prominent in west valley business and served several years on the Tolleson City Council. (Thelma Green.)

Tolleson Union High District No. 214 was officially formed on January 24, 1914, with five farming communities as feeder schools. Pendergast School housed the high school until 1927, when the institution was moved to Tolleson. The district purchased 10 acres and began a building project. On May 31, 1929, the first graduating class of five received diplomas. Old Main continues to serve the district.

The VanLandinghams came to Tolleson in 1924. Guy and Rubie led a civic-minded family who shared much in the growth and development of the city. Family members were as follows, from left to right: (first row) Edith, Sharon, Guy Jr., Joan, Rubie, Gene Jr., Guy Sr., Buela, John, Karen, Patty, and Joyce; (second row) Wayne, Harold, Mary Jo, Eileen, Gene Sr., Winnifred, Garnell, Virginia, unidentified, and Gerald. (Virginia Vanlandingham.)

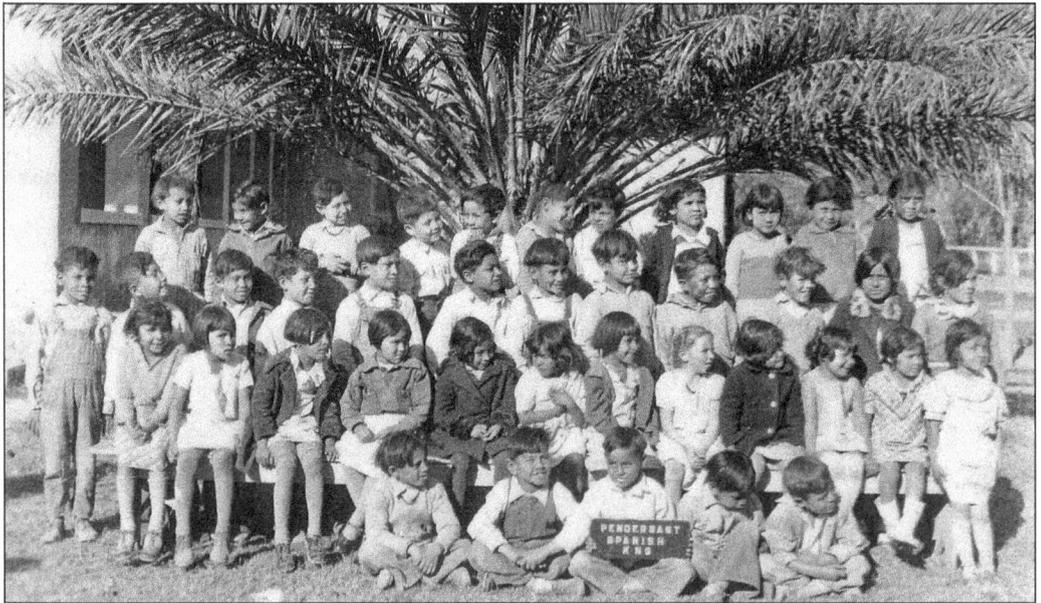

Pendergast School was another of the farm schools that eventually fed the Tolleson Union District. The Pendergasts homesteaded the property around Lateral 22 and Avenue K (Camelback Road) before the start of the 20th century. A need for schooling for both the landowners' and workers' children resulted in a community school. Years later, segregation became the norm.

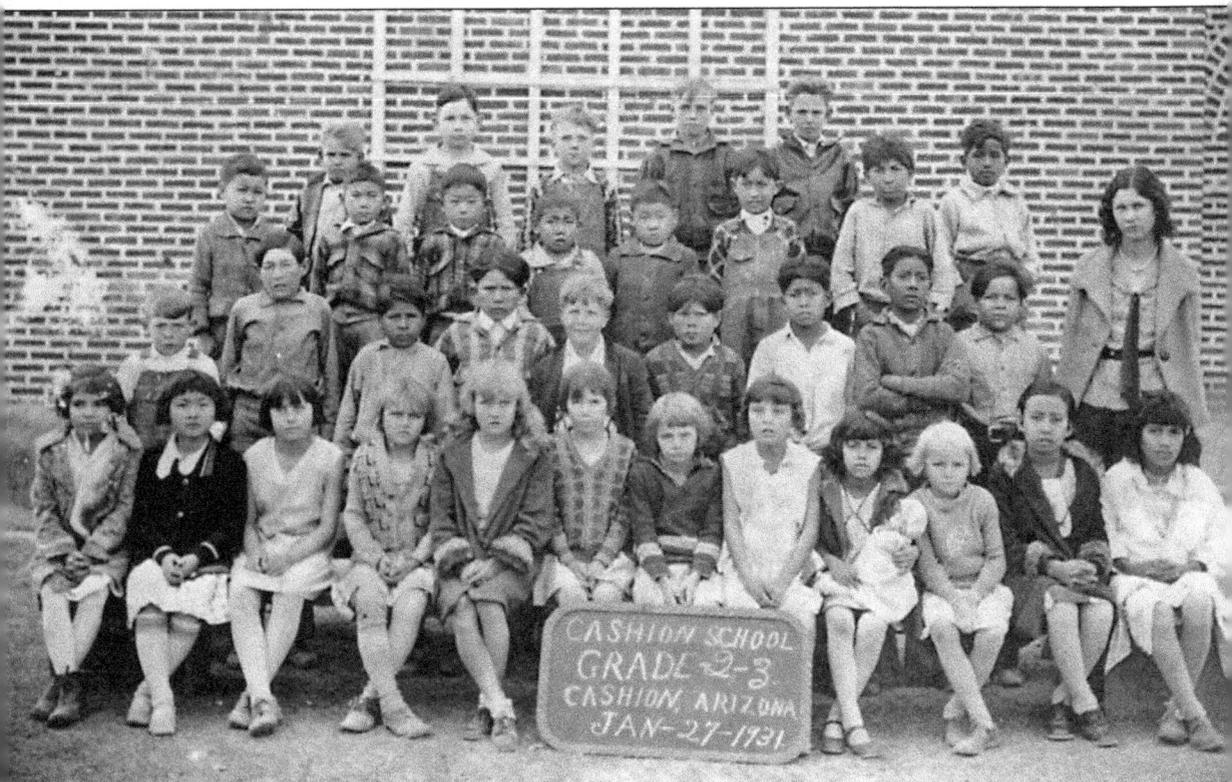

The home of Dr. S. D. Little was built near the west line of James Arthur Cashion's property on Lateral 25 and the Buckeye Road. Dr. Little, a practicing physician, moved from Maine to Tolleson before 1910. His wife's brothers Charles and Oscar Tuele came with him. Dr. Little's property is the current site of the Littleton School District administration buildings. The class of 1931 included members of the Sagawa family, who had established the first Japanese Christian Church in Tolleson, as well as several members of prominent southwest valley farming families. Some of the Littleton School's second- and third-grade students were Jack Start, Wallis Fleming, Carl Madden, Russell Start, Celia Mendez, Vera Madden, Little Crandall, Lucy May Wells, Rita Nelson, Frances Pena, Marie Wells, Makoto Sagawa, Keyosh Sagawa, Jack Davis, Analasico Valenzuela, Guadalupe Ramirez. Their teacher was Galen D. Sapp. Many of the Japanese farmers in the area either lost or sold their farms when they were placed in internment camps in 1941. (Lucy May Miller.)

H. Clifford Armstrong married widow Lida Hedger of Tolleson. Together they owned several farms in the west valley, where Clifford often constructed the living quarters. Armstrong's daughter Louise Lamar said he loved to build houses. In 1938, he was elected state legislator, serving devotedly for 14 years. The last home he built was on Adams Street in Tolleson in 1948. (Barbara Hudson.)

Joseph George, a Lebanese immigrant, opened and ran a grocery store on the northwest corner of Lateral 22 and Van Buren Street until he moved a few blocks west. The Tibshiranis from Lebanon/Syria ran the grocery store on the southwest corner of the intersection in the 1920s and 1930s. It later became the Pioneer Market. The town had 10 additional groceries over the years, 3 owned by families of Chinese heritage.

The Pioneer Grocery and Market saw several proprietors through the years. The southwest corner of Lateral 22 and Van Buren Street is the location of the Old Yuma Road's Ten Mile Store, the first stagecoach stop on the Phoenix-to-Yuma run. In the old adobe building, which served as a feed storage shack for Tolleson's livestock, Walter and his friend Arthur Finley began the first southwest valley grocery store.

Russian Molokans came with the hope of cheap land and religious freedom. Four Russian villages were formed—two along Eighty-third Avenue north of Christy Road (McDowell) and two closer to Glendale. The Russians became an important part of the Tolleson area. The site of the Conovaloff farm is now a substation for the Salt River Project. The Conovaloffs, Popoffs, Papins, Bogdonoffs, Gazdiffs, and Treguboffs were important community families. (Salt River Project.)

The Nakazawa brothers and their parents returned to the valley after internment to take up their farm on the corner of McDowell Road and Lateral 23 (Ninety-ninth Avenue). Today the modern shopping center Crossroads Pavilion occupies the property. Koki, one of the three brothers, stands at the home in Tolleson that he shared with his wife, Mitsueko "Mitzi," and their family. (Tony Nakazawa.)

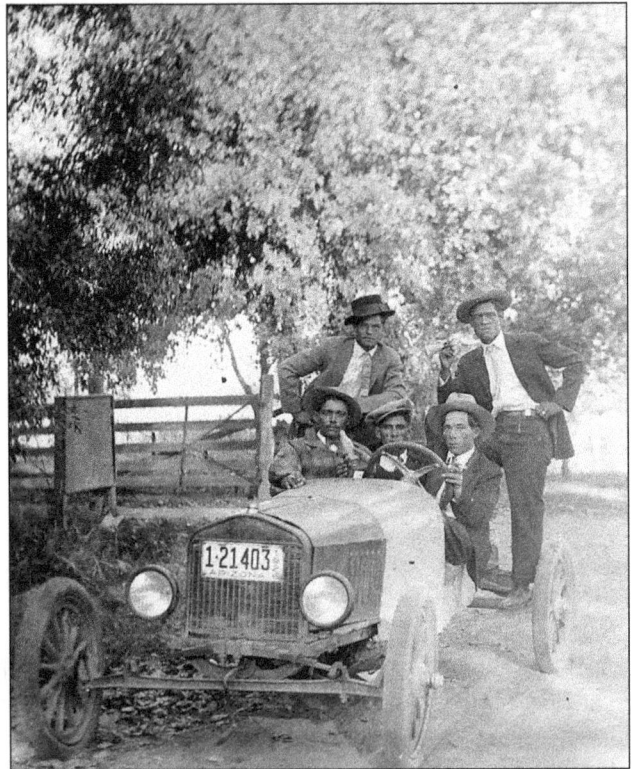

Sophisticated workers prepare for some relaxation on Lateral 23 between Christy and Yuma Roads (McDowell Road and Van Buren Street) sometime around 1926. Hispanics came to the valley from Mexico with their families; however, many were native to the lands in the northern Sonora before the Gadsden Purchase of 1854. Three of these gentlemen are, from left to right, (first row, far right) Francisco Hernandez Lorenzo; (second row) Lorenzo Martinez and Francisco Gonzalez. (Carmen Florez.)

This 1923 photograph of Tolleson Elementary School children shows a mixture of ethnicities—something that would change in the 1930s with segregation. Laura Arnold (center, second row) served on the Tolleson City Council during the 1980s. Santiago "Jimmy" Ruiz (second row, sixth from left) worked as a produce foreman for one of the largest processors in the valley. Jimmy was also a city businessman and community leader.

Hispanic families came to the valley looking for a better life, but work was generally hard and living conditions difficult. Typically, these children of 1920s working parents lived in housing provided by the landowner. Laborers spent the greater part of their lives employed by the same farmer. (Jackie Diaz.)

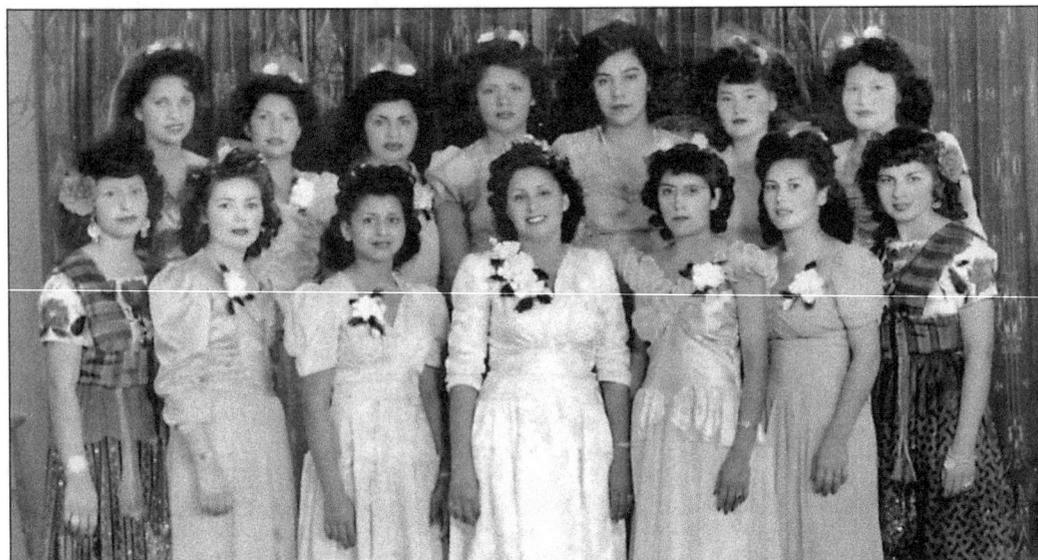

The Hispanic heritage introduced customs that have become important parts of the community. Attending the 1945 *Fiestas Patrias Mexicanas de Phoenix, Arizona* are Tolleson's ambassador, Nellie Alcocer, and her entourage. Members included the following, from left to right: (first row) Lala Cabrales, Emma Moreno, Vicki Alcocer, Nellie Alcocer, Virginia Pena, Mary Nogales, and Lupe Rodriquez; (second row) Carmen Moreno, Lydia Ledesma, Margie Jimenez, Mary Godinez, Evangelina Chavira, Velia Moreno, and Paula Mendoza.

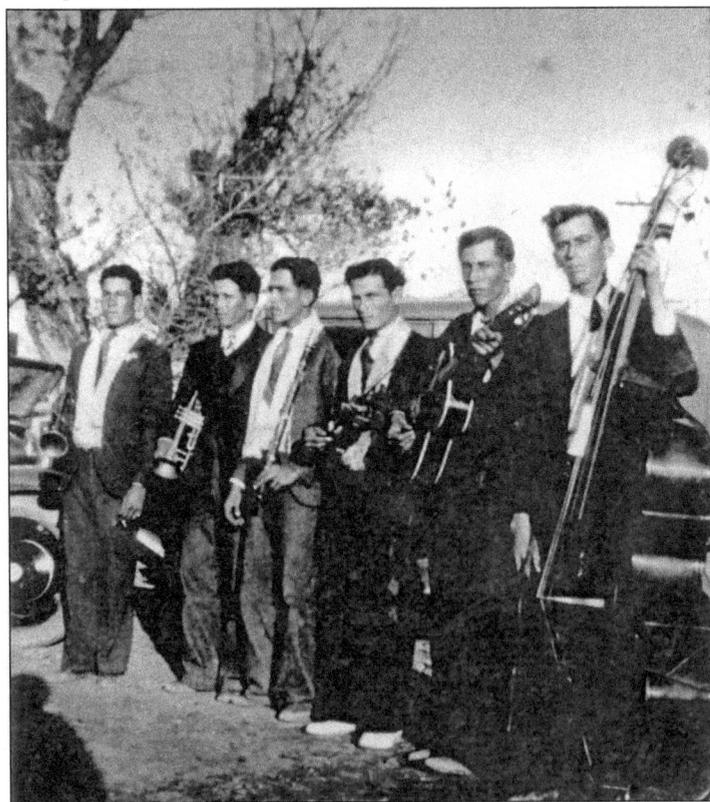

The Villas formed a Mexican music group, Los Villas, and played across the valley. Seen in 1935 from left to right are Francisco, Clemente, Manuel, Alejandro, Bartolo, and Jose. *Gay ranchera* dance music was the band's specialty. Their claim to fame was helping to open the San Carlos Hotel in downtown Phoenix. (Jack Villa.)

Pictured from left to right are Carmen, Manuel, Jesus, and Ramon Hernandez in the 1930s. Carmen, who married into the Flores family, eventually owned much property in the town. Jesus and Ramon served in the Korean War and received several decorations for bravery. The Hernandezes continue to be a part of the Tolleson community.

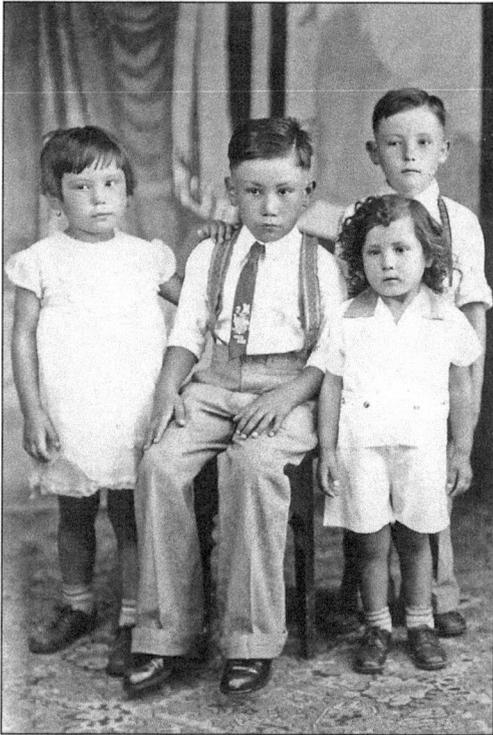

Sotero Diaz and his sisters reflect the sophistication of Hispanic families. Catalina Diaz (first from left) later became a Tarango. Through marriage, the Tarangos were connected to the Medranos, the Valenzuelas, and the Garcias. The community was a true extended family. Pictured to the right of Sotero right are Paula and Maria. (Jackie Diaz.)

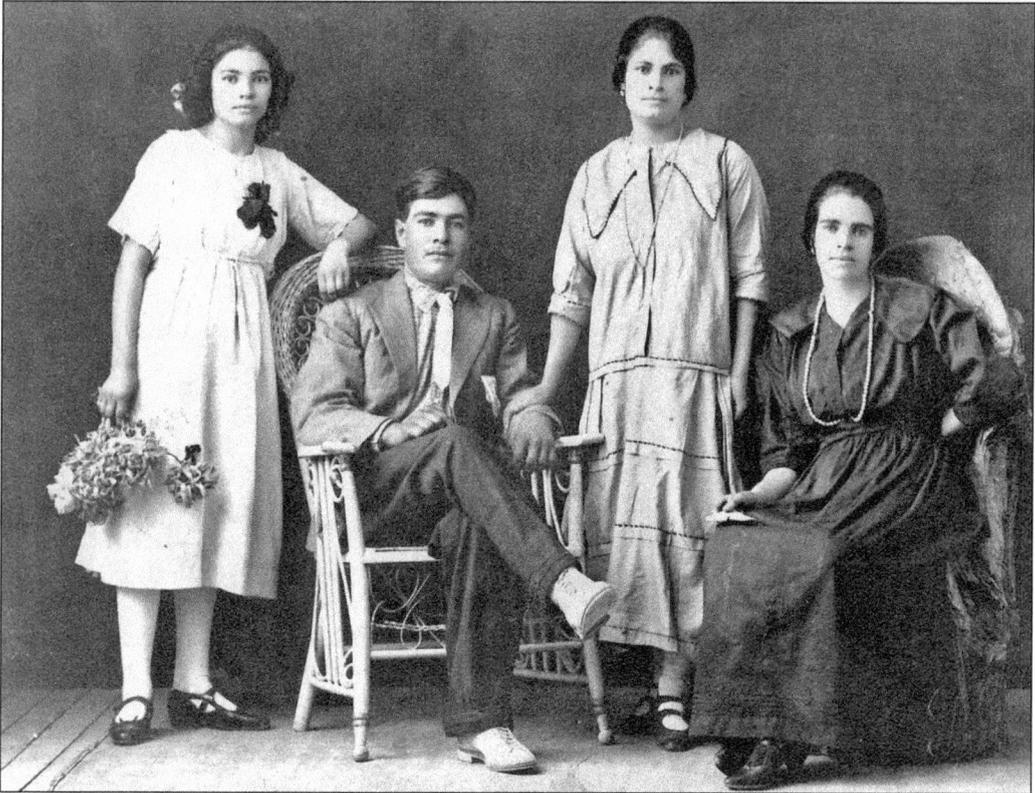

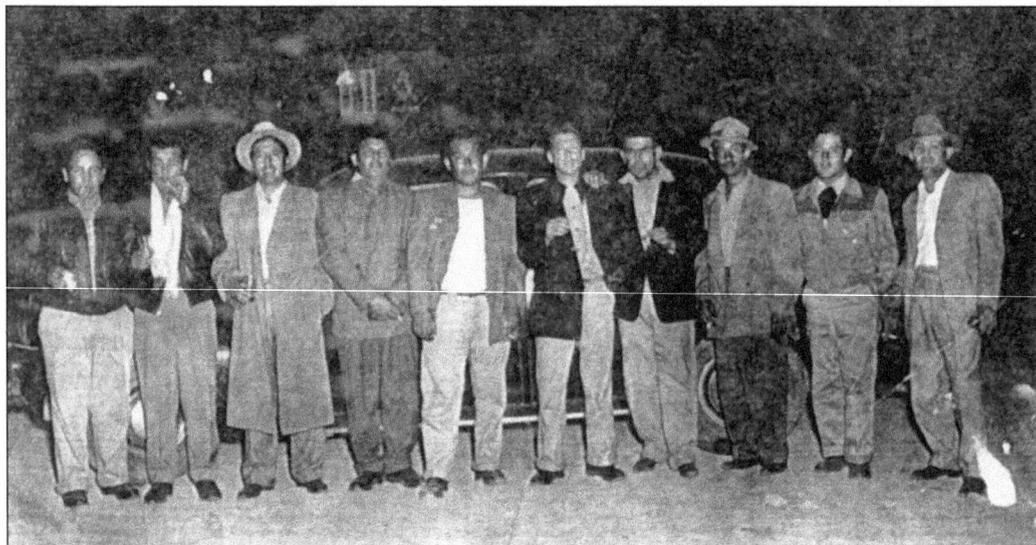

Tolleson's young men often socialized wherever their work took them. Taken in 1950, this photograph shows a group of men after a day of hard work in produce. Pictured from left to right are Jesus Jimenez, Ignacio Espinoza, Cipriano Zaragoza, Luis Beltran, Manuel Hernandez, Jose Espinoza, Samuel Chavira, Joe Arias, Jesus Hernandez, and Eduardo Gonzalez.

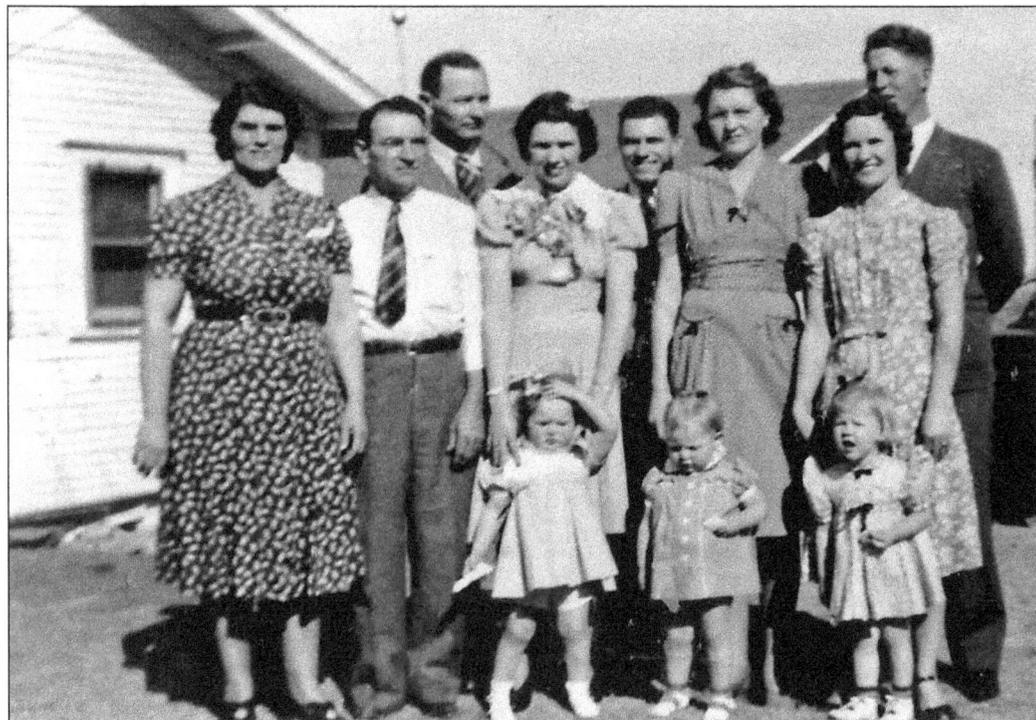

Members of the Black and Green families first arrived in Tolleson in 1935. Within 15 years, more than 45 members of the family were living south of Van Buren Street in a six-block square. Seen in 1938 are the following, from left to right: (first row) Rita Perrin, Mary Black, and Barbara Green; (second row) Iola Black, William Black, Lorrine Perrin, Normalee Black, and Thelma Green; (third row) Bill Perrin, Steve Black, and P. J. Green. (Thelma Green.)

The Nogales Trio carried the love for music throughout the area in the 1930s. Members included Dulces Loya (left), Francisco Nogales (center), and Manuel Nogales. Their families contributed to the nation through the military and to the community as service employees. For instance, John Loya (Dolces's brother) was a Korean War veteran and city employee, and Ruben Nogales (Manuel's son) served as a Green Beret during the Vietnam War.

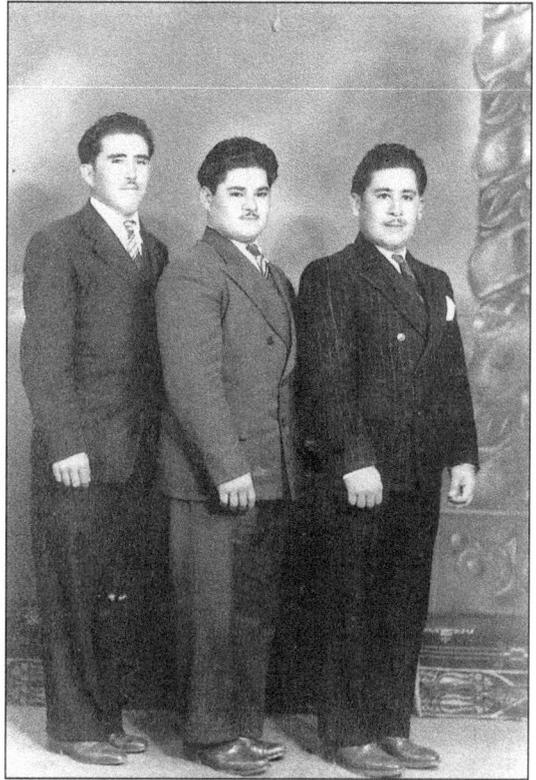

In the 1920s, the Brogdon family migrated to the Tolleson area. Brothers Cecil, L. V., L. J., and Leroy all owned individual farms, and sisters Zelma Brogdon McBride and Alice Brogdon Parker married into farm families. Many Brogdon children attended Union and Littleton Elementary Schools and Tolleson Union High School. (Carroll Brogdon.)

Cleto "Teclo" and Maria Camacho came to Tolleson in the 1930s and raised a large family, with several children becoming prominent residents in the community. Their teenage son Johnny, in particular, played a significant part in the desegregation of the elementary school. (Jesse Camacho.)

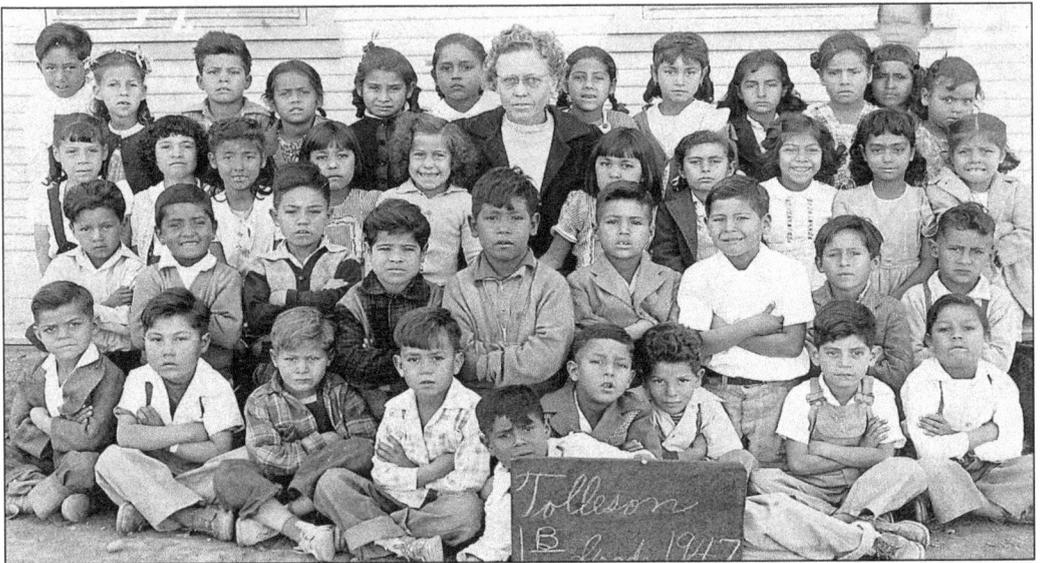

Tolleson Elementary School's first-grade class at Unit II reflects the segregated nature of the district in 1947. Pictured from left to right are (first row) Eugene Contreras, Frank Hernandez, Arthur Martinez, Louis Gallardo, two unidentified, Mike Navarro, two unidentified; (second row) three unidentified, Armando Cruz, two unidentified, Alex Berumen, unidentified; (third row) Annie Gonzales, Gloria Gonzales, Delores Elias, unidentified, Estella Villa, Mrs. House, unidentified, Carmen Barraza, Virginia Rodriguez, unidentified, Vera Lizarraga; (fourth row) Manuel Loya, unidentified, Mike Martinez, seven unidentified, Jenny Noriega, and Ruth Rojas. (Carmen Florez.)

In 1918, the Catholic Church first built a small chapel on Second Avenue and Washington in Tolleson. In 1949, Blessed Sacrament Church was erected at its permanent location on Ninety-third Avenue and Pierce Street. The Society of Guadalupanas continued to be the foundation of Catholic spiritual and community service. Original members included Annie Pena Sotelo, Esther Angulo, Nellie Navarro, Rose Balsz, and Nellie Rodriquez.

During the early years of its agricultural peak, Tolleson offered housing in the form of courts—5 to 10 small cabins—for migrant workers. Utey's Court, Opals Court, LaRue's Court, the Second Avenue Court, Duncan's Court, Carlos Gutierrez's Cabins, and several others provided living accommodations. In this early-1940s photograph, Helen Smith visits Utey's Court with her children. Pictured from left to right are Jimmy, Helen, and Jarrie Smith. (Jarrie Holliday.)

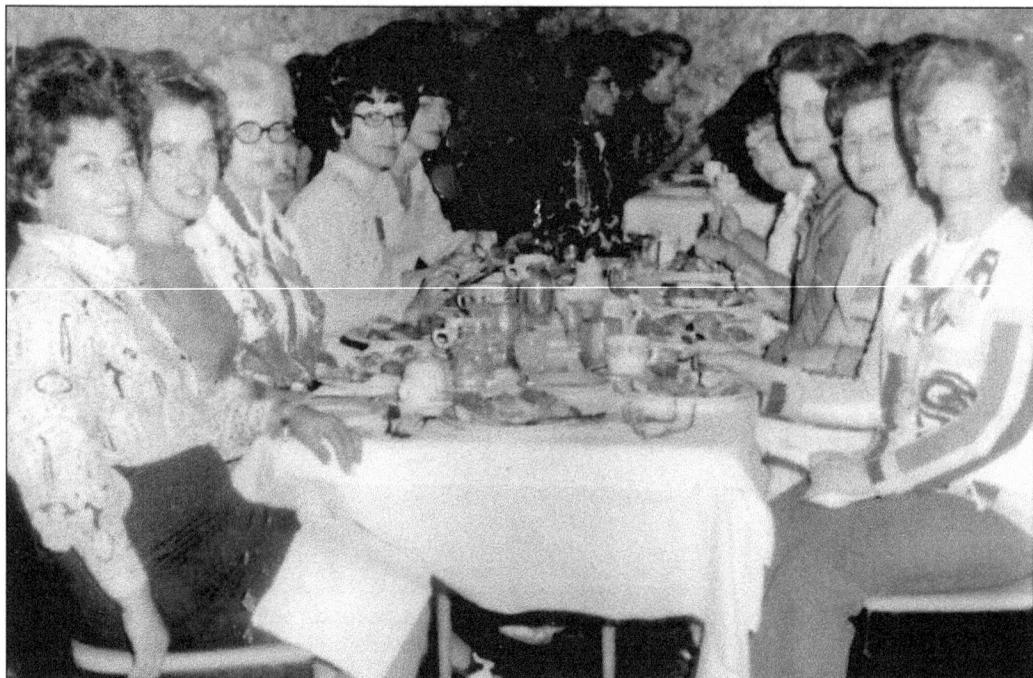

Here Tolleson City Council members' and city employees' wives attend a city council convention in Nogales, Sonora, in the 1960s. From left to right on the left side of the table are Nellie Rodriguez, Mary Watson, Eileen Gray, and two unidentified women. On the right side of the table are two unidentified women, Edith Green, and Thelma Green. (Thelma Green.)

Juan and Ernestina Bustamante were married and raised their family in the Tolleson area. Ernestina owned property along First Avenue (Ninety-first Avenue), where she and Juan began a small town grocery store called John's Market, operated by the family for years. Today Juan and Ernestina's children and grandchildren live in the area and provide services to the citizens as professionals and municipal and school employees. (Tina Solorio.)

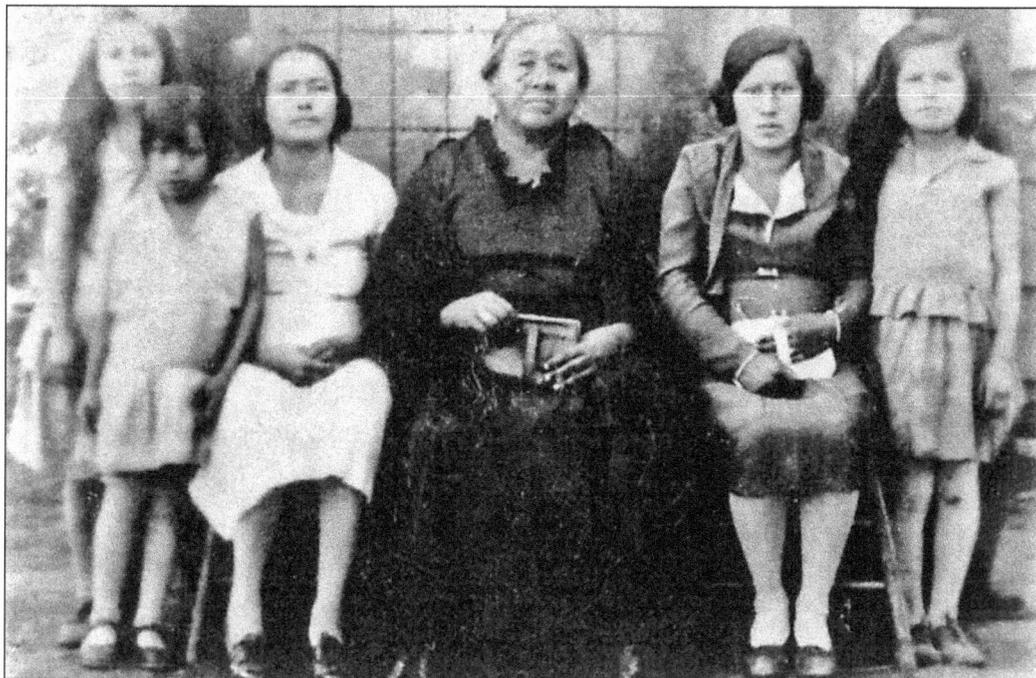

Shown in the 1930s are, from left to right, Frances, Mary, Maria, Dolores, Luz, and Billie Hernandez. Dolores Quinonez Hernandez worked as the area midwife during the 1920s and 1930s. She is the great-great-grandmother of Juan Medrano, the principal of Tolleson's Porfirio Gonzales Elementary School, and Reyes Medrano Jr., Tolleson's city manager. (Geanne Medrano.)

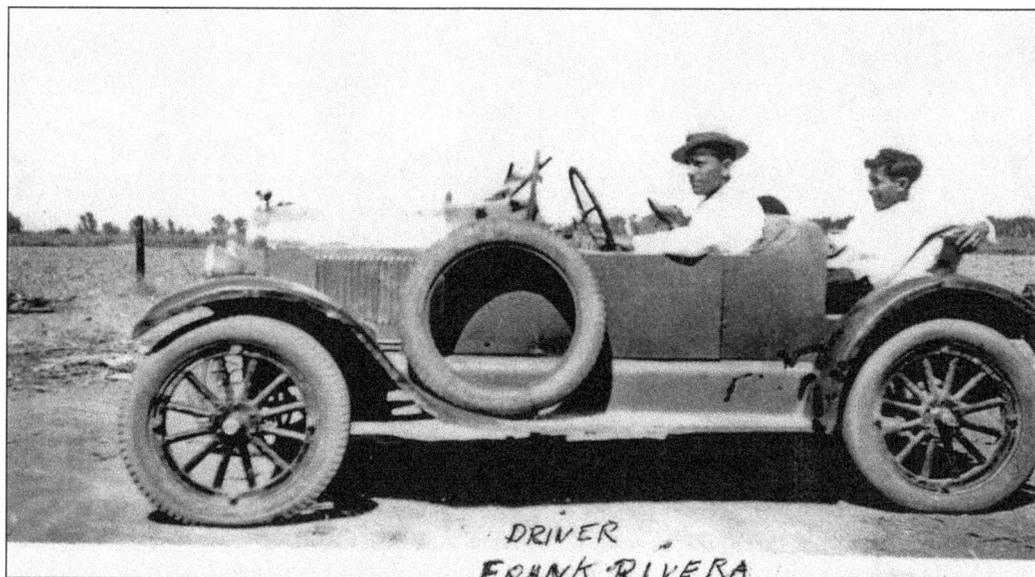

DRIVER
FRANK RIVERA

Frank Rivera (left) and a friend try out his newly acquired roadster on one of the laterals west of town in 1934. Frank became a World War II veteran, Tolleson property owner, reputable businessman, sports promoter, and city councilman. Frank's brother Joe (not pictured), a Korean War veteran, still resides in Tolleson, where he and his wife own Mary's Flower Shop.

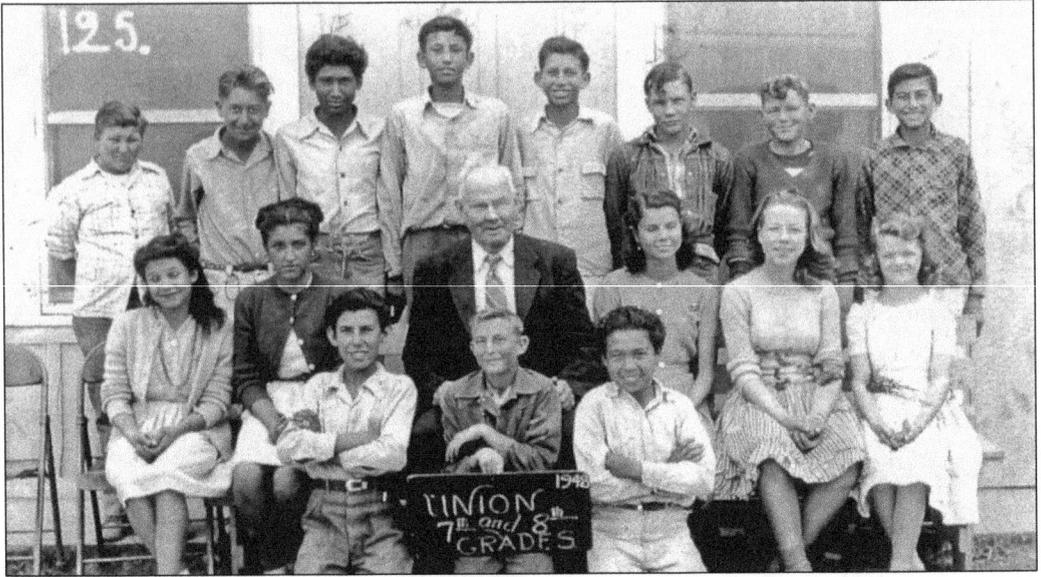

Union Elementary School was organized on south Lateral 22 in 1899 and served as another Tolleson feeder school. Three rooms made up the instructional building. Pictured in the 1940s are the following, from left to right: (first row) Pancho Gaxiola, Ralph Herrell, and Robert Andrade; (second row) unidentified, Otilia Quinonez, teacher O. C. Jones, Flossie Turner, Joanne Cooke, and Roberta Parker; (third row) George Poque, Joe Guzman, Manuel Quinonez, Gilbert Villa, Murl Lee, Jack Hanna, and Jack Villa. (Jack Villa.)

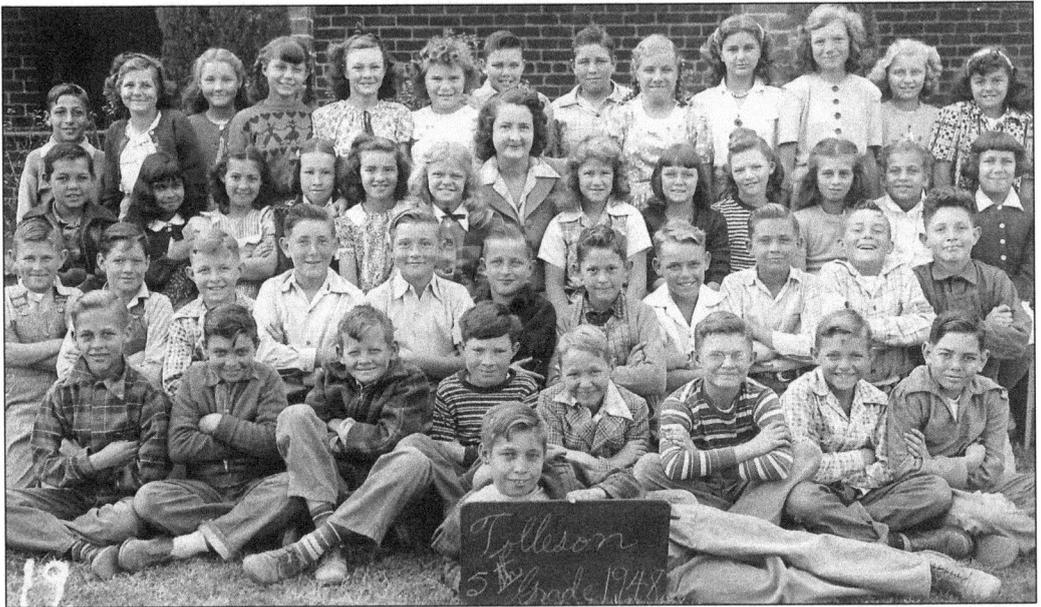

During the 1930s, segregation was practiced in some form or another in southwest valley schools. At Tolleson Elementary, Hispanic students attended Unit II and Anglo European students attended Unit I until seventh grade. This policy changed in 1951. Pat Clark's 1948 fifth-grade class included three youngsters who continue to make the Tolleson area their home: John Caudle (first row, sixth from left), Jarrie Smith (third row, ninth from left), and Dorma Johnson (third row, third from left). (Barb Bryant.)

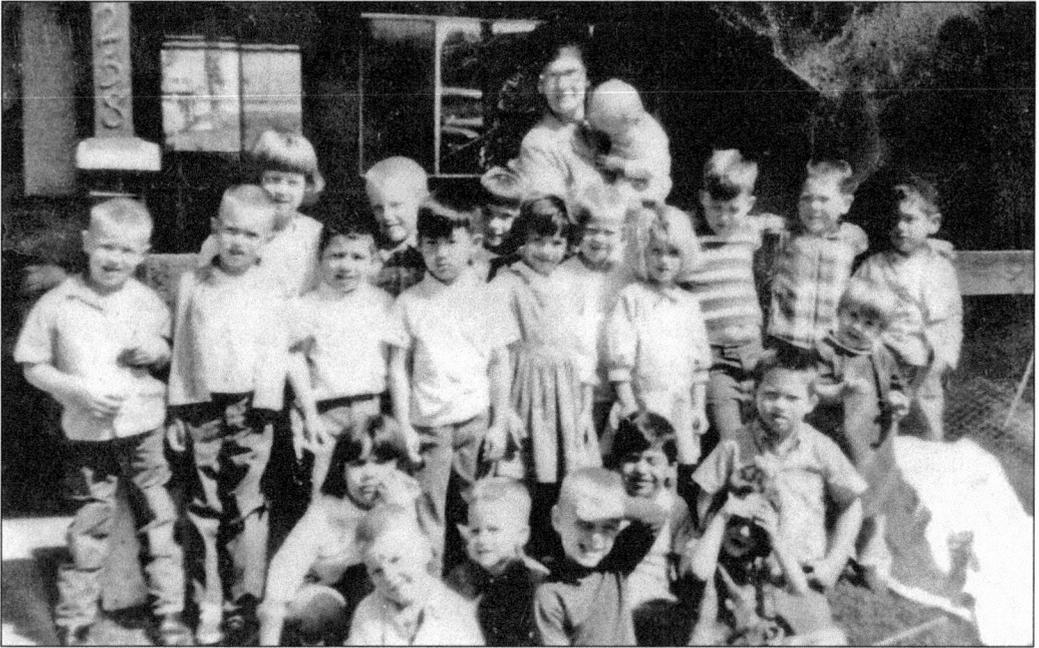

By the 1960s, the Tolleson community was coming to grips with the ethnic divisions that had permeated the schools for several years. Thelma Green's 1967 private kindergarten class shows the relationships experienced by children of Asian, Hispanic, and Anglo families. (Thelma Green.)

The Tritz family came to Tolleson from Wisconsin in 1951. Jack, the father, sat on the city council, held the little league presidency, served on the volunteer fire department, and fought for change as a community activist. Jack's wife, Dorothea, continues to participate in the Tolleson Women's Club and has readily supported the community. Here their son, honor student Tom Tritz, receives his acknowledgment of acceptance into the U.S. Naval Academy at Annapolis in 1973. (Dorothea Tritz.)

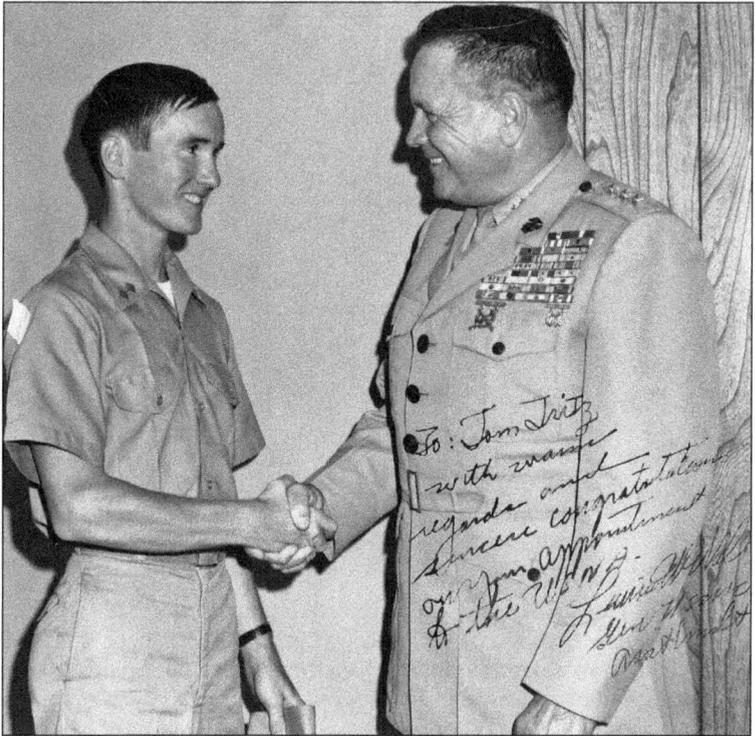

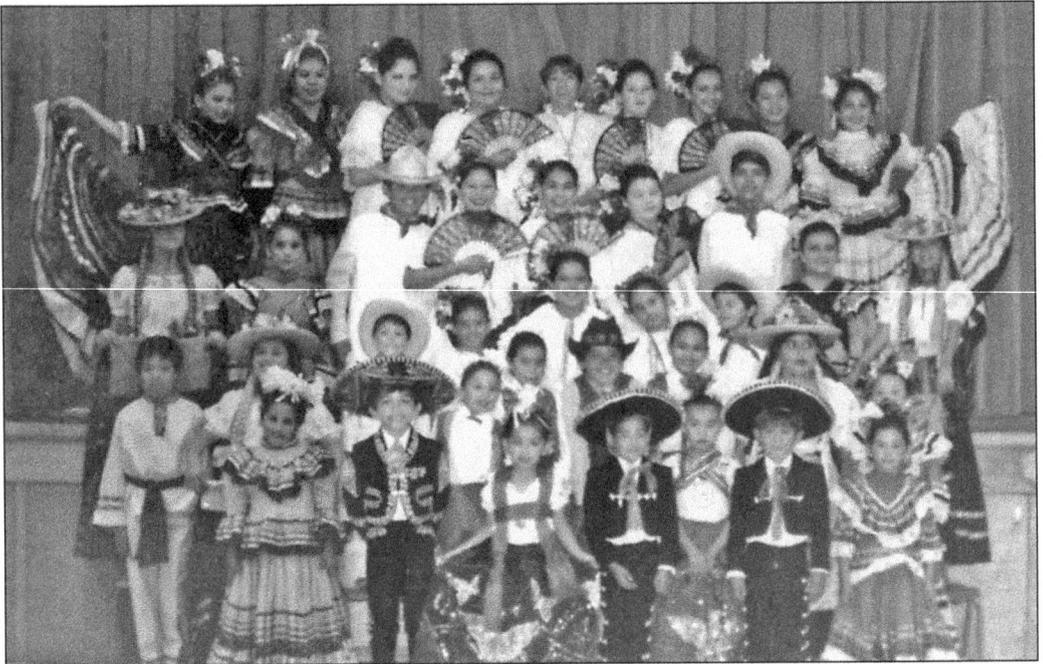

The Hispanic culture has contributed immensely over the years to the growth and development of tradition in the Tolleson area. The city, which encompasses only six and a half square miles, is now approximately 75 percent Hispanic. Spanish cultural nuances have influenced the lives of all citizens. This photograph, taken in the 1980s, highlights the importance of Tolleson's community folk traditions. (Kathy Rivera.)

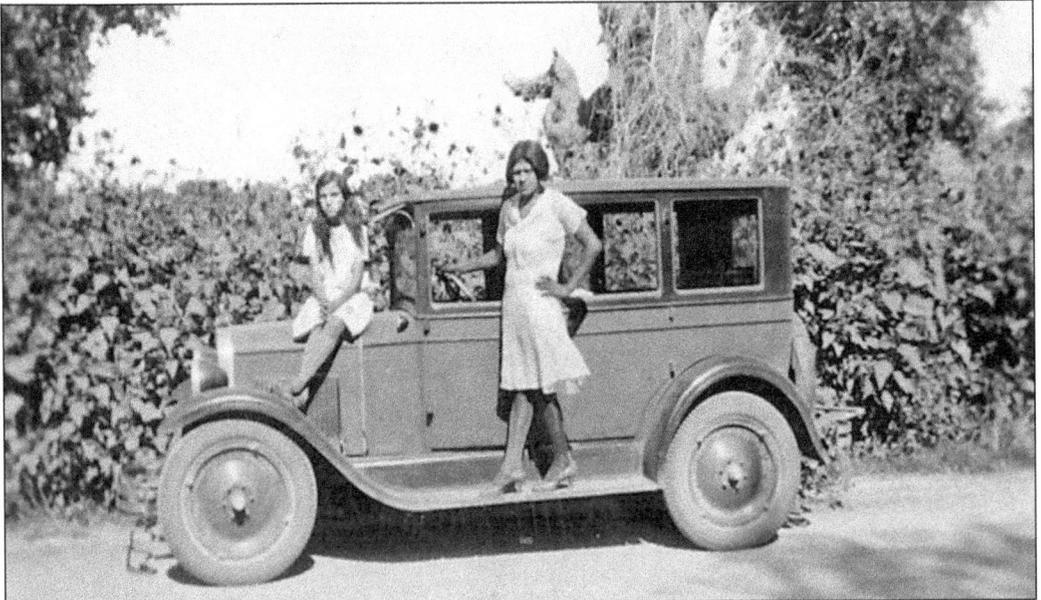

In 1929, when the town of Tolleson was incorporated, censes records show that the Salt River Valley had approximately as many Hispanic residents as Anglo Europeans. However, most records of the time fail to recognize Hispanic contributions. Many were sophisticated businesspeople and community advocates. These two ladies embody the elegance of the 1920s. (Jackie Diaz.)

Three

THE LAND
RICH LAND, GOOD PEOPLE,
ABUNDANT WATER

"I am the river," wrote Richard Carlson in *Arizona Highways* in April 1961. The poet speaks of water for a thirsty land. . . . But this land of the Salt River Valley needed strong dams, canals, ditches, and wise people with tenacity supporting the river.

Upon arriving in Arizona, Walter Gist Tolleson immediately bought property: a home and dairy, a 160-acre investment that developed into one of the most valuable farms in the state because of his widely coveted lettuce crops. The area below the Grand Canal, built in 1878 along the Salt River Canal—Jack Swilling's original—was tremendously fertile, centrally located, and irrigated by the precious water turning the desert into a bountiful garden. The Paxtons, the Quinonezes, Gabriel Fuentes, Noboru Takiguchi, Charles. J. Baden, Denny Isabelle, Ray Cowden, Russell Badley, the Armstrongs, James Cashion, the Arenas, Cecil Miller, Laurence Anderson, John Conovaloff, Pete Treguboff, Koki Nakazawa, the Kahns, the Shulkeys, Joe Sheely, James G. Trout, Garland Shahan, the Brogdons, Dutch Hudson, the Lukes, the Pendergasts, the Tolbys, the Waddells, the Vigils, the Brookses, and the Fowlers tamed the harsh land.

Jesus H. "Rod" Rodriquez remembers Walter Gist Tolleson as a debonair Southern gentleman, meticulous in manner. The love of the land forced his vision outward from his farm. In 1912, when he subdivided the first 40 acres on the Old Yuma Road, Walter Gist Tolleson stepped far into the southwestern Salt River Valley of Maricopa County, Arizona.

Prior to 1910, Helen Sergeant came to the southwest valley to live on Buckeye Road and Lateral 24. Here her husband built a home for his new wife. In 1960, Helen Sergeant's book *House by the Buckeye Road* told of the great challenges faced by the early farmers and ranchers: the struggles with too much or too little water, the battles with the unforgiving desert, and their relationships with the arrogant rivers. (Barbara Hudson.)

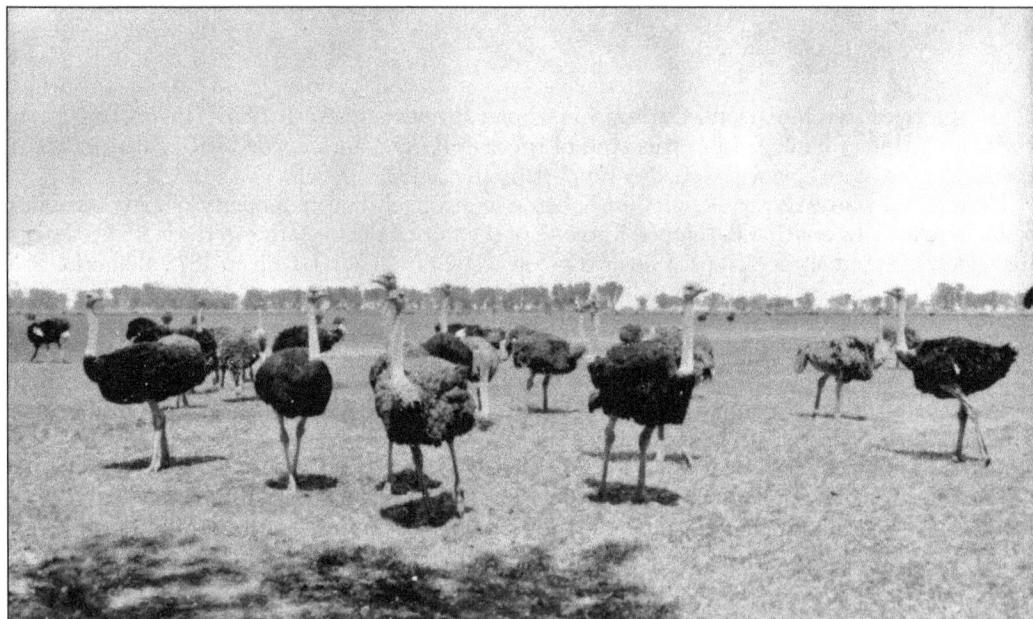

The Pan American Ostrich Company, incorporated in 1906, owned a ranch north of Buckeye Road and Lateral 24 (107th Avenue). Ostriches were raised for their colorful plumes, which would adorn women's attire. Arizona is known for the world's only "ostrich drive," taking place when Dr. Chandler of the east valley purchased the stock in 1910. An attempt to drive them like cattle left most birds lost in the desert and river bottom. (Salt River Project.)

James Clifford Lamar and Louise Hedger ready for a trip on their wedding-gift horses in 1925. Louise, born on West Christy Road (McDowell Road) in 1907, tells in her *Memories* of the usually dry Agua Fria River in its flood stage. The river would stretch a mile wide, and her family could hear its constant roar on the ranch three miles to the east. (Barbara Hudson.)

Before the Salt River Federal Reclamation Project's first dam was constructed, irrigation water in the Salt River Valley took the course of either feast or famine. After the Roosevelt Dam's completion in 1911, bountiful harvests were the norm. Here workers cut an alfalfa field on West Christy Road in 1912. (Barbara Hudson.)

With abundant water, many of the valley's farmers and ranchers found lucrative lifestyles as a result of their hard work. After crops were harvested and sold, there was often time for fun. Lida Armstrong and her daughter Louise prepare for a trip to an engagement requiring the sophistication of the time in 1919. Where some landowners were successful, others could not meet the challenges, gave up, and left. (Barbara Hudson.)

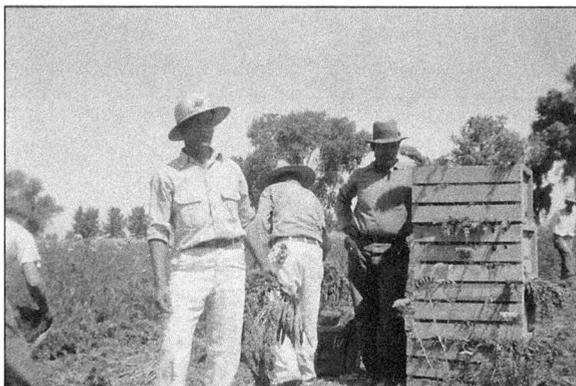

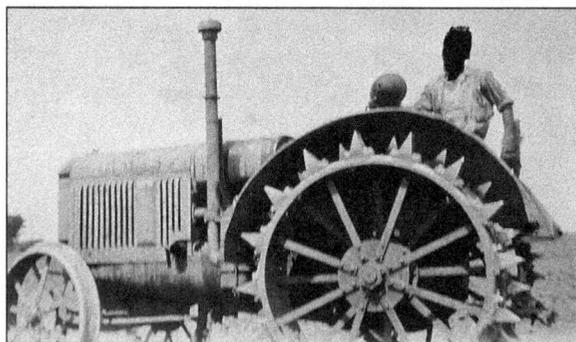

The early days of produce production in the southwest valley were much different than that of today. Field laborers worked generally in crews of 50 to 100 who prepared the product for the packing shed. It was difficult, since much was stoop labor. Machine operators had none of the current conveniences. Laborers and machine operators eventually succumbed to the environmental hazards of the occupation. (Jackie Diaz.)

Tenacious farm laborers often became managers, foremen, and eventually property owners. With the knowledge of farming and the willingness to work hard, families gained affluence and a future of sophistication. Education was important to the laborers, and they saw that their children took the opportunities they had lacked. (Jackie Diaz.)

As water became available to the land in the west valley, desert turned to irrigable fields from the Salt River north to the Arizona Canal. Water user associations were founded and rights established. In the southwest valley, the major provider became the Grand Canal. Here Civilian Conservation Corps workers perform rubble paving near Lateral 21 and Bethany Home Road in 1938. (Salt River Project.)

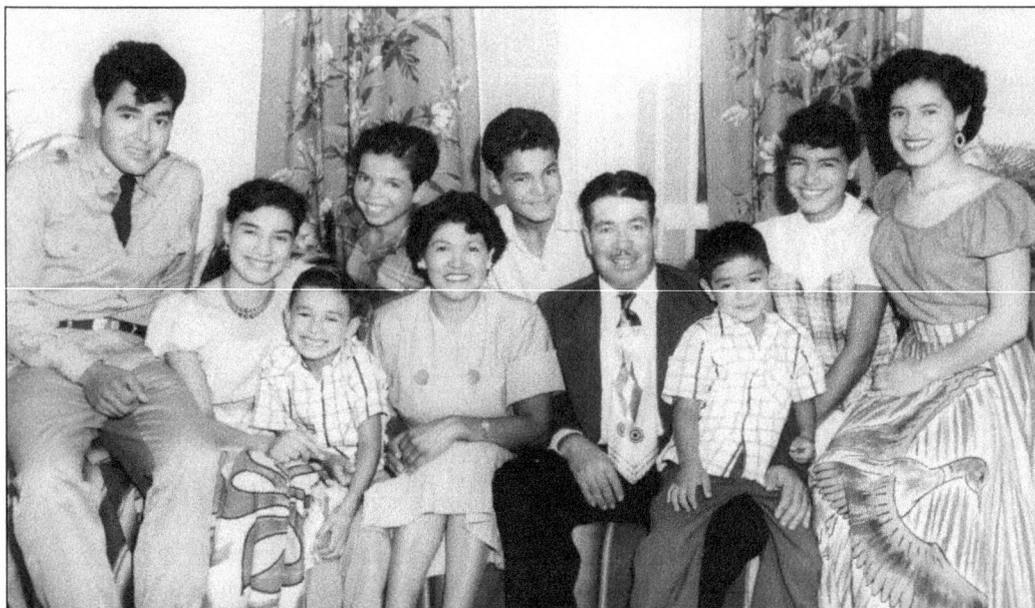

This 1952 photograph of Sotero and Jesusita Diaz's family reflects the accomplishments of many workers of the time. They were able to raise families, acquire the necessities of life, and advance their status in the community. The Diazes became integral parts of the Tolleson area as professionals, educators, and civic leaders. (Rebecca Diaz.)

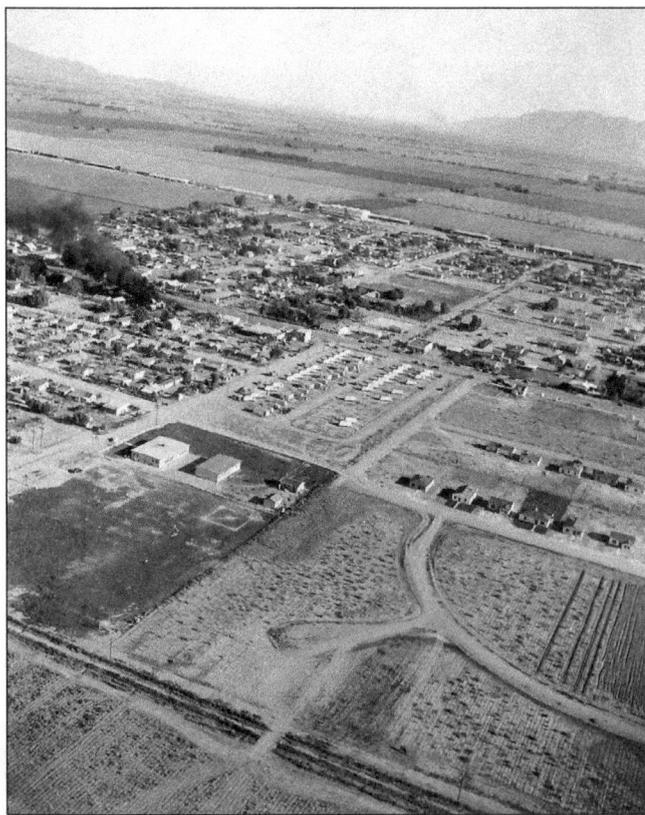

By the 1940s, Tolleson had become the recognized hub of the southwest valley. Most land south to the Gila Indian Reservation and beyond had become irrigable farms, ranches, and dairies. The same held to the north all the way to the Arizona Canal. Some farmland was turned into subdivisions, whose new residents found work in produce. Tolleson soon became known as the Vegetable Center of the World.

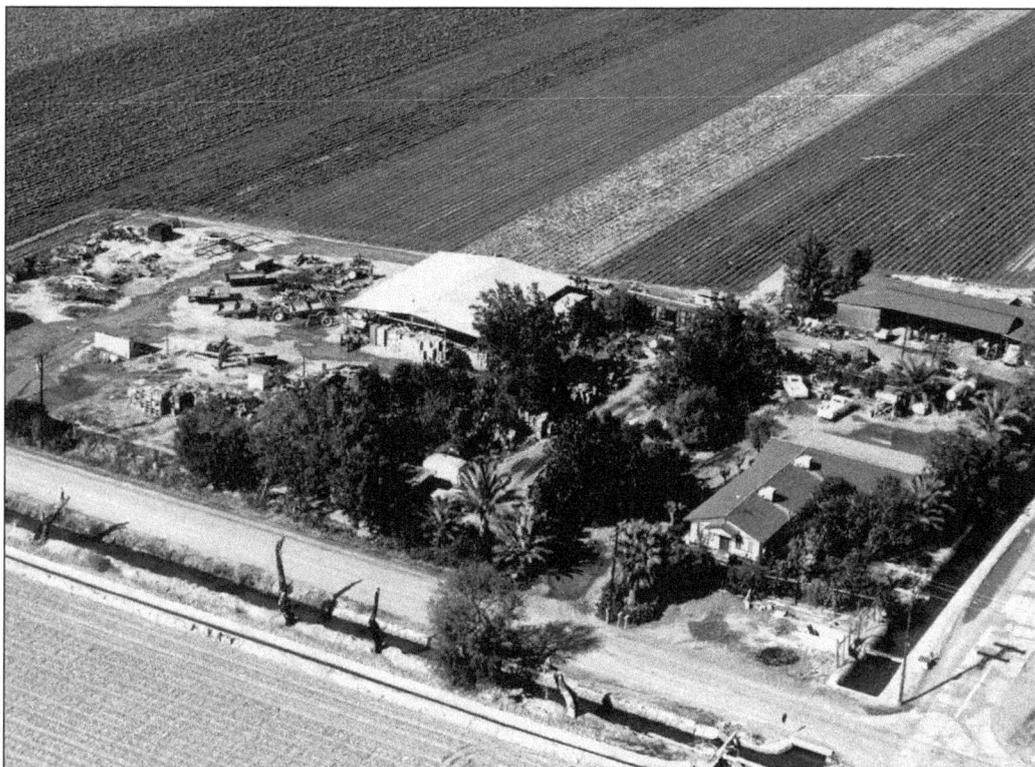

A typical southwest valley farm was generally surrounded by irrigation ditches bringing water from large canals. The Nakazawa farm, on the corner of Lateral 23 (Ninety-ninth Avenue) and McDowell Road was an example. Lateral 23 delivered irrigation water to the sections of land through ditches and head gates. The Nakazawa property is now Gateway Pavilion, a modern shopping mall one mile from downtown Tolleson. (Tony Nakazawa.)

A produce packing label placed on shipping crates indicates the popularity earned by the Tolleson packing industry. Fruits and vegetables of all kinds were processed and shipped across the nation. Tolleson's population peaked during this time, with businesses and services making it a truly self-contained community. Grocery stores, service stations, clothing stores, a movie theater, a skating rink, variety stores, pharmacies, and restaurants were established in town.

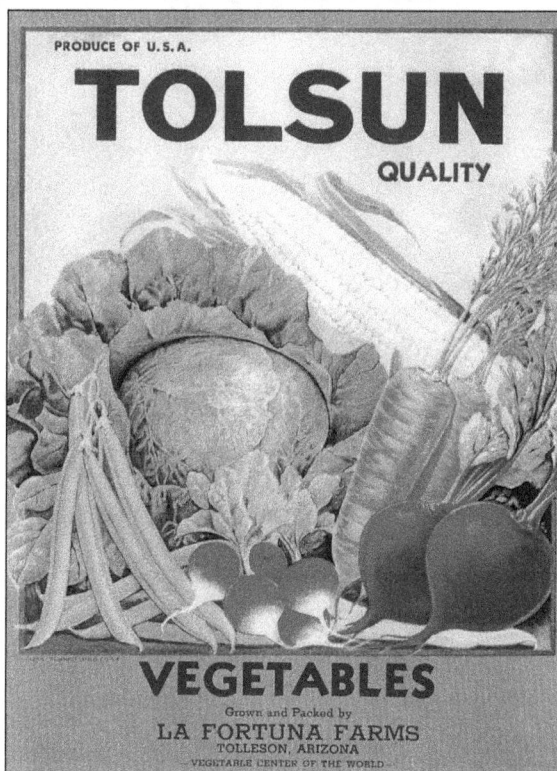

PRODUCE OF U.S.A.

TOLSUN
QUALITY

VEGETABLES
Grown and Packed by
LA FORTUNA FARMS
TOLLESON, ARIZONA
·VEGETABLE CENTER OF THE WORLD·

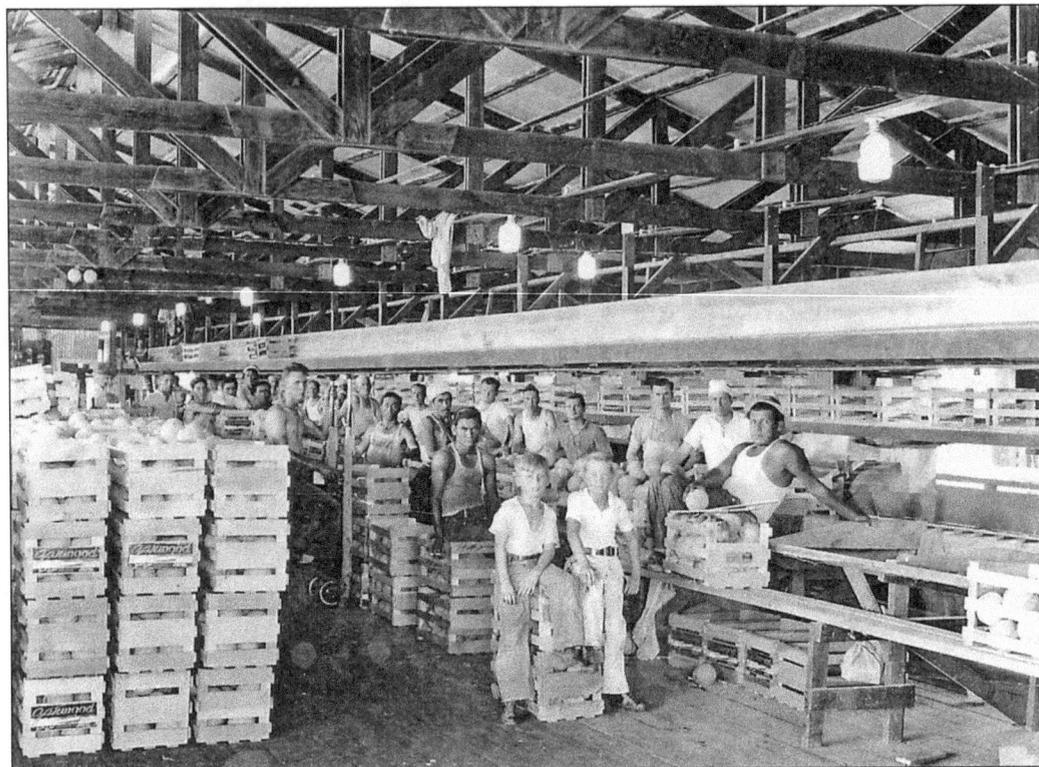

In the 1930s and 1940s, thousands of acres in the southwest valley were planted in cantaloupes. The rind blight of 1933 brought setbacks. By the 1950s, however, the area again saw busy packing sheds. Here J. A. Wood Company workers sort, pack, and prepare melons for shipping in 1949. Even youngsters worked in the bins. Since then, processing methods have changed greatly.

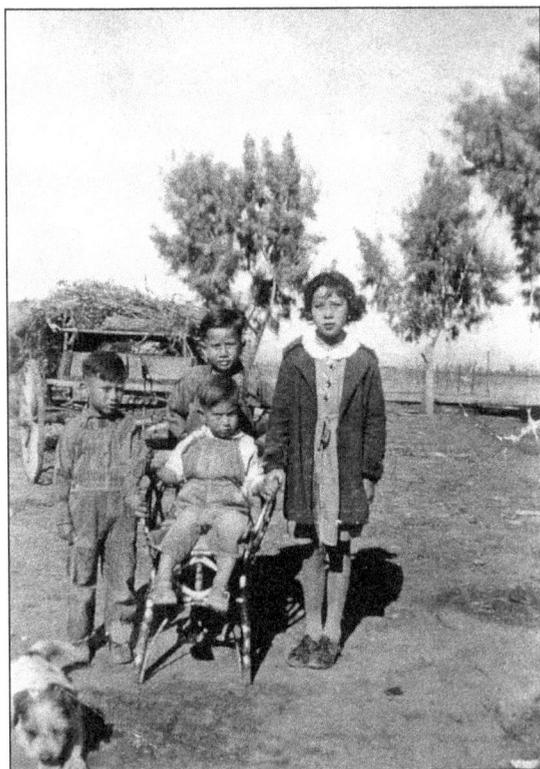

Even with abundant water to most areas, farm life for many families meant hard work. The Villa family lived in town for several years and then moved to a farm within the area. Jack, seen sitting in the chair, was born in 1935 and remembers his family's move in 1942. The Villas later ran their own small farm. Taken in 1938, this photograph also shows, from left to right, Jack's brothers, Gilbert and Albert, and his sister, Cora. (Jack Villa.)

Mary Chavira (left) and a friend prepare for a day's work in the fields in the 1930s. Mary gained a reputation by winning several competitions in the cotton fields. She could gather more pounds of cotton per row in less time than any other female worker. After her marriage to Santiago Ruiz, she became a prominent businesswoman in the community. Mary's family continues to reside in Tolleson.

A lettuce crew takes a break from fieldwork around 1946. Labor was usually long and tedious for salaries that remained less than appropriate for the task. All of these men were Tolleson residents who helped make the area the Vegetable Center of the World. Pictured from left to right are Juan Ramirez, Tony Chavira, unidentified, Rudy Ramirez, unidentified, Rudy Chavira, and Joe Ramirez.

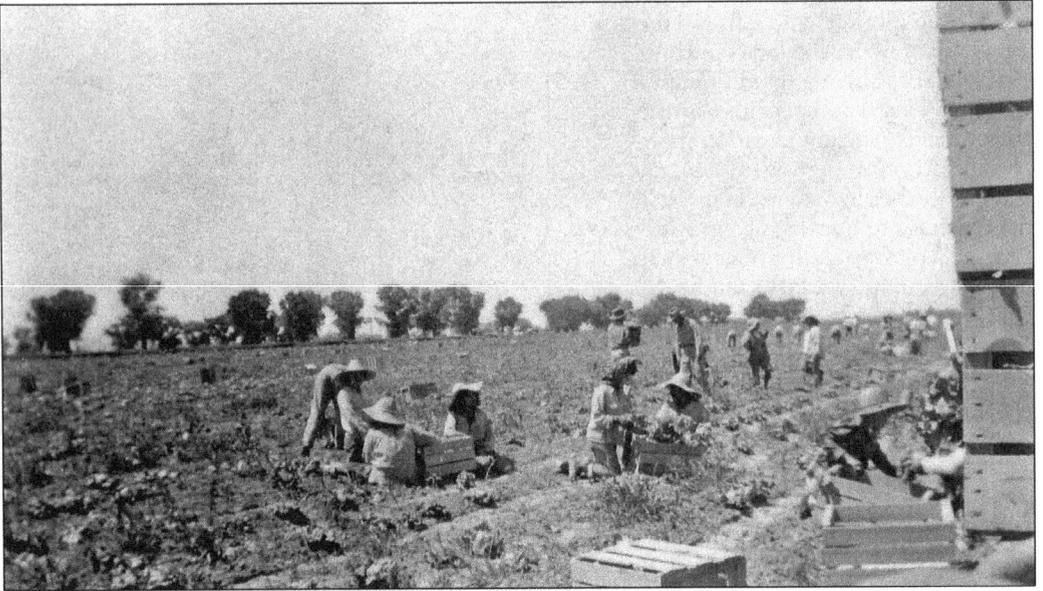

The land provided fruits and vegetables for the nation, but it was valuable in other ways as well. This field being farmed and processed by a local grower, on the northeast corner of Ninety-first Avenue and Van Buren Street, eventually became Tolsun Farms, an exclusive small ranchette subdivision developed by Ed Luke. The pecan trees surrounding the land were planted in the 1920s by workers for Denny Isabelle, a previous landowner.

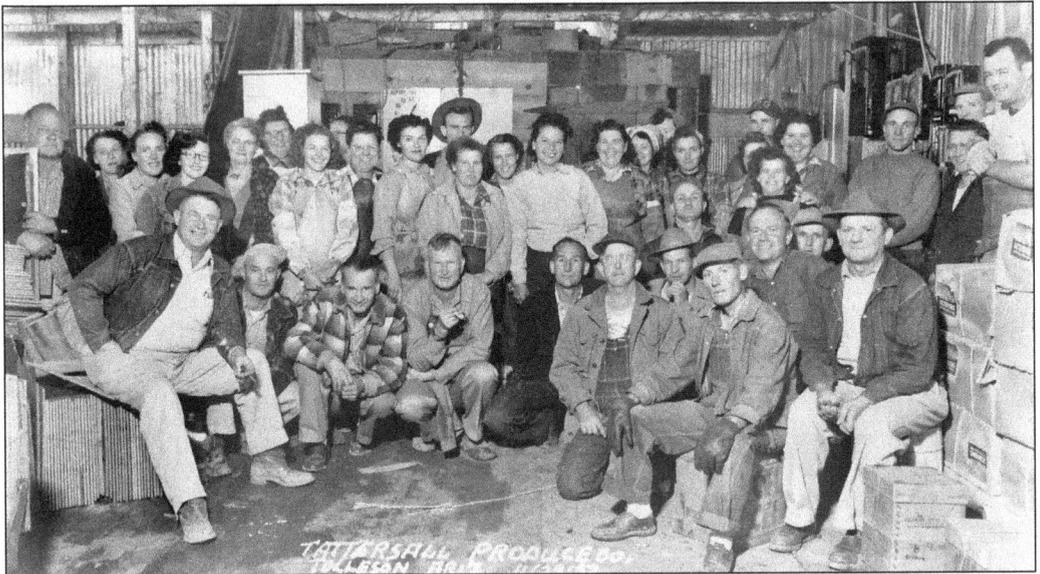

This 1952 lettuce crew at the Tattersall Produce Company, east of Ninety-first Avenue and north of the Southern Pacific Railroad tracks, took the produce picked by field crews and processed it in the packing shed. Hundreds of jobs were available between Eighty-seventh and Ninety-ninth Avenues at such companies as J. A. Wood, Garretts Packing, MBM Farms, Palmacino's Packing, Stanley's, and Tattersall Produce. (Thelma Green.)

Wearing a leather jacket, Luis Chavira (center) supervises a lettuce crew on the northeast corner of Ninety-ninth Avenue and Van Buren Street in 1955. Juan Vizarra (left), one of his workers, takes instruction from his foreman. Crews used short-handled hoes to "chop" the lettuce field. Today the area is in the throes of new commercial development. (Mary Villalobos.)

Most citizens found regular work in the fields harvesting crops or at shed row, where the produce was processed. Warren D. Smith (center) worked in the shuck yard making crates on several produce deals. On May 31, 1953, he was appointed acting postmaster, serving in that capacity until March 8, 1955. His daughter Jarrie Holliday still resides in Tolleson. (Jarrie Holliday.)

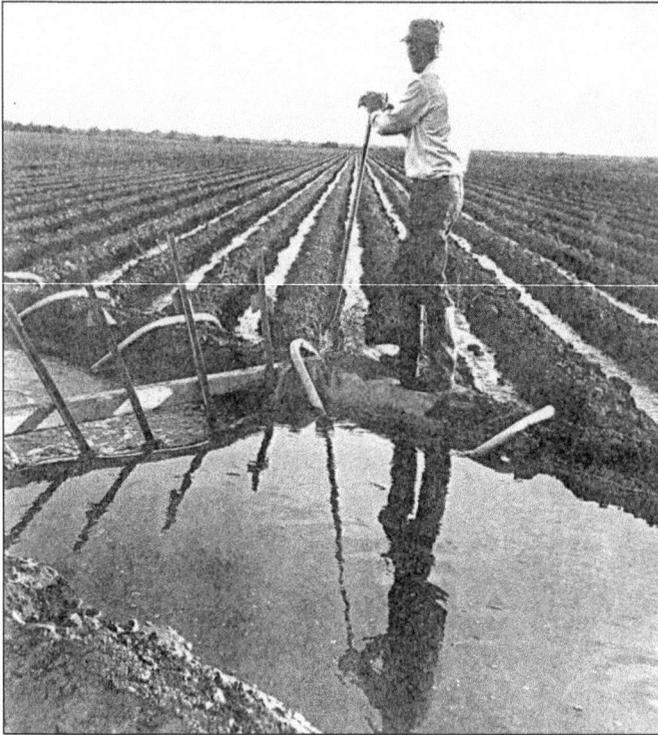

A Russian farmer irrigates his field on Maricopa Road (Thomas Road). Out of 150 immigrant families, only 4 remained in the Tolleson area after the Depression. Some 90 percent left the valley. Most of the remaining families turned from traditional crops to dairy farming, but the 1950s, 1960s, and 1970s saw prosperity for Russian Molokans, many returning to successful farming. Two of these were Alex and John Conovaloff. (Fay Veronin.)

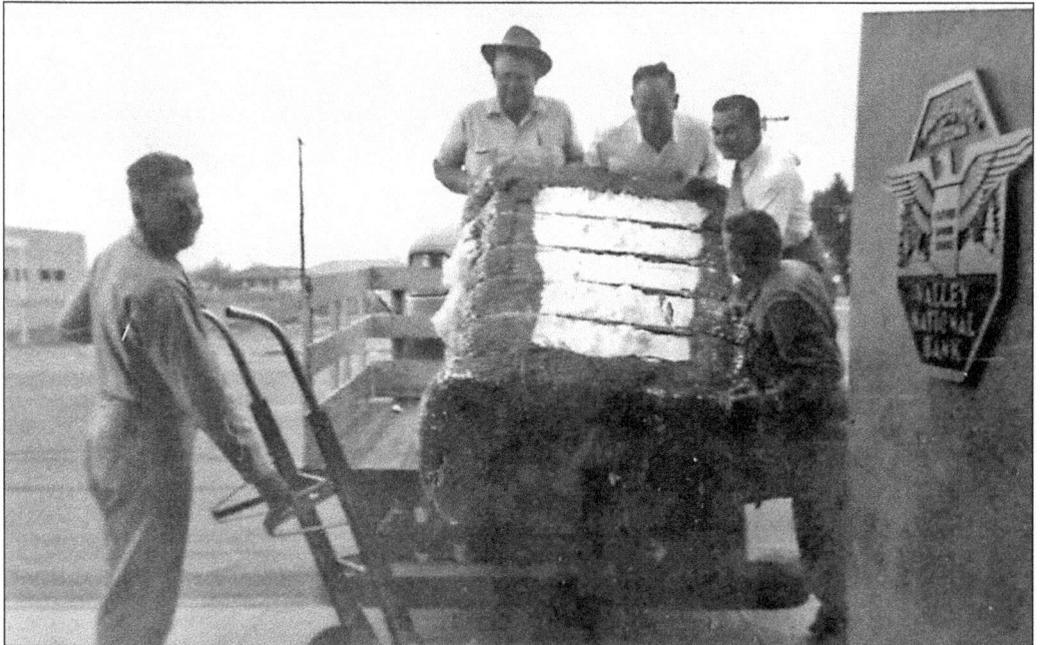

Cotton was raised in abundance in the area (to be used as the fiber in tires), and many farmers, including Walter Gist Tolleson, took advantage of the boom. In 1917, he sold his cotton interest to the Holmes-Wooten Cotton Company. By 1921, the cotton market had crashed, and Tolleson was forced to reclaim his land. Here local businessmen prepare to display a symbolic bale in front of the town's bank in 1952. (Thelma Green.)

50

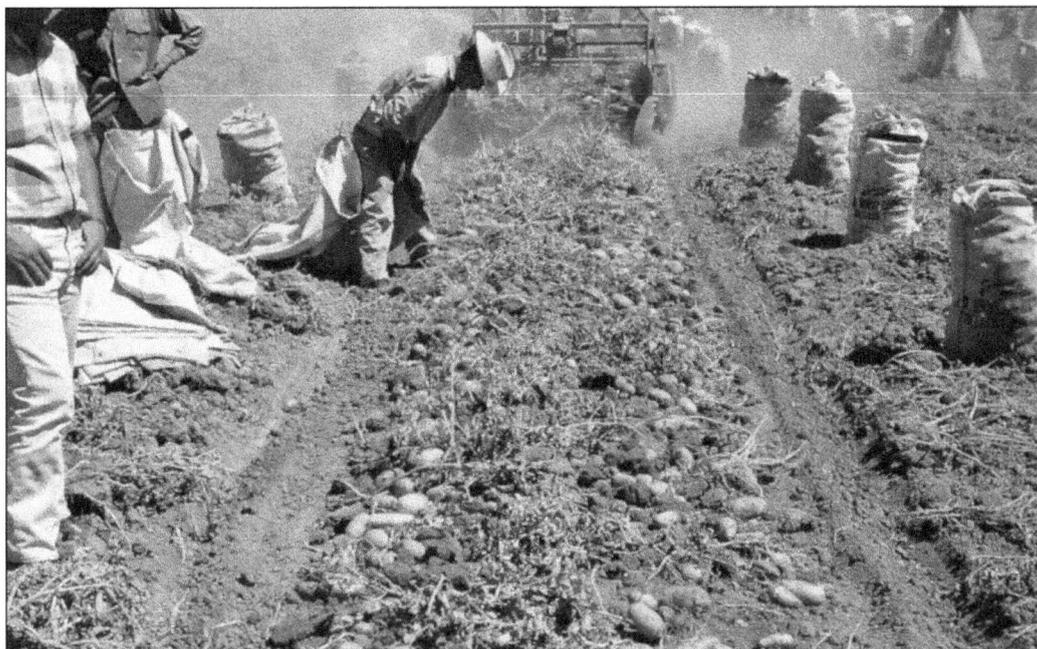

For many families, the fields meant survival. In the 1950s, technology began to eliminate the need for laborers in some areas. Mechanical cotton pickers, potato diggers, in-field packing, cardboard boxes, and cellophane wrappings replaced people. A modern potato digger turns the vegetables for the J. A. Wood Company field crew. (Jackie Diaz.)

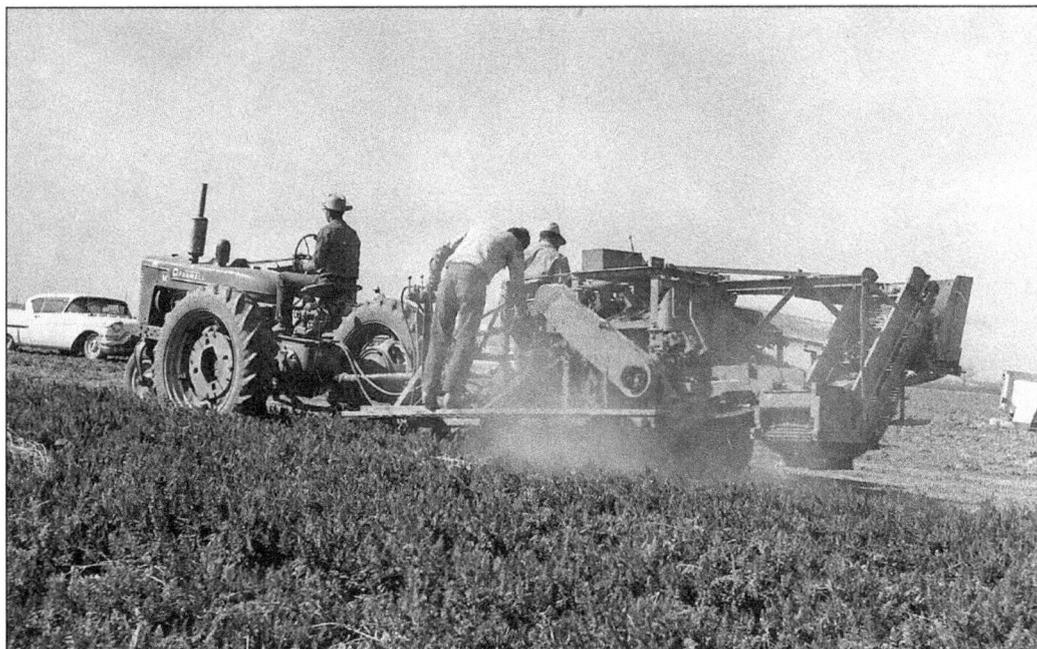

In the 1940s and 1950s, farmers even contracted with Navajos from New Mexico and Filipinos from California to perform fieldwork. Some of these laborers became permanent residents. Here a potato digger harvests crops west of Tolleson in 1959. By the 1960s, machines had begun to replace as many as 150 workers per field, thus changing community dynamics. (Jackie Diaz.)

Not all families made their livelihood in produce. The Martinez family moved from Tolleson to Cashion, where many property owners simply pitched their tents until they could build a home. This 1949 photograph shows Carmen, Pedro, and their son Pete at their new property. Carmen was a housewife, and Pedro worked for a granite company across from the Greenwood Cemetery on Van Buren Street.

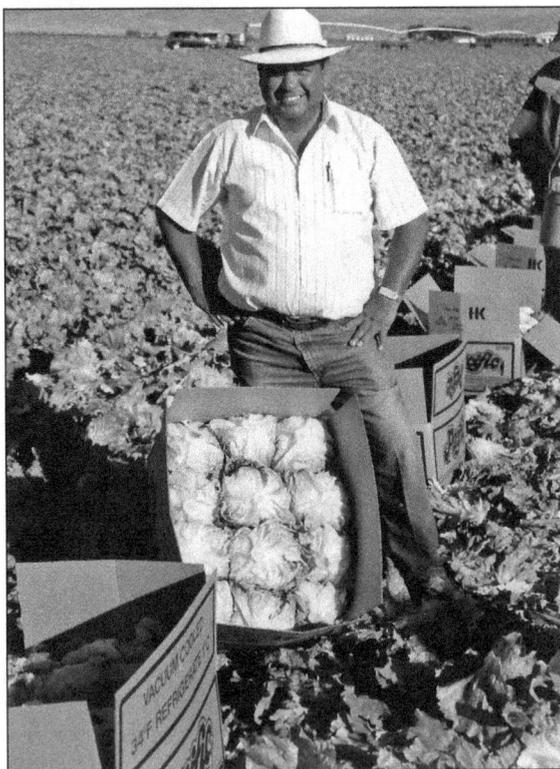

Field foreman Daniel Lopez displays a "ready for market" package of prime lettuce. Daniel worked as a produce supervisor for more than 40 years. His expertise was second to none in the nation in preparing vegetables and fruits from field to market. His brothers Carrillo and Fred "Lico" have also spent their lives in the produce business. Many family members continue to reside in the area. (Elena Lopez.)

Much of the prime farmland in the southwest valley has given way to urban growth. In this 1970s photograph, a field once plush with produce on the Cowden Ranch is being readied for the Tolleson City Complex. The view signifies the development that has slowly eliminated some of the best farmland in the world.

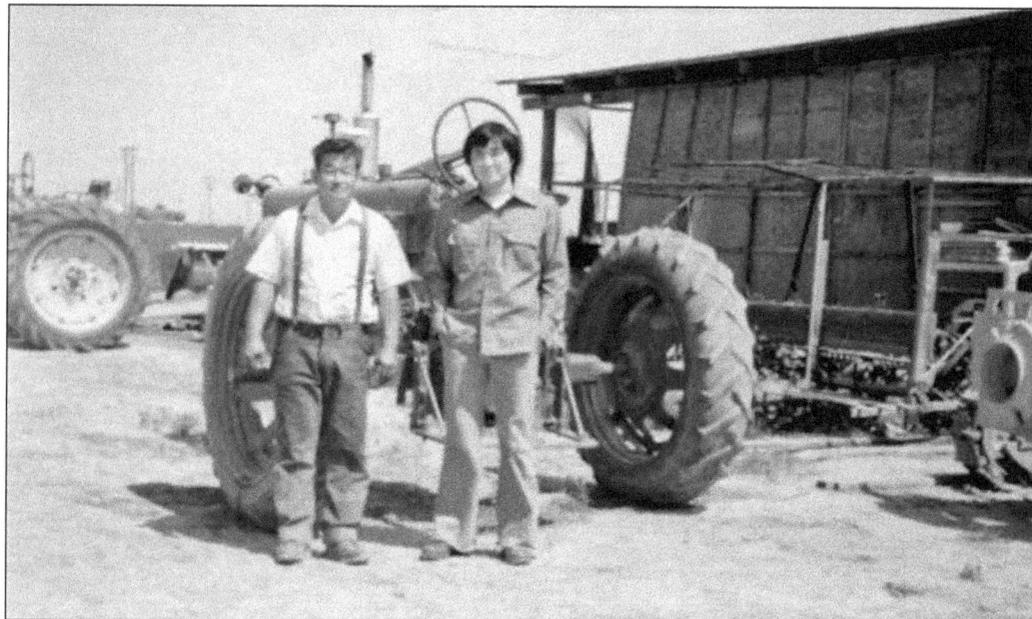

Ted Nakazawa (left) and his nephew Tony stand by the equipment used to farm their land at Ninety-ninth Avenue and McDowell. The Nakazawa brothers and their parents farmed the land for decades before the property was sold for the giant Gateway Pavilion Mall. Tony attended Tolleson schools, received a doctor of philosophy degree, and now teaches in the economics department at the University of Alaska. (Tony Nakazawa.)

After the 1878 completion of the Grand Canal, lateral ditches were dug south to the river. Lateral 22, running along what is now Ninety-first Avenue, the main thoroughfare for the city of Tolleson, has seen much controversy. In the 1920s, the ditches were lined with pecan trees, which eventually gave the lateral a distinction cherished by the community. Modern needs begrudgingly eliminated the open ditches and jeopardized the more-than-80-year-old trees.

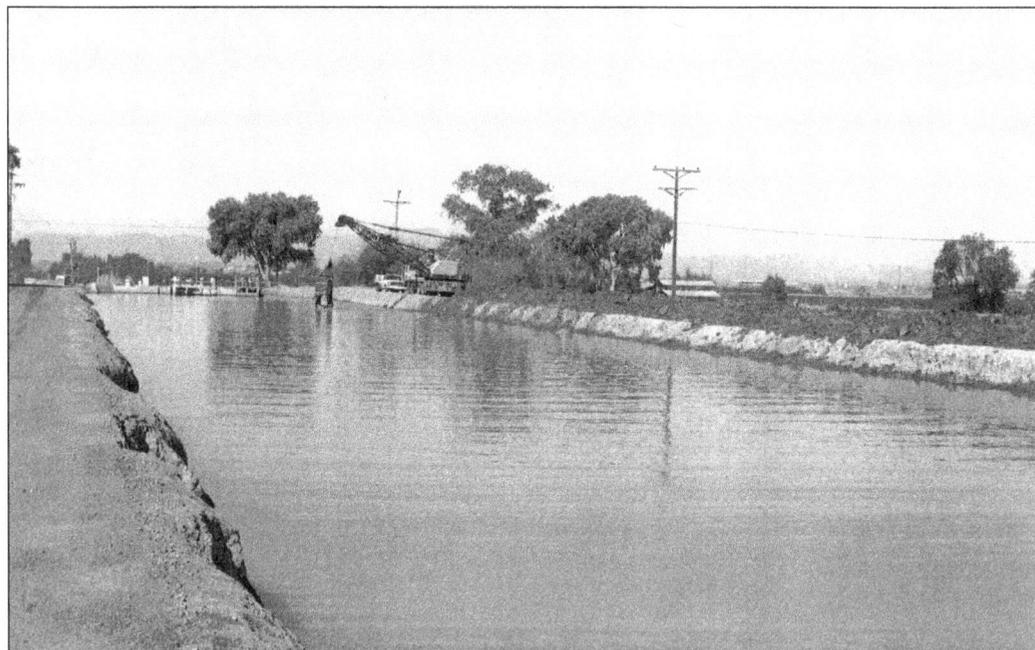

Today water remains the lifeblood of the land. Fields have changed to golf courses, produce sheds to strip malls, and ranches to sports complexes. The southwest valley has moved from Vegetable Center of the World to one of the nations' fastest-growing metropolitan areas. Here the Grand Canal meets the Agua Fria River at Ninety-ninth Avenue and Bethany Home Road, continuing to provide water to the thirsty land. (Salt River Project.)

Four

THE COMMUNITY
JOYS, STRUGGLES, CHALLENGES

Walter Gist and Susan Alethea Tolleson married in 1894 and had seven children; all became reputable citizens. The Tollesons claimed the Baptist faith as their religious affiliation, generously donating to their church. In *History of Arizona* Volume IV, the biographer says of Walter Gist, "He stands for those things which are good and true, and during all the years of his residence here has lent his efforts and influence in the direction of progress and advancement along material, civic and moral lines, so that he has been found worthy of the confidence and respect of his fellowmen."

Before and after its incorporation in 1929, Tolleson faced both tragedy and victory with the same inexhaustible spirit of Walter Gist and Susan Alethea. By 1930, over 1,000 people could call the small farming town home.

In 1913, Walter and a friend named Arthur Finley turned the old adobe Yuma Road Stage Stop into a general mercantile that became known as Ten Mile Store.

In July of that same year (1913), Leon H. Tolleson was appointed the first Tolleson postmaster, and in 1917 a U.S. postal rural route was allotted. The Tolleson Union High School District was organized in 1914.

However, life is set by challenges, and joys come as they will. Property deals were not all productive. A big sale was reversed in 1921 with the decline of the long-staple cotton market. World War I ensued, followed by Susan Alethea's death in 1924, the stock market crash of 1929, and the Great Depression, but still Walter's project continued to be productive.

Although Walter Gist Tolleson was a Baptist by faith, he had no qualms when a group of ladies from the surrounding community asked to use his Ten Mile Store for Christian Church services. Lida Hedger, Vernetta Ivy, Elizabeth Wilson, ? Harmon, Valera Ott, Milie McCreight, and June McCullough began this first church with their What-So-Ever Circle in 1914. The name comes from the Old Testament "What so ever thy hand findeth to do, do it with thy might" (Ecclesiastes 9:10). The circle appears to be the title of their group that does Christian service.

The Christian Church moved from the Ten Mile Store to Second Avenue (Ninety-second Avenue) and Yuma Road. This church site later became a furniture store and flower shop owned by Sy Slaughter after the church was moved. In the 1960s, the site served as the location of the city's first Circle K. The church had been moved to the corner of Ninety-third Avenue and Monroe Street. Today Lida Hedger's church is no more. The building houses another denomination.

Christian Church members gather in the 1970s to socialize and contemplate the congregation's future. The Arnetts, Helen Hengstellar, and Louise Lamar are some of the longtime members. By the 1980s, the city had eight churches within its limits, and the surrounding area offered eight additional denominations. (Barbara Hudson.)

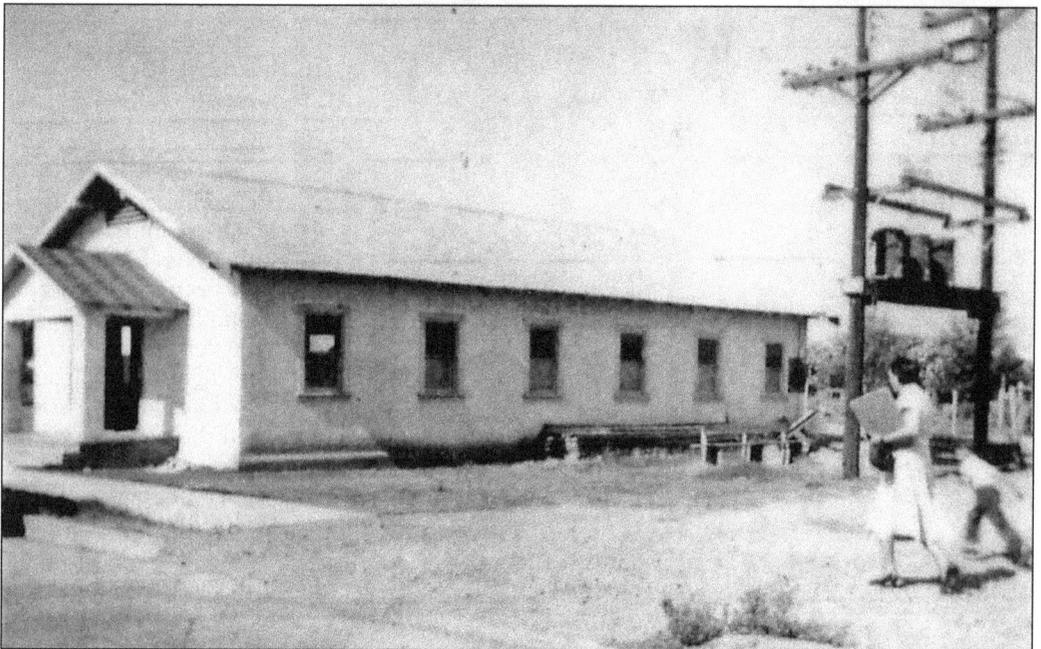

In 1929, the Tolleson First Southern Baptist Church was founded at Second Drive and Jefferson when a group pitched a tent for a community revival. Frank Wilson was the church's first pastor. In this photograph, the original chapel, moved from a mining camp north of Peoria in 1944, stands on the back lot next to the alley.

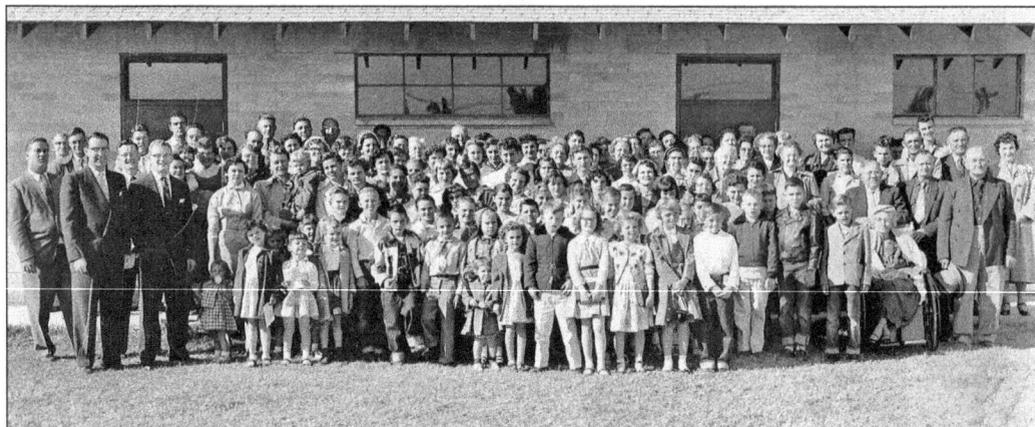

In 1952, the Baptist church's Sunday school posed for a group portrait. James Barber (front row, second from left) was serving as pastor. Many of these members continue to live in the community. Today the church property includes a sanctuary that can hold 200 congregants. The small chapel is gone, and the 1950s buildings are used as the recreation hall and Sunday school classrooms. (Thelma Green.)

The First Southern Baptist Church, throughout its history, has been the mother church to the Spanish Mission of Tolleson, the Starlight Park Mission, the Litchfield Mission, and the El Mirage Mission. The newest sanctuary and Sunday school buildings were constructed under the guidance of Rev. Reid Lunsford in 1960. Carroll and Lorna Brogdon were the first to be married in the new sanctuary. (Grace Shelton.)

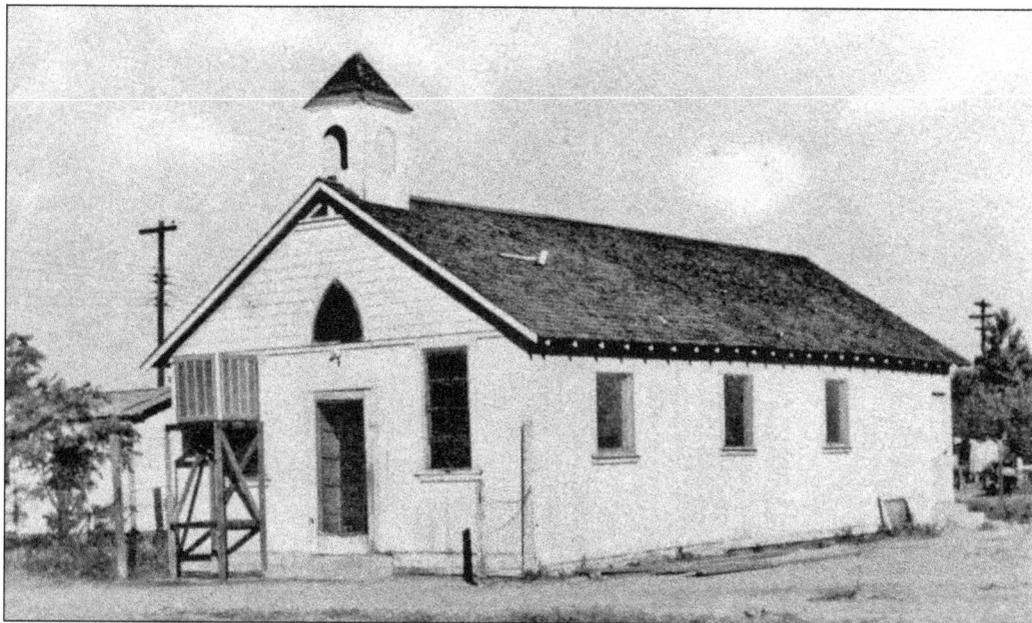

In 1918, the first Catholic chapel was erected near Second Avenue and Washington Street by the Franciscan Fathers. During the cotton boom, the government imported Mexican nationals to the area, most of the Catholic faith. This chapel soon became too small for the growing community, and in 1948, ground was broken for a new church on the north side at 512 North Ninety-third Avenue.

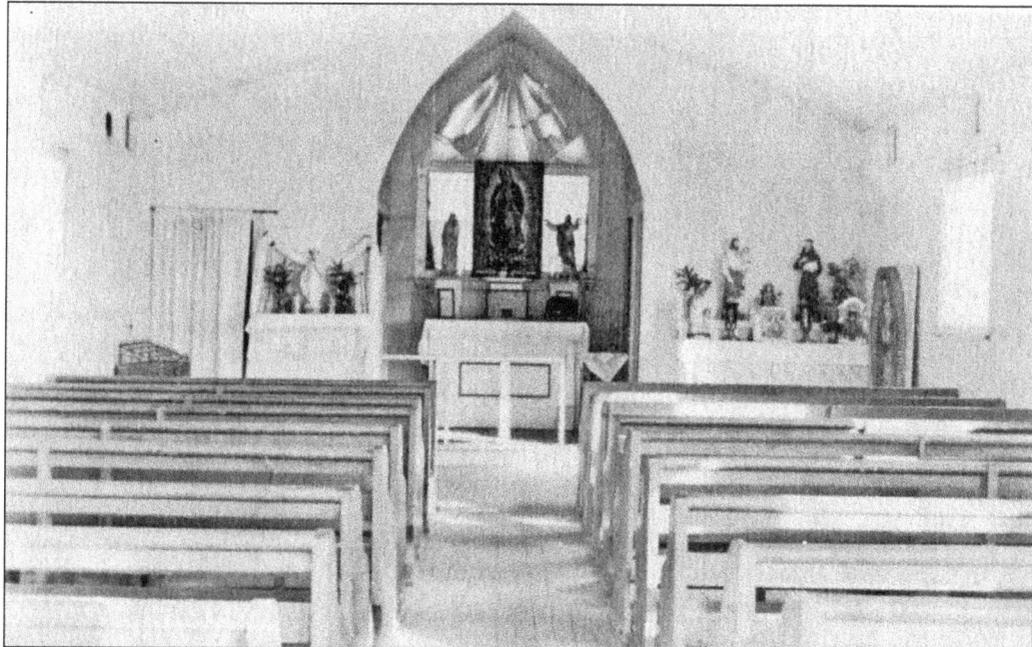

The old Catholic chapel could only accommodate 25 people until it was enlarged to double its original capacity by Fr. John Atucha of the Claretian Fathers. After the completion of the new church, the original building was moved to the northeast corner of Taylor and Ninety-second Avenue, where it serves as a residence.

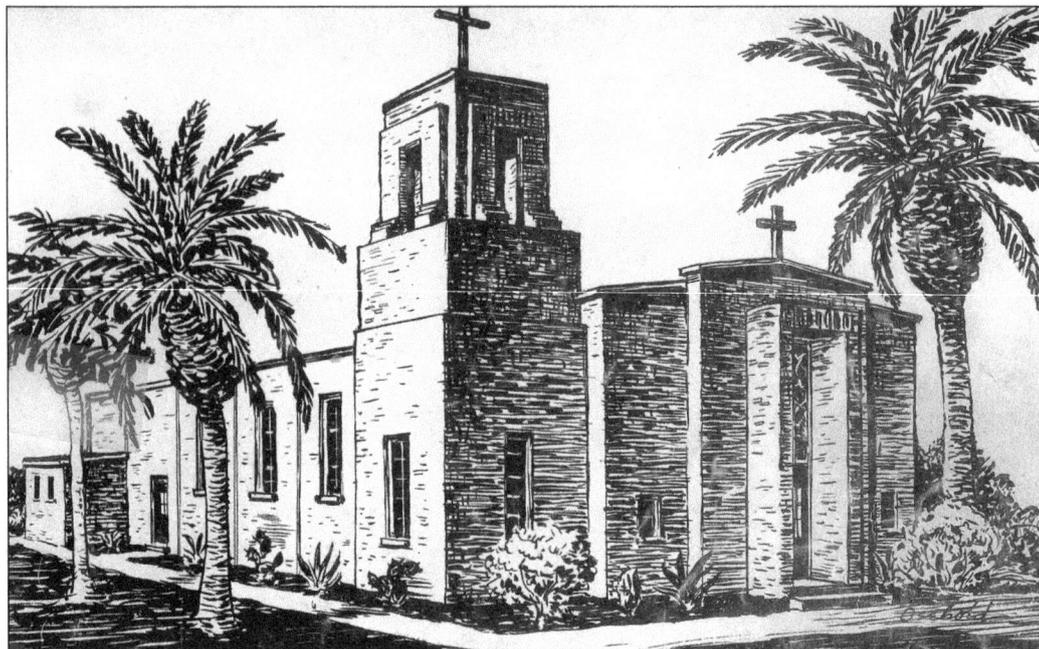

This 1948 sketch of Blessed Sacrament Church depicts the projected beauty and modern architectural design of the building and grounds, as envisioned by the Catholic community, measuring 106 feet long and 24 feet wide. Through time, several buildings have been added: Regina Hall, named after the daughter of the church's first deacon, Tony Chavira; Blessed Sacrament Hall; the Agape Youth Ministry offices; and the outdoor celebration area.

A group of Blessed Sacrament parishioners visit Greenleaf Swimming Pool in Avondale in 1960 after participating in the annual church Cinco de Mayo celebration. From left to right are (first row) Patsy Murietta, Vickie Berumen, unidentified, Pete Navarro, unidentified, Mary Ruiz, Henry Ruiz; Rose Balz (second row, fourth), Ray Murietta (second row, eighth), and Ernie Carranza (second row, far right). (Mary Ruiz.)

La Hermandad Del Santisimo Sacramento, a Blessed Sacrament service organization, usually did whatever was necessary to support the church. Members in 1978 included the following, from left to right: (first row) Carlos Rodriquez, Lupe Rodriquez, Euladia Godinez, Hortencia Tempelton, Luisa Ramirez, and Faustino Curiel; (second row) Jessie Valdivia, Josephine Valdivia-Contreras, Luisa Bejarano, Socorro Silvas, Carmen Mandurraga, Frank Torres, Eusevia ?, Mary Torres, Maria Curiel, Delores Cruz, Aurelia Gonzales, Porfirio Gonzales, Mercy Rocha, and Nellie Navarro.

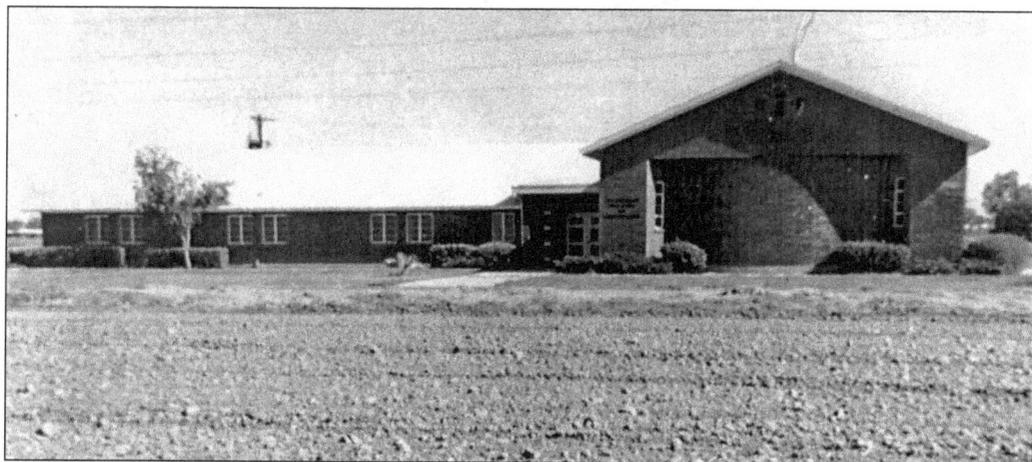

The early 1960s saw the Church of Jesus Christ of Latter-day Saints purchase land in north Tolleson. This photograph, taken in 1962, shows Ninety-fifth Avenue under construction and without curbs and sidewalks. Some key members to the development of the ward were De Nelson and Clayre Jones, Lester and Elaine Hepworth, James and Charlcey McBride, R. Clair Decker, Paul Smith, and Deloy Barrus. (Joy Burton.)

Lester and Elaine Hepworth were two active members of the Tolleson Latter-day Saints ward. Lester served as bishopric to Bishop James McBride until he was called to be bishop himself. He and Elaine served Tolleson's ward for 16 years. Lester sat on the library and school boards and worked as a veterinarian pathologist for the Swift meatpacking plant in the city. (Joy Burton.)

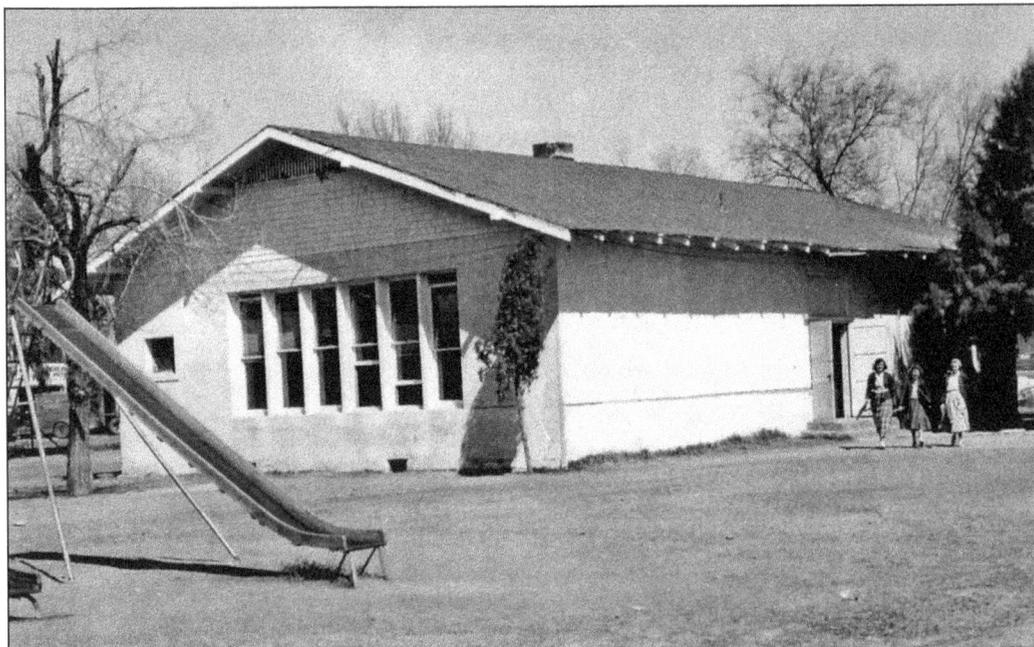

Most local Tolleson Elementary District residents remember the original first-grade building, which remained a city landmark until its razing in 2004. Mrs. Sherman and Ms. Jones taught hundreds of west valley residents in this two-room school. Because it could not safely be restored, the structure was removed and replaced by the new district administration offices.

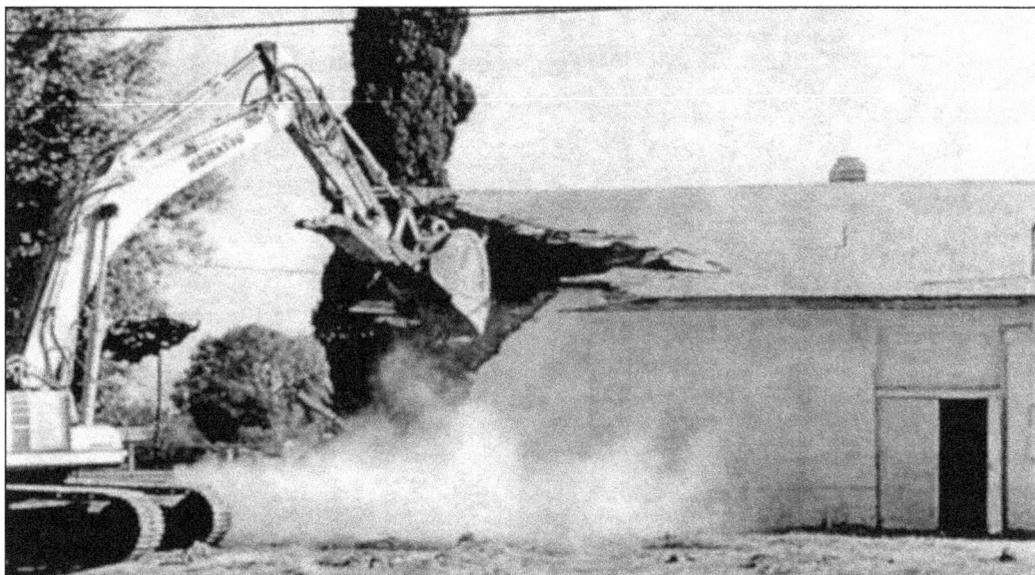

Hearts were broken when the old Tolleson Elementary building was destroyed after the school board decided on its demise. The structure was unsupportable, leaving little alternative, but it had been the educational starting gate for literally thousands of youngsters, many of whom continue to make the Tolleson area their home.

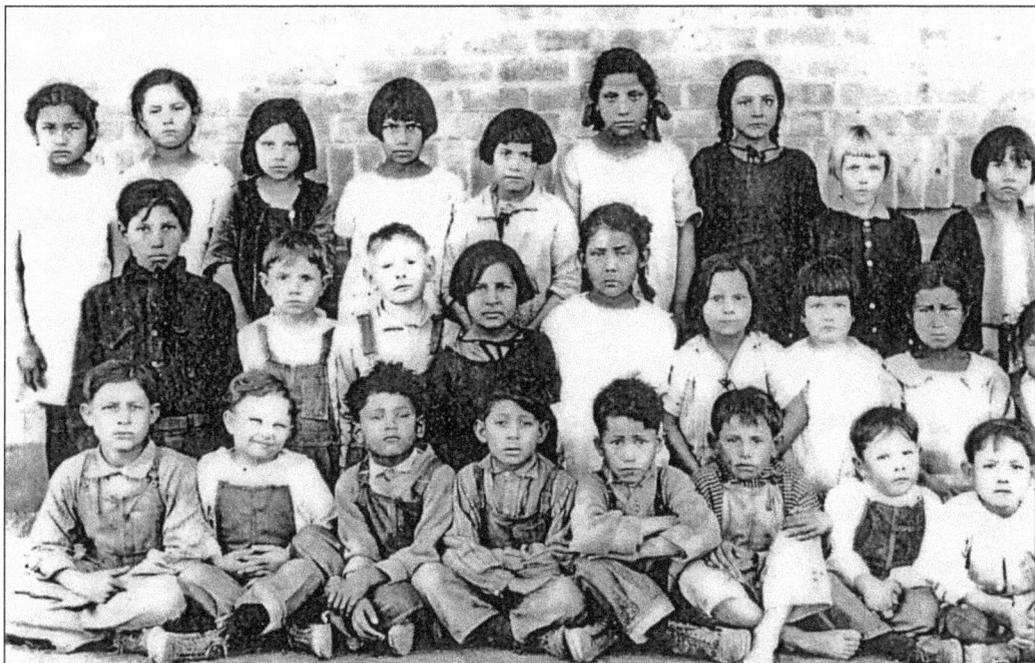

In 1928, the Tolleson Elementary School class was merged with students from the surrounding area onto one campus. By the late 1930s, Tolleson Elementary was segregated. Some of the students in this photograph are Eduardo Gonzales (first row, far right), Rose Sosa (third row, sixth from left), Jessie Espinoza (third row, far right), and three youngsters who became lifelong Tolleson residents: Jesus "Rod" Rodriquez (first row, fourth from left), Placido Berumen (first row, fifth from left), and Ray Murrieta (first row, sixth from left).

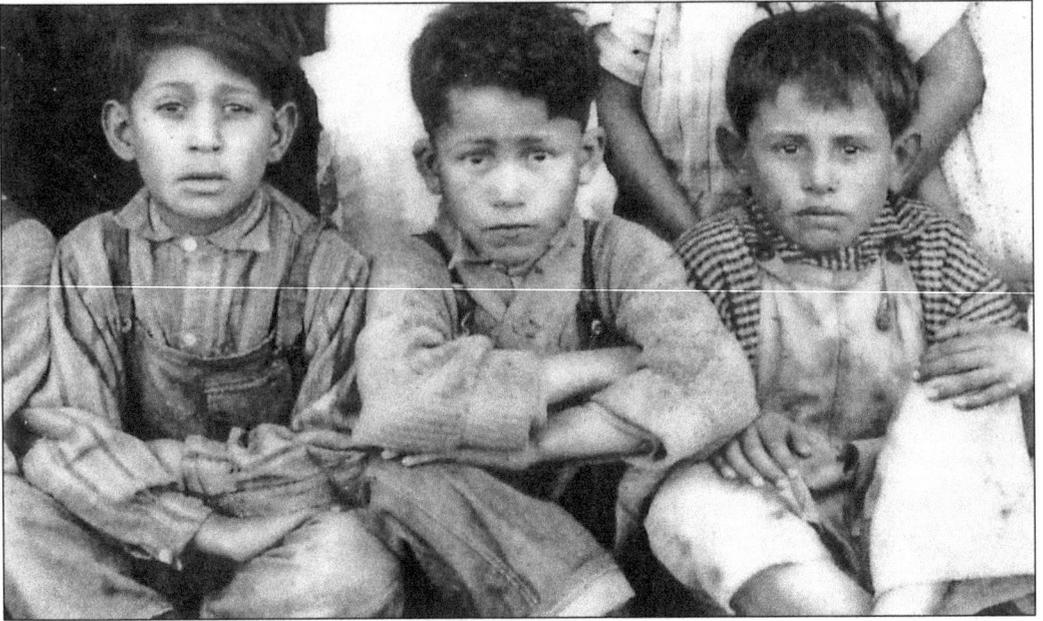

Rod Rodriquez (left) served heroically in World War II at Normandy and the Battle of the Bulge, where he was critically wounded. Returning to Tolleson, he became a businessman, establishing a radio and television repair shop. Nellie, his wife, continued to operate her beauty salon. Ray Murrieta (center) was a longtime Tolleson businessman and real estate owner, while Placido Berumen (right) dedicated himself to his community and church.

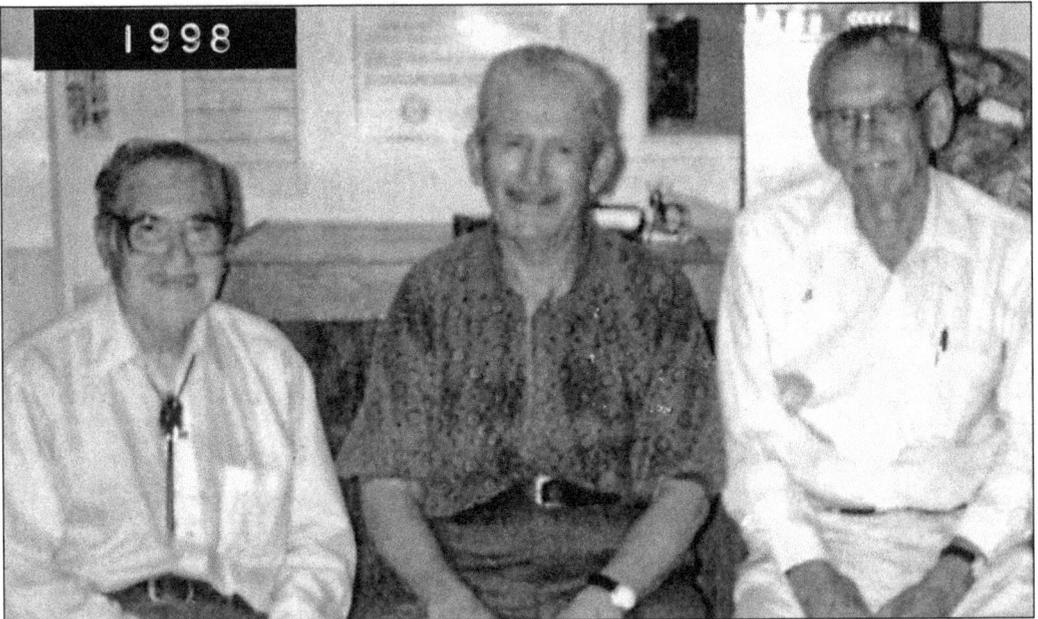

These three gentlemen (pictured above as 1928 school classmates) came to the area at a very young age, served their country and the community, raised their families in Tolleson, and grew into senior citizens together. Rod Rodriquez (left) served several terms on the local city council; Ray (right) had a daughter also sat on the council; and Placido (center), after retirement, aided the school community as the congenial crossing guard.

64

Charles Pendergast homesteaded at Lateral 22 and Avenue K (Camelback Road) before the 1900s. A school was established in the area at the corner of Avenue J (Indian School Road) and Lateral 22. The first southwest valley high school began at the farming community of Pendergast around 1920 and was later moved to Tolleson three miles away. This corner with the school and church on Avenue J became known as West End.

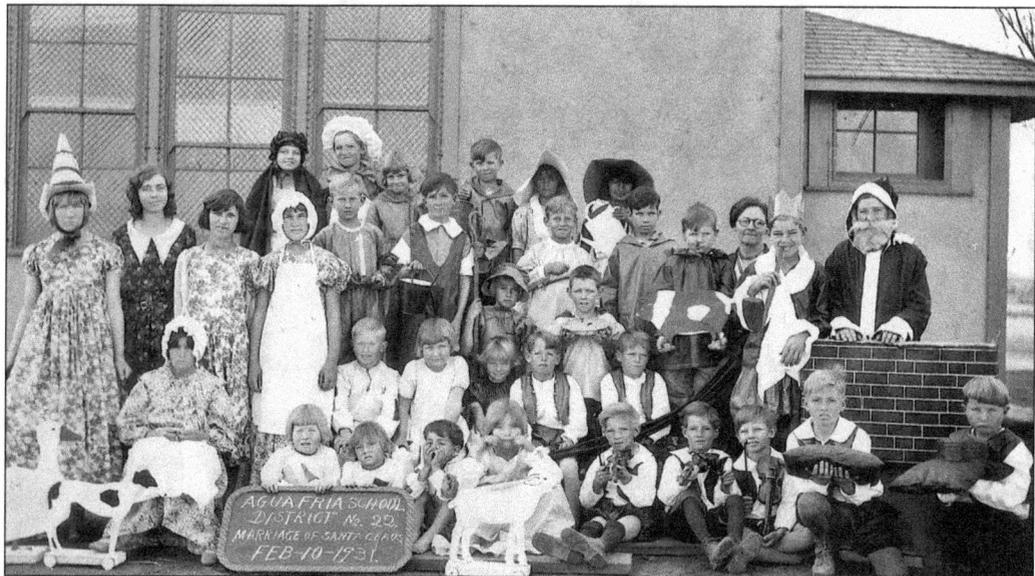

On the corner of 115th and Southern Avenues stood a small one-room elementary school known to most people as St. John School, named after the irrigation district's developer, W. H. St. John, who dug the ditch with a team of partners in 1887. The seven-mile ditch, on the north side of the river, provided irrigation from today's Eighty-third Avenue west to the Agua Fria River. (Eva Martin.)

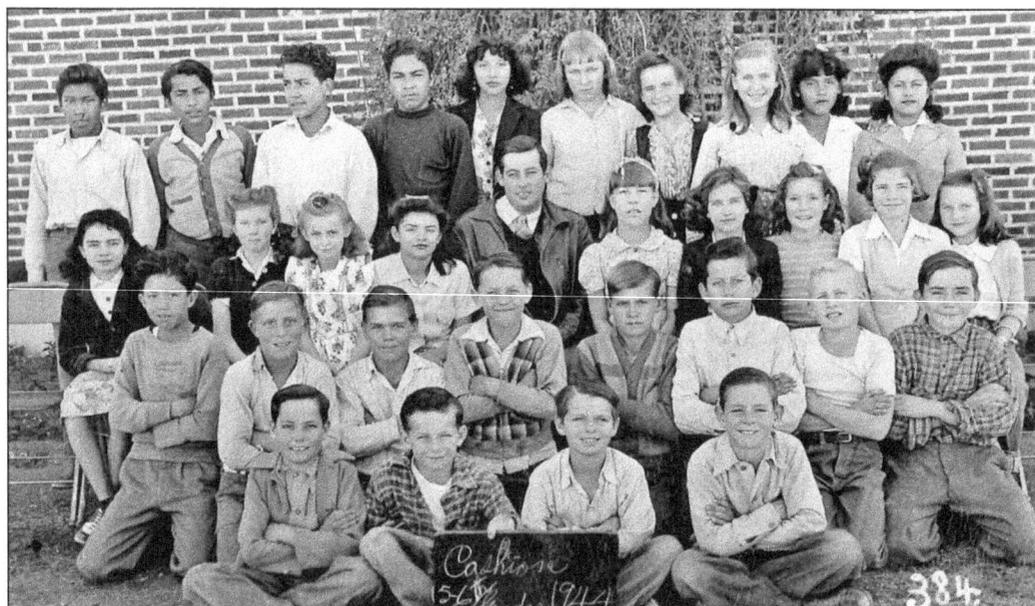

In 1931, Cashion School (Littleton) had a number of Japanese students (see page 22). By the early 1940s, most Japanese families had returned to Japan or had been confined to the internment camps at Poston or Florence. This sixth-grade Cashion class highlights some of the ethnic changes in area schools during the first half of the 1900s.

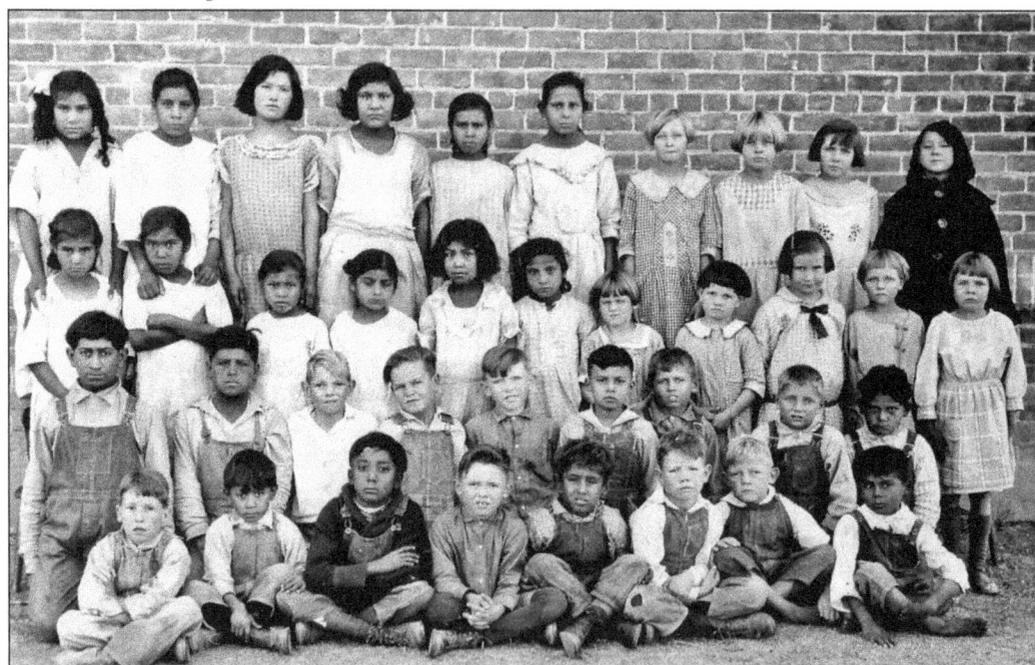

Tolleson Elementary classes were totally integrated in 1924. By the 1940s, however, Hispanic students attended Unit II on the north side of Van Buren and Anglo students attended Unit I on the south side. This 1924 class portrait includes several longtime Tolleson residents: Rod Rodriquez (first row, second from left), Rosa Soza (third row, sixth from left); and Laura Arnold (fourth row, far right).

Tolleson Elementary School was established during the second decade of the 20th century. Unit I stood on Monroe Street and served the entire community until a second school was built across town. Unit I housed the early grades and the seventh and eighth grades. Also included were storage basements, a gymnasium/auditorium, and a large play area. Today this land holds a small single-family home development, and the Unit II property belongs to the Catholic Church.

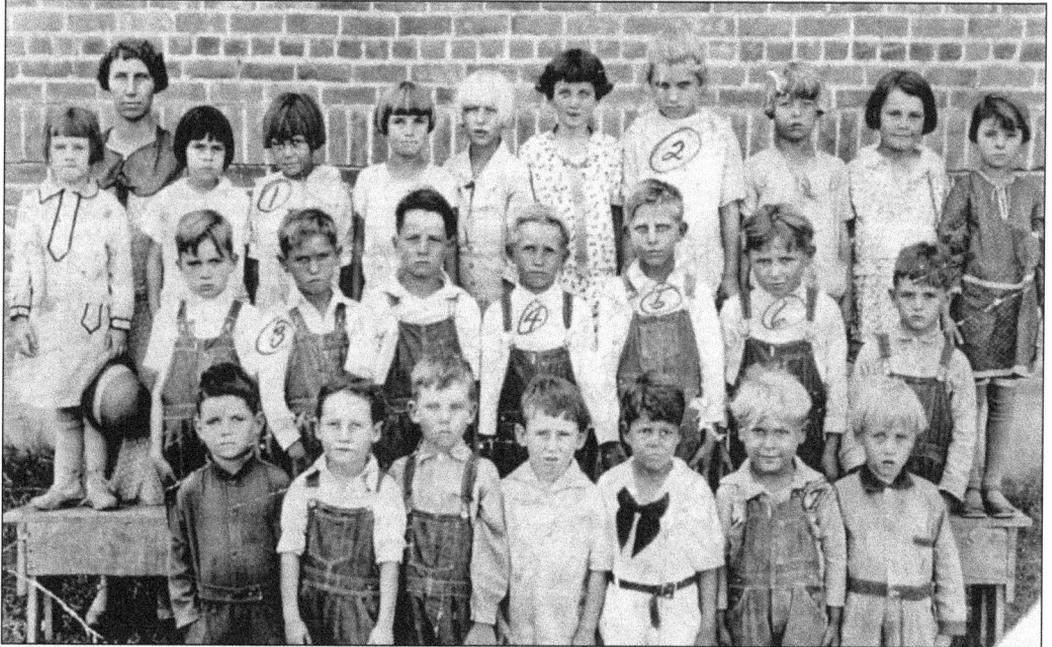

This 1927 photograph of Pendergast School's first-grade class shows a bit of disparity in the grouping of students compared to the image on page 22. Prior to their exodus during the Depression, Russian Molokan farming children attended this class. The Russian children pictured are, from left to right, Esie Efsaoff (first row, sixth); Mike Prohoraff (second row, second), William Papin (second row, fourth), Pete Popoff (second row, fifth), and Steve Papin (second row, sixth).

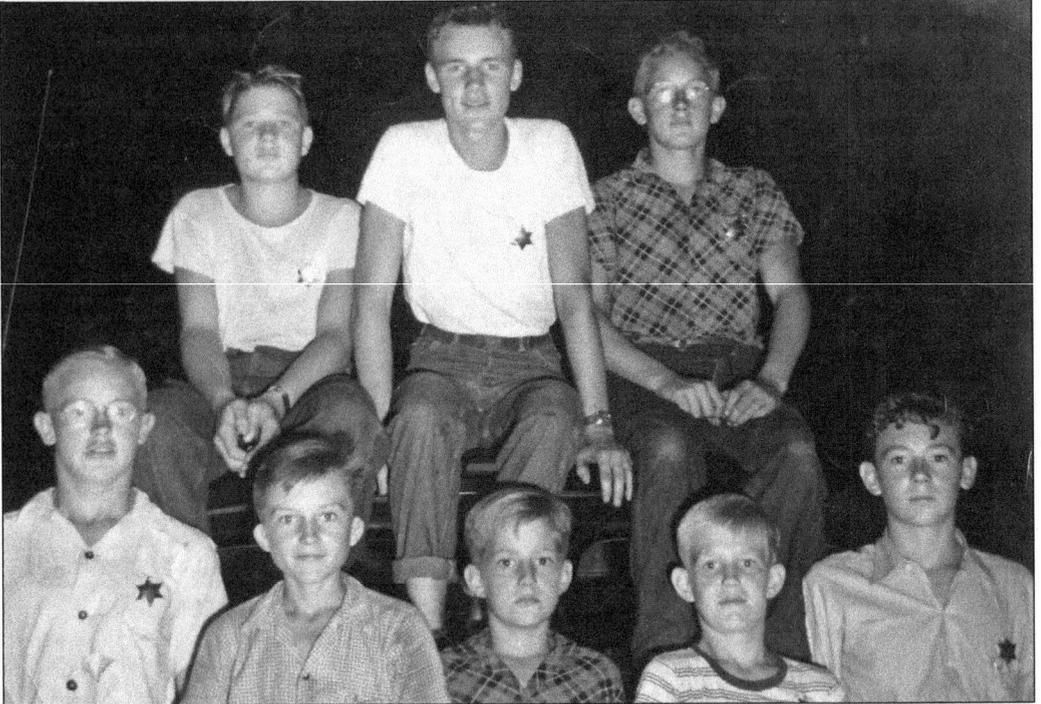

Tolleson Elementary School youngsters dawn their safety patrol badges in the 1940s and prepare to control traffic on Van Buren Street. For liability and safety reasons, school safety patrols were replaced by adult crossing guards in the 1960s. This team of Tolleson patrollers includes, from left to right, (first row) Charles Wolf, Morgan Bryant, unidentified, Donny Ryan, unidentified; (second row) Pat Hintz, unidentified, and Orval Wolf. (Morgan Bryant.)

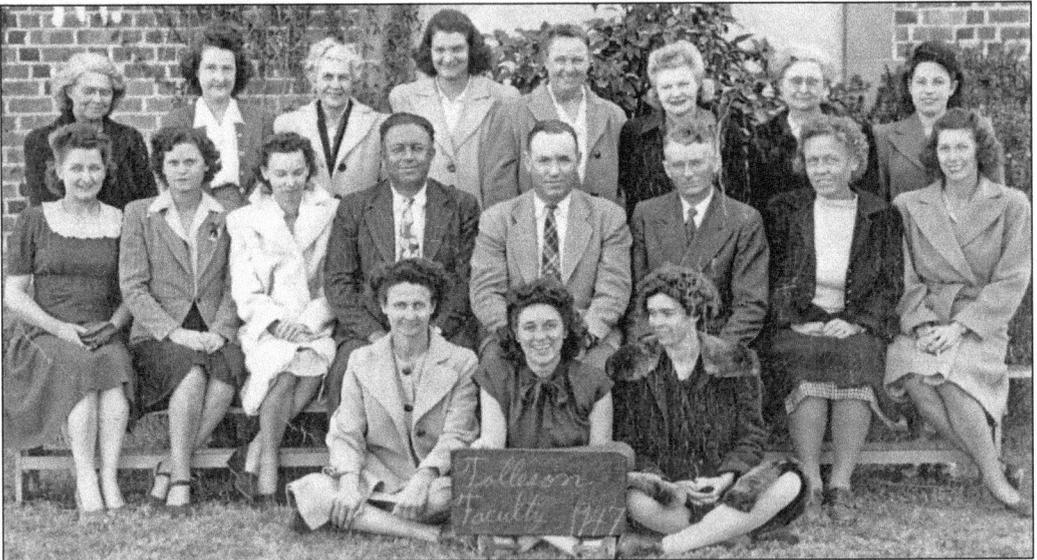

The 1947 Tolleson Elementary School teaching staff consisted of 18 teachers and a superintendent. Some of the instructors were, from left to right, (first row) Gladys Lewis (first); (second row) Glennis Johns (second), Superintendent Kenneth Dyer (fifth), ? House (seventh); (third row) Pat Clark (second), ? Jones (third), and ? Sherman (sixth).

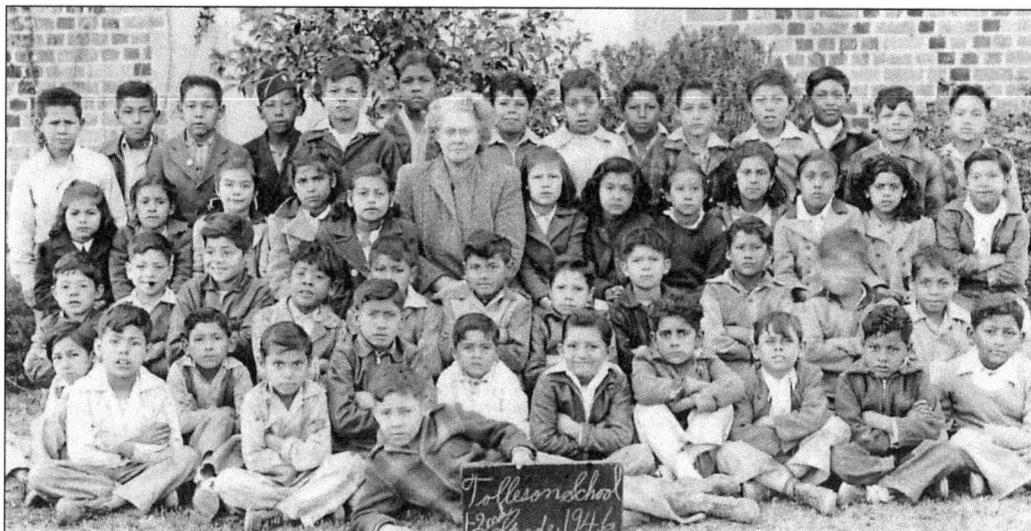

Posing for a class portrait in 1946 are Tolleson Elementary School's first- and second-graders at Unit II. Here 49 Hispanic students were segregated from the Anglo students; however, the community was not satisfied. In 1951, by federal court order, this scenario changed. Hispanic and white students were again integrated as they had been in the early days of the school district's development.

Concerned Tolleson citizens determined that segregation had no place in their community. A preliminary injunction from the U.S. District Court in March 1951 directed Tolleson Elementary School to integrate immediately. This was the first such lawsuit entered in the state of Arizona—three years before the famous Supreme Court *Brown v. Board of Education*.

RALPH ESTRADA
GREG GARCIA
A. L. WIRIN
257 South Spring Street
Los Angeles 12, California
Telephone: MIchigan 9708

COPY

Attorneys for Petitioners

IN THE DISTRICT COURT OF THE UNITED STATES

DISTRICT OF ARIZONA

PORFIRIO GONZALES, et al.,

Petitioners,

NO. 1473

-vs-

PRELIMINARY INJUNCTION

ROSS L. SHEELY, et al.,

Respondents.

This cause came on, on an application for a preliminary injunction on the 6th day of June, 1950, before the Honorable Dave W. Ling, the petitioners being represented by their attorneys, Ralph Estrada, Greg Garcia, and A. L. Wirin, and respondents being represented by their attorneys, Warren L. McCarthy, County Attorney, and Joseph F. Walton, Deputy County Attorney; and evidence having been introduced both oral and documentary; and said cause having been taken under submission, and the Court having made its Findings of Fact and Conclusions of Law, it is, therefore,

ORDERED, ADJUDGED AND DECREED:

The regulations, customs, usages and practices of respondents herein in segregating person of Latin and Mexican descent in separate schools within the Tolleson School District No. 17, in the town of Tolleson, County of Maricopa, State of

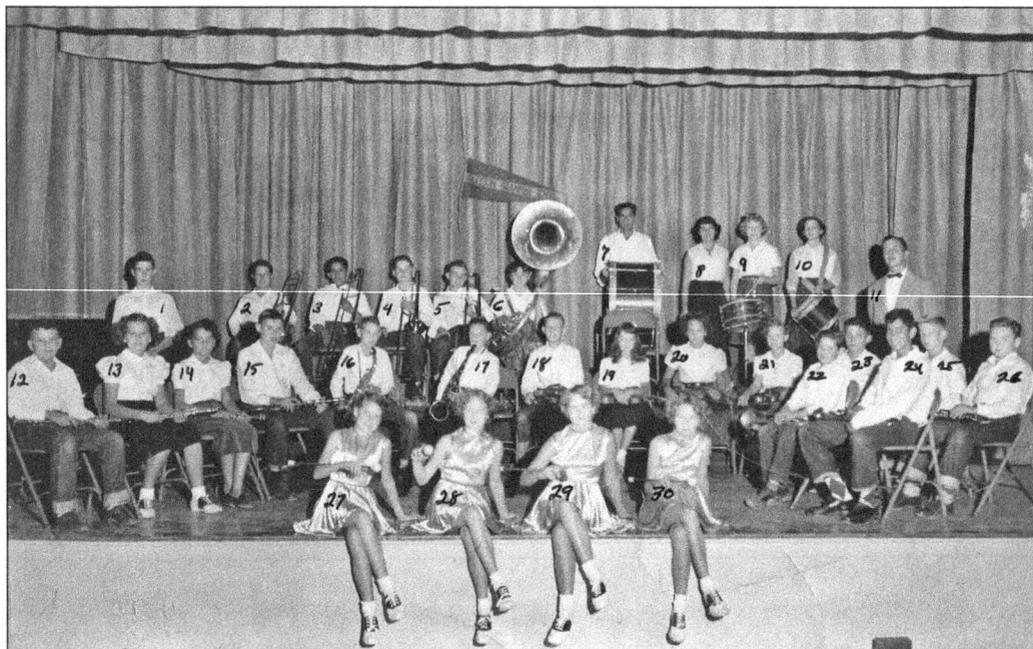

The 1953–1954 Tolleson Elementary School marching band prepares to perform in the school auditorium. The band was comprised of both Hispanic and Anglo students, including (first row) Betty Biscoe, Patricia Ball, Janice Chilcoat, Beatrice McPherson; (second row) David Arnett, Frank Alcocer, Bill Van Zanten, Robert Venegas, Gloria Gonzales, Alton Burns, Alan White, and David Conovaloff.

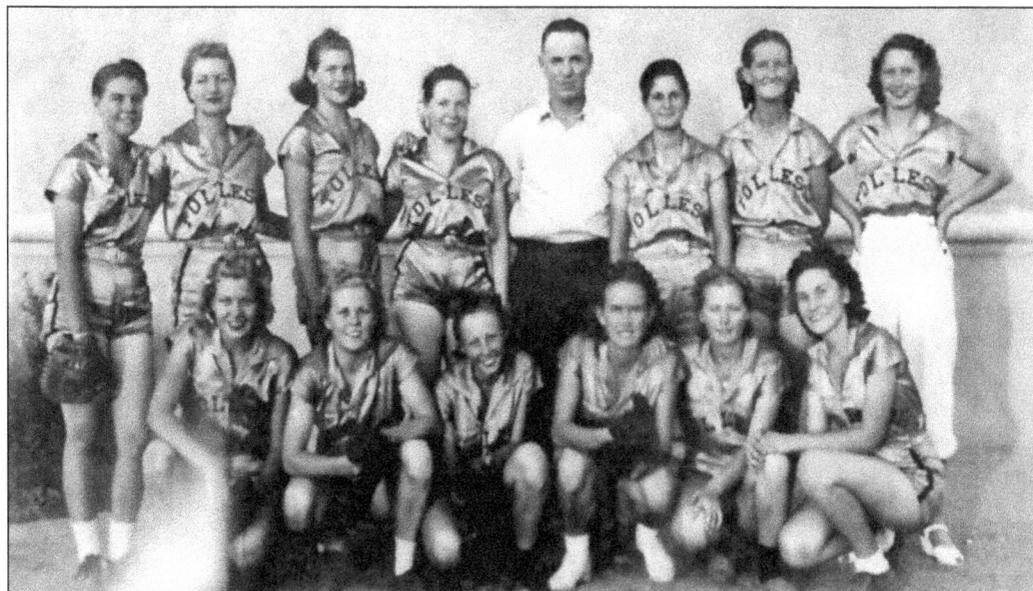

In 1939, Phoenix's PBSW Ramblers were the world's women softball champions. Tolleson also had a women's championship team that year. Pictured from left to right are the following: (first row) ? Keely, Merle Patterson, Geneva Turnbull, Helen Turner, Arlyne Anderson, and Fannie Papin; (second row) Zada Lee Boles, Helen Kelly, ? Kelly, Alice Hedgepath, "Papa" Ken Dyer, Josie Lindsay, Lois Turner, and Marie Greer. (Fay Veronin.)

Tolleson High School's first football team was organized in 1943 with Henry "Hank" Jones as coach. The players borrowed uniforms from neighboring Litchfield Park, which had been the state champion, to compete in the six-man sport, and Tolleson won the game. Although the first team failed to complete the season because it had not been scheduled into conference play, the club went undefeated in games actually played.

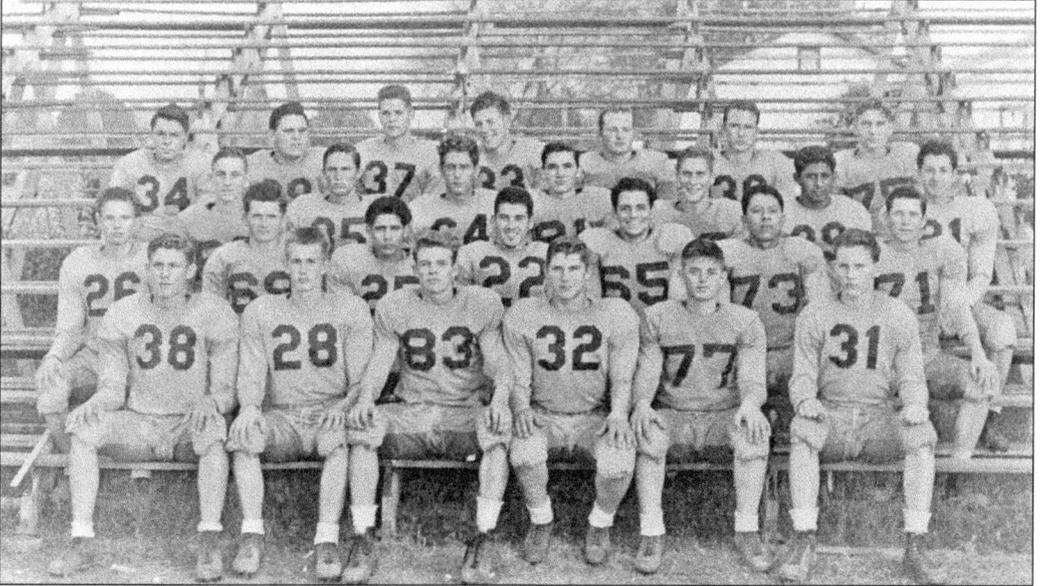

The 1951 Tolleson football team included the following, from left to right: (first row) Troy Hall, Don Ryan, Henry Evans, Don Poppe, and Sam Holliday; (second row) Bob Huckleberry, ? Perkins, Frank Moreno, Buddy Holland, Claudell Smith, Pete Garcia, and Jim White; (third row) Keith Holly, Amos Randall, Evan Mosley, Sam Russell, Leon Yoesting, Terrell Cabrales, and Gilbert Mendez; (fourth row) Johnny Woodruff, Roy Ross, Dick Walters, Quentin Tolby, Kenny Sullivan, Dale McBride, and Gary Shelton.

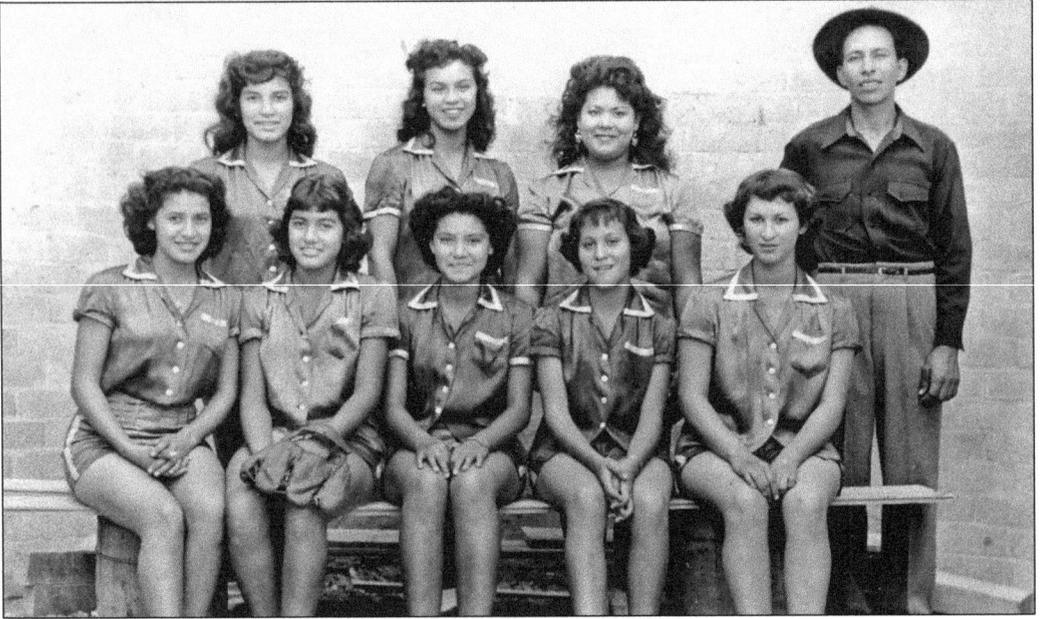

Sponsored by Blessed Sacrament Church, the 1949 Tolleson Rockettes were the state champions in girls' fast-pitch softball. Jesusita Diaz made the uniforms by hand. Members of the team were as follows, from left to right: (first row) Rachael Diaz, LoCha Diaz, Della Capono, Sally Moreno, and Estella Moreno; (second row) Rebecca Diaz, Paula Capono, Esther Lopez, and coach Ross Sotelo. Players Lucy Johnson, Wendy Green, and Joyce Vanlandingham are not pictured.

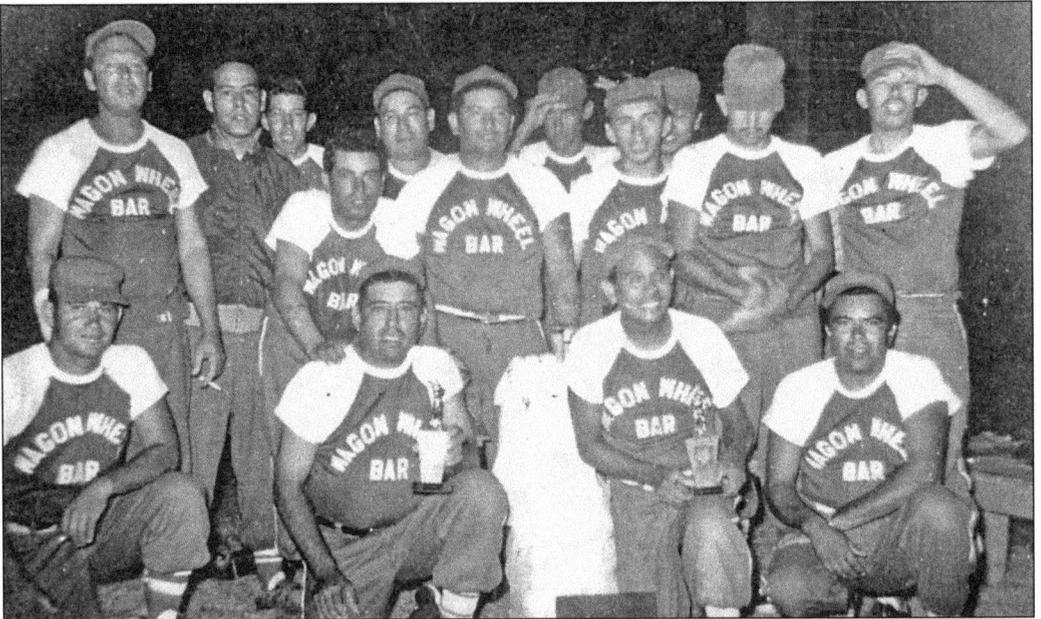

Tolleson sports were always important. The Wagon Wheel Bar softball team, comprised of many of the original Crusaders, celebrates after a victory in 1958. Shown from left to right are the following: (first row) Richard Moreno, Cipriano Zaragoza, Frank Salazar, and Jose Acosta; (second row) Jose Espinoza, Manny Hernandez, Trinidad Soto, Frank Navarro, Tico Hernandez, Juan Navarro, Fernando Cuen, unidentified, Pete Castenada, Manuel Loya, and Joe Soto.

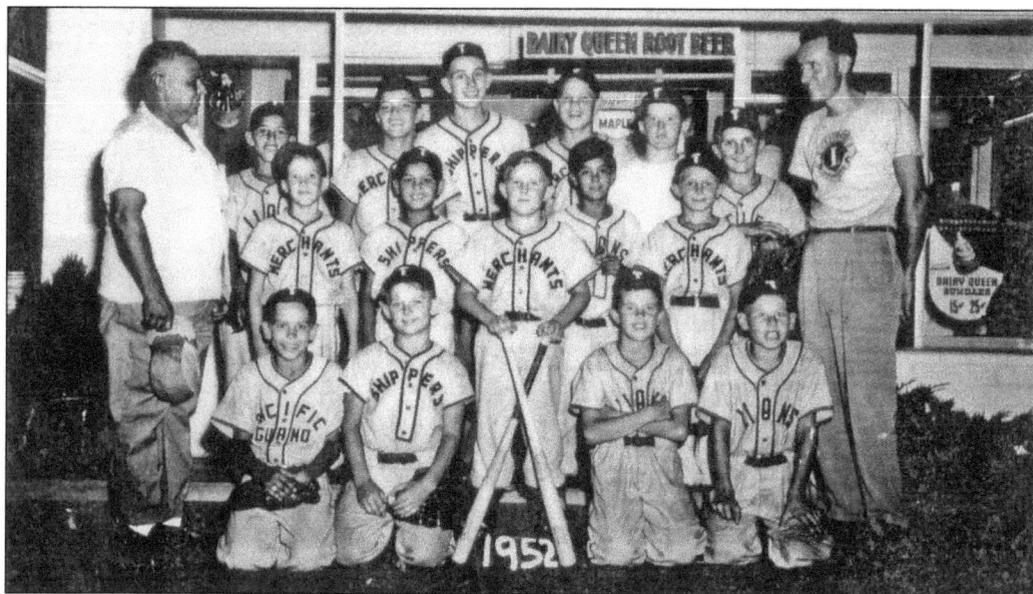

The summer of 1952 saw the community charter its first little league under the impetus of Laurence "Pappy" Robinson. Teams from across the valley wondered who these kids were from the west side as they won game after game. The original Tolleson Little League All-Stars finally experienced defeat, coming in second in the state tournament at Winslow—still quite an achievement for their first year. The coaches were Doc Stover and William Van Zanten.

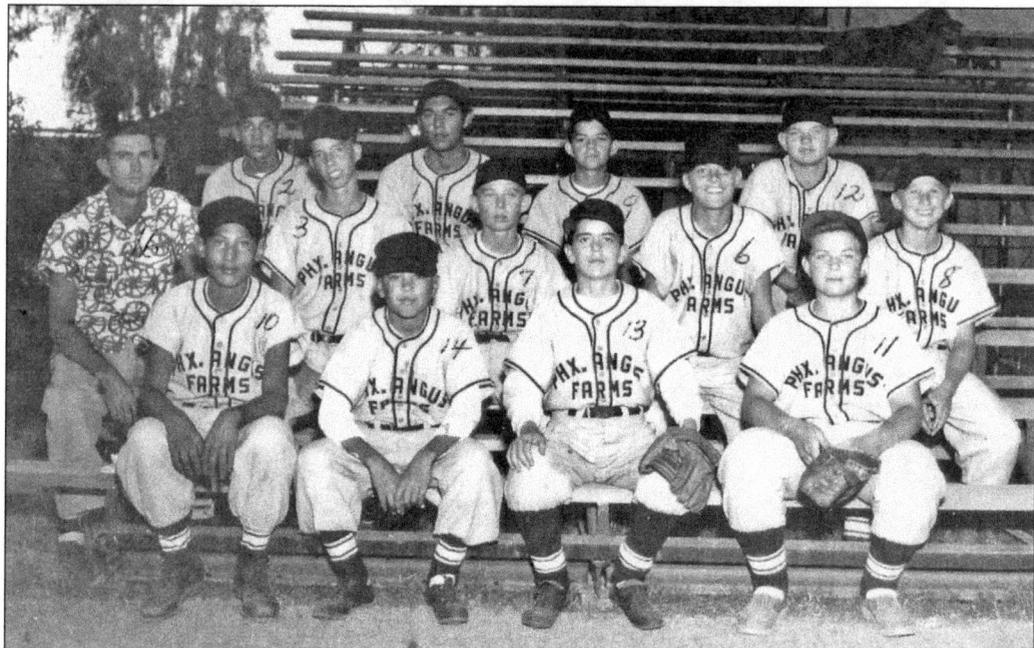

In 1953, the community fathers expanded the summer sports program to include older boys in the Babe Ruth League. The Phoenix Angus Farms team included the following, from left to right: (first row) Phillip Padilla, Louis Gallardo, Basil Ballard, and Carl Strandquist; (second row) coach Bill Thrasher, Wesley Johnston, William Knight, Maynard Tidmore, and Jack Hatfield; (third row) Gregorio Medrano, Joe Arredondo, Eugene Contreras, and Wayne Patterson.

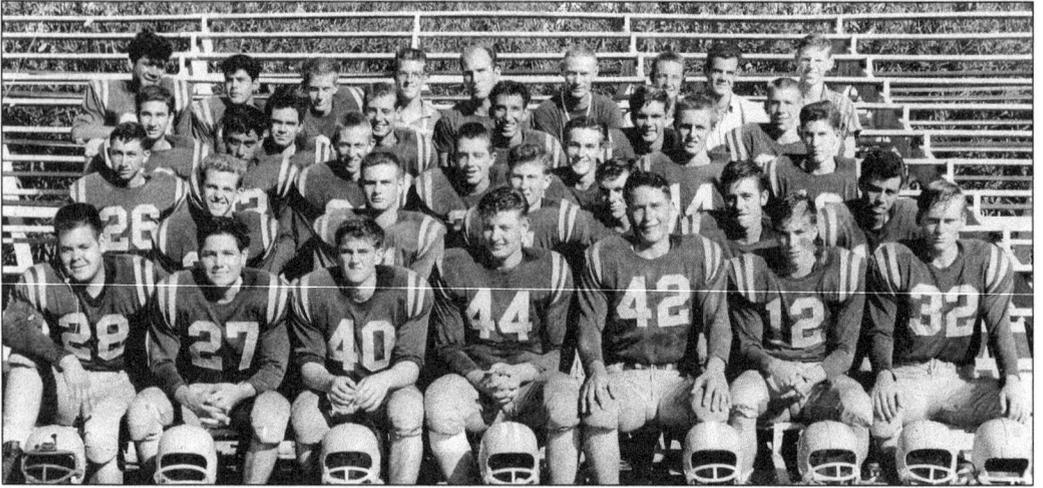

The 1958 Tolleson Wolverine football squad consisted of, from left to right, (first row) Donald Payton, Terry West, Alvin Cruz, James Patterson, Wallace Stewart, Steve Cornelson, Ray Raper, (second row) Carl Strandquist, Roy Bell, James McBride, Richard Alcocer, Fred McPherson, Wayne Sparkman, James Green, (third row) Glen McBride, Frank Tarango, Mike Hudson, Art Quinonez, Ray Landers, Gerald Johnson, (fourth row) Joe Cordova, Rosalio Medrano, Frank Norris, coach Jess Pease, coach Don Snyder, Butch Johnson, Bill Gollihare, and James Newman.

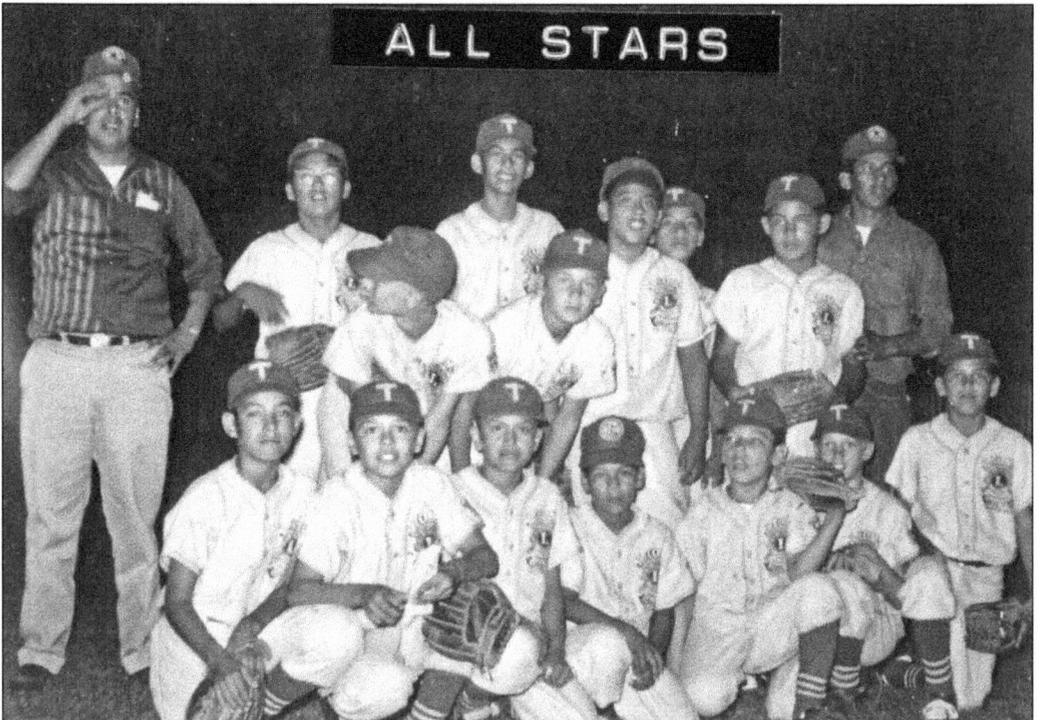

About nine years after the area's first little league program began, the All-Stars, under the tutelage of Rudy Contreras and Gregorio Medrano, won the state little league championship. The players were as follows, from left to right: (first row) Hector Zaragoza, Fred Duran, Manuel Ramirez, John Lopez, Eddie Camacho, Terry Smiley, and Victor Piña; (second row) Ruben Camacho, Al Olsen, Larry Rodriquez, Roy Moreno, Reyes Medrano, Robert Ruiz, and Louie Alcocer.

74

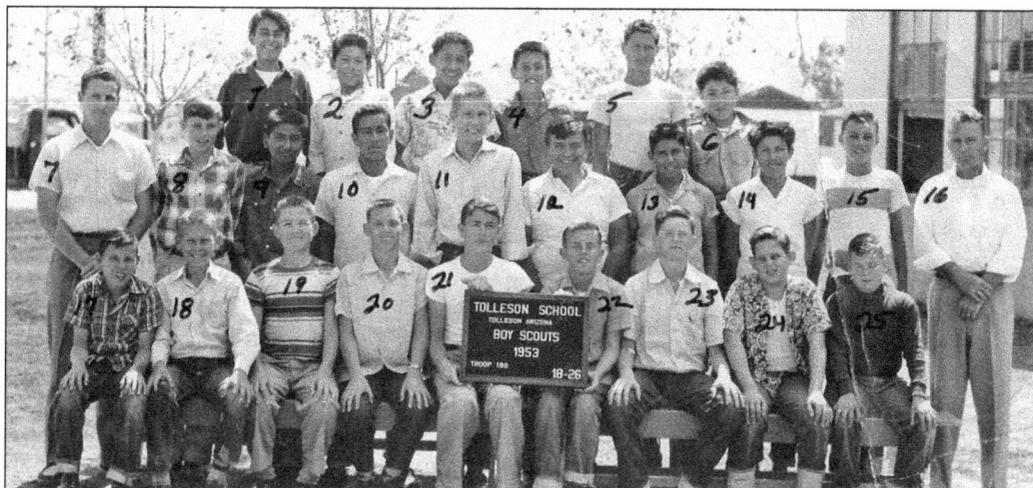

Service organizations for youth have always been important in the Tolleson area. The 1953 Tolleson Boy Scouts were led by William McNeel and ? Lohmann. Some of the scouts were, from left to right, (first row) James White, Jack Hamilton, Alton Burns, Bill Dowden, unidentified, Bill Van Zanten, Glenn Ellis, and Richard Pace; (second row) David Arnett, Robert Venegas, Terry Mendenhall, Albert Soto, Maynard Tidmore; (third row) John Montano, Fred Mendoza, Frank Alcocer, Sonny Espinoza, Clifford Swindel, and Frank Hernandez.

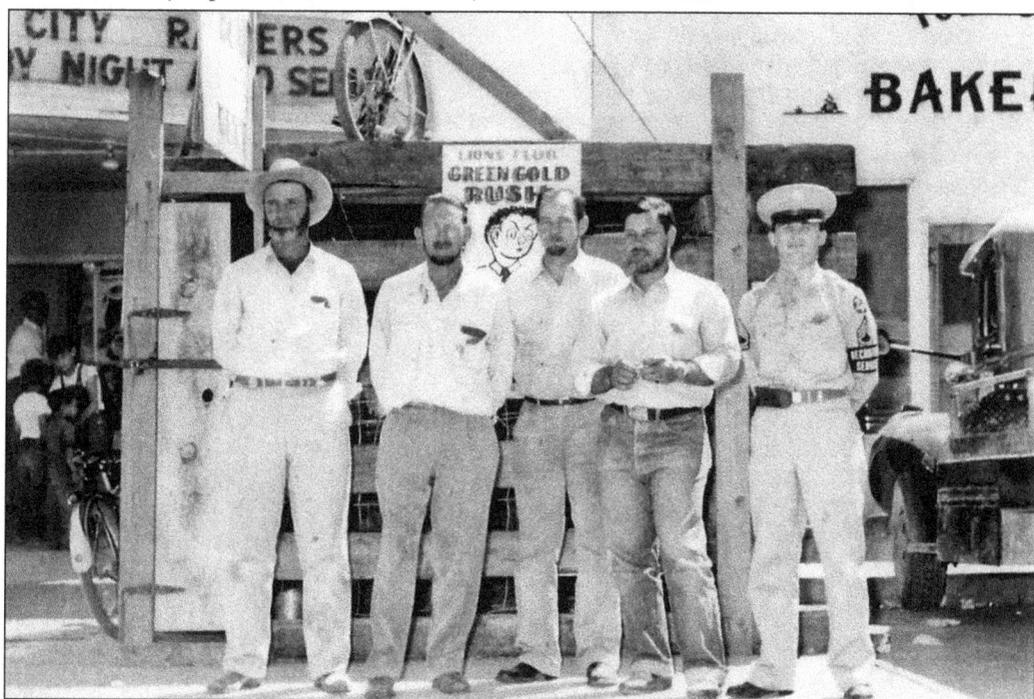

The forerunner of Tolleson's Whoopee Daze, the Green Gold Rush Days was an event beginning in 1949 and sponsored by the Lions Club, the connection being Tolleson's title as Vegetable Center of the World. From left to right, Leon Stout, Norman Anderson, Ralph Schmidt, Charles Marriott, and an unidentified military officer hold down the Kangaroo Court Jail for residents with no beards. The celebration included a week of activities with a street dance, auction, barbecue, parade, and entertainment.

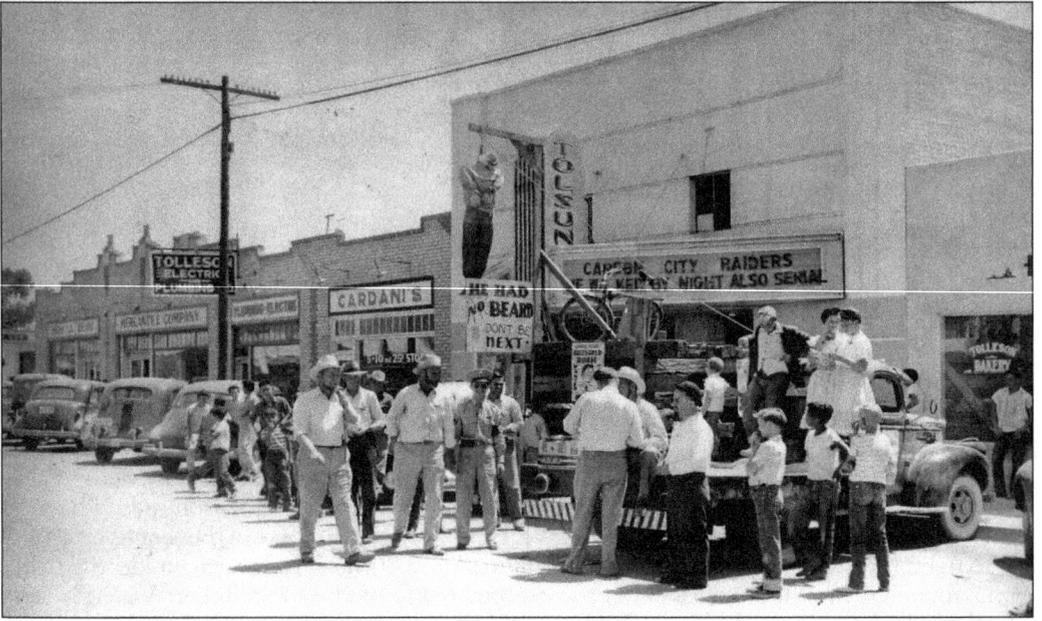

During the Green Gold Rush Days, P. J. Green (left), Leon Stout (center), and police chief Laverne Turner (with his back to the camera) begin a street activity in front of Tolleson's movie theater. Spectators watched, except for one poor soul, who was hanged because he failed to grow a beard. The award-winning 1948 movie *He Walked by Night*, starring Richard Basehart, Scott Brady, and Jack Webb, was playing at the Tolsun.

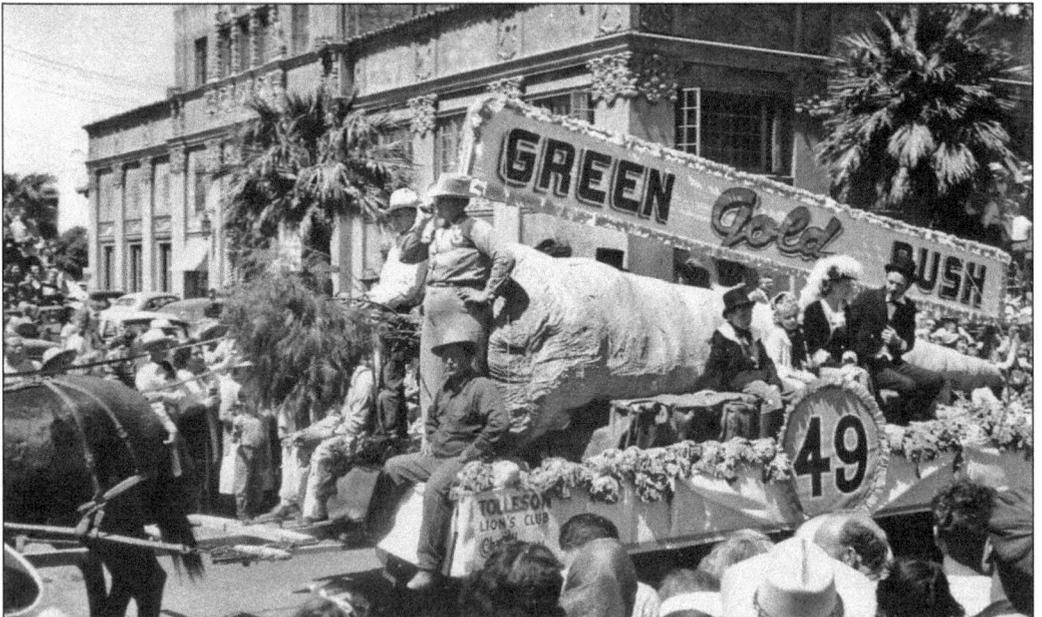

The town's Green Gold Rush float, depicting the community as the Vegetable Center of the World, participated in Phoenix's Junior Chamber of Commerce Rodeo Parade. Here the float passes a Phoenix landmark, the Westward Ho Hotel, with passengers (from left to right) Billy Van Zanten, Patty Van Zanten, Wink Van Zanten, and William Van Zanten Sr. The teamster and his helpers were Jesus Arredondo (seated, front right) and friends. (Elsie Busse.)

Community activities over the years have included carnivals and fiestas. The Tolleson Lions, Boosters, and Kiwanis Clubs, the Parent-Teacher Organization, the Wolverine-Knight Foundation, the Catholic church, city government, and others have continued to provide avenues for entertainment and community pride. Town boosters prepare an old vehicle for use as a carnival ride in 1958. Included in this group are Fred Buck (second from left) and Wayne Caudle (third). (Jackie Diaz.)

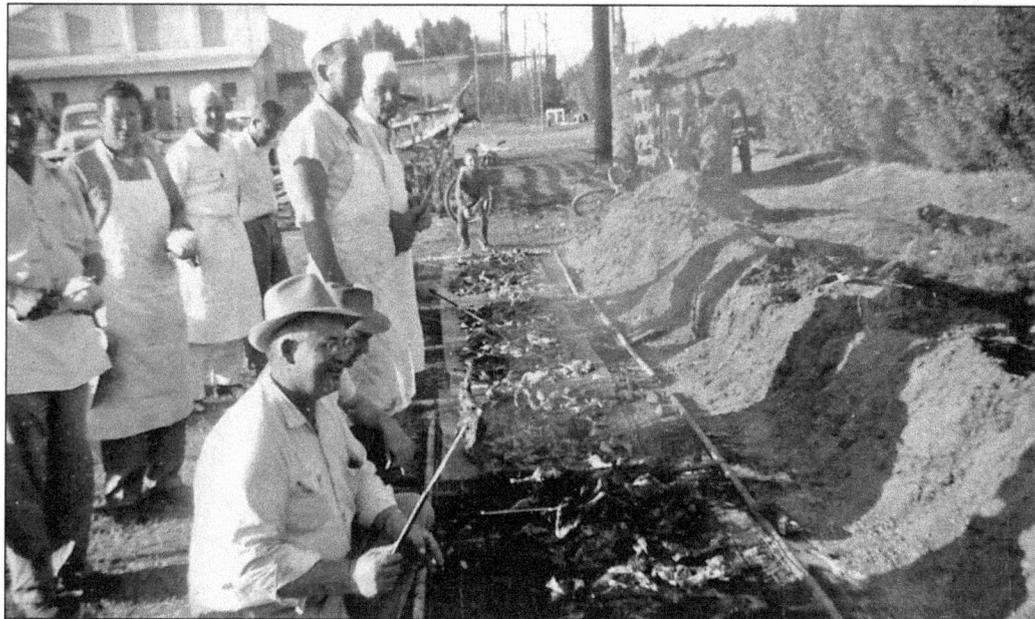

Big on the community agenda has always been a good barbecue. Community leaders have dug a pit behind the old Tolleson High gymnasium to barbecue chicken. In 1953, the New York Giants came to help celebrate the little league's 1952 season. Giants coach Leo Durocher along with such players as Alvin Dark, Dusty Rhodes, Hoyt Wilhelm, Wes Westrum (not pictured), and others joined in the festivities with autographs, photographs, and, of course, lots of barbecue.

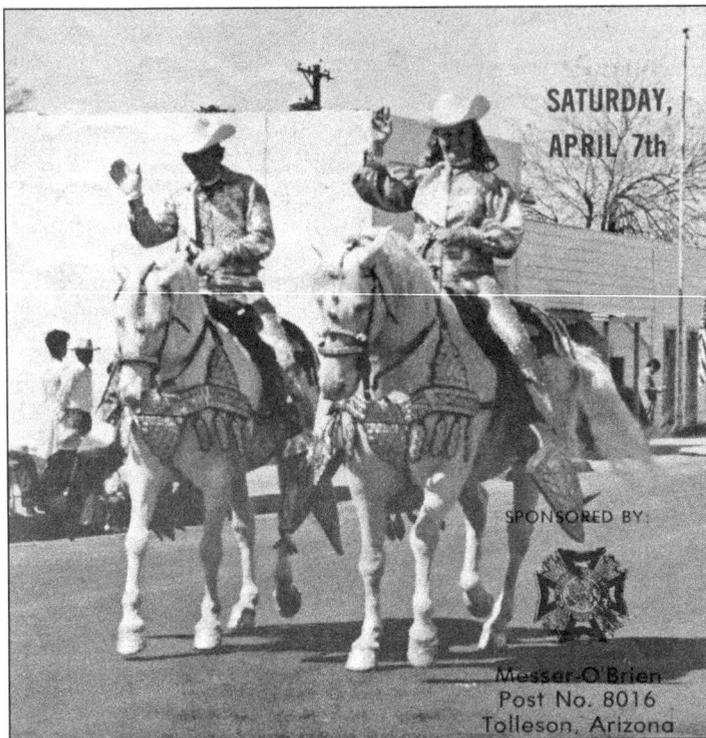

By 1961, the Green Gold Rush had faded. The Tolleson Boosters Club determined that a lasting community celebration was in order. Soon the Whoopee Daze festival, named by John Tritz in a grammar school contest, was born. The event gained recognition as having the second-longest parade in the state, surpassed only by the Phoenix Rodeo Parade. Nelson Mullins (left) and Pearlyne Mullins display award-winning animals and attire in an early Whoopee Daze Parade.

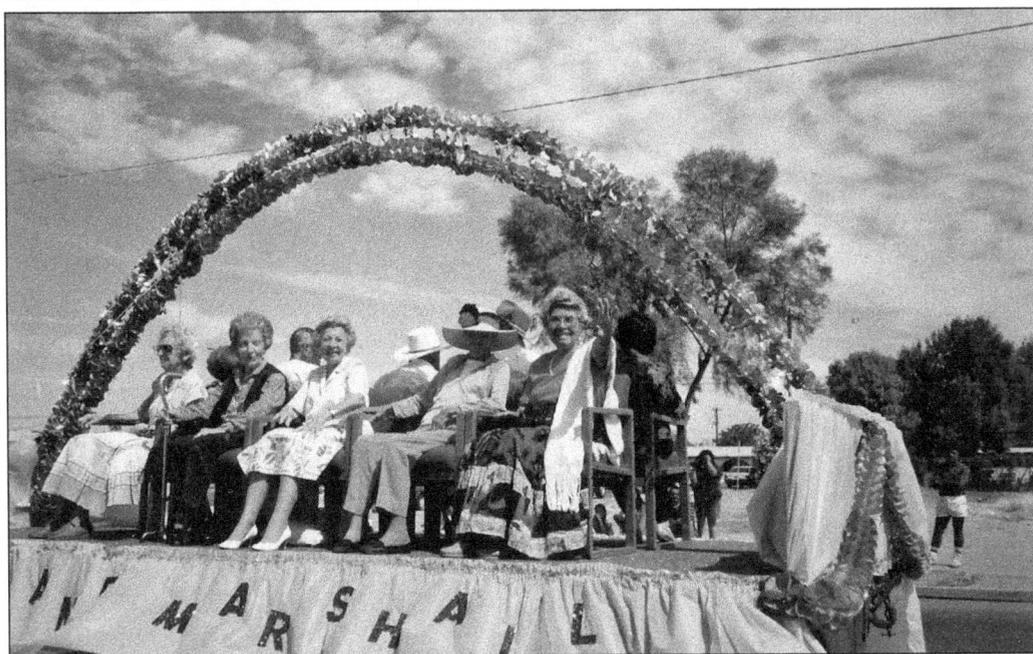

One of the most important parts of the Whoopee Daze is the selection of grand marshal, a person who is honored as head of the parade. Honorees over the years have included both state and local dignitaries. The committee for this celebration selected Tolleson's own senior citizens. Some of those riding the honorees' float are, from left to right, Hazel Hengsteller, Louise Lamar, Laura Arnold, unidentified, and Jesusita Diaz. (Jackie Diaz.)

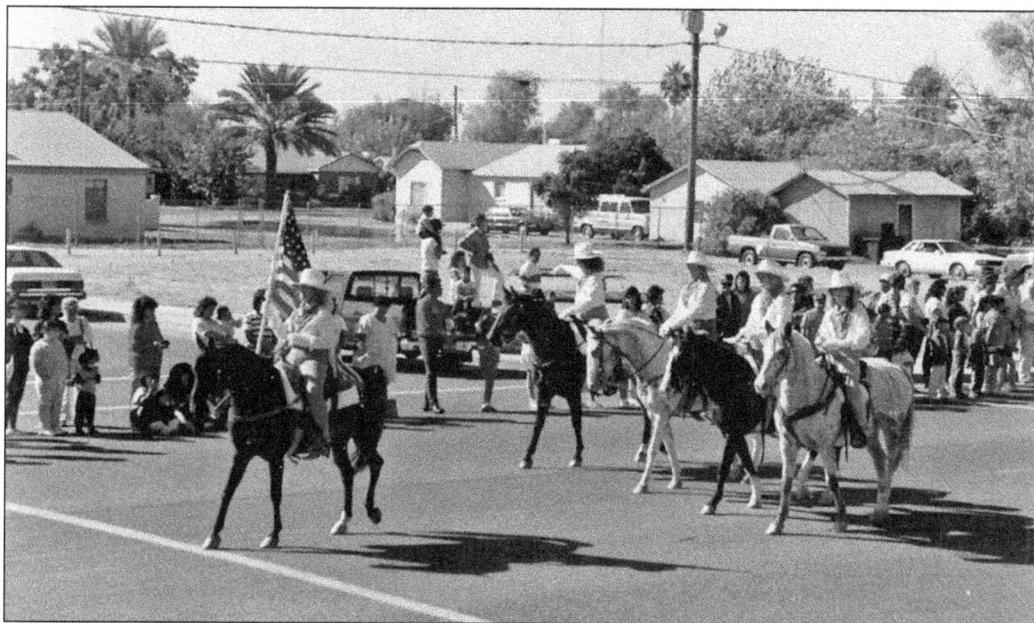

Horses, marching bands, floats, and clowns highlighted the opening weekend celebration. The queen contest, carnival, talent show, food, tournaments, and entertainment combined to give the community a special treat. In the late 1960s, even a rodeo was included. The first Whoopee Daze queen was Shirley Jones, a 17-year-old Tolleson High senior; the first grand marshal was Aquannetta, a valley television and movie personality.

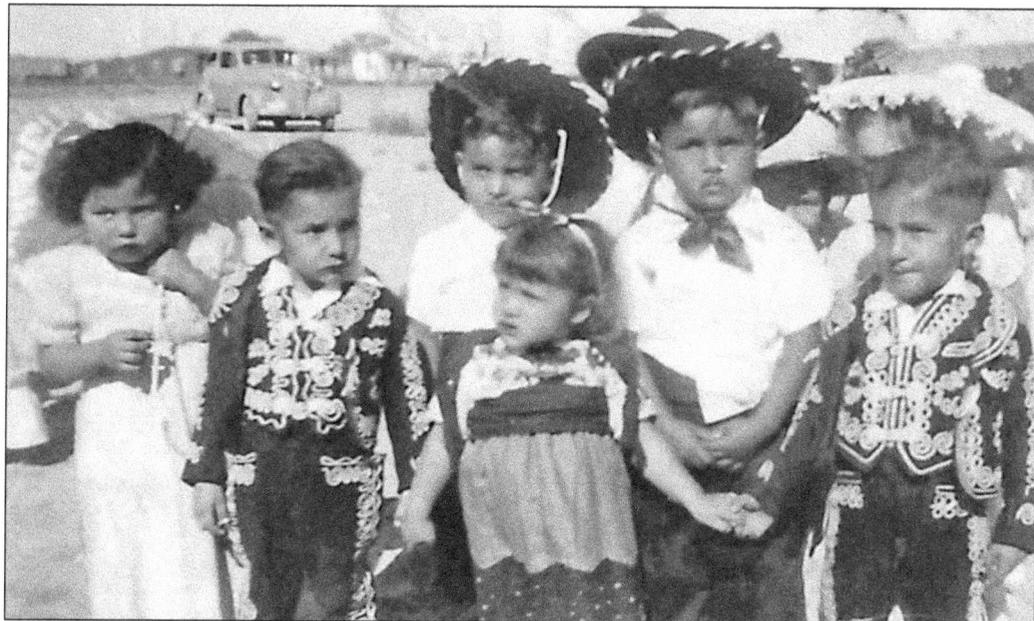

A typical fiesta sponsored by the City of Tolleson or Blessed Sacrament Church provides many citizens with an opportunity to celebrate their heritage. Youngsters dress in folk attire, participate in native dancing, and celebrate with amenities such as rides, native foods, and contests. Queens and attendants are often selected to reign over the several-day event. This 1950s photograph shows a group of youngsters ready to participate.

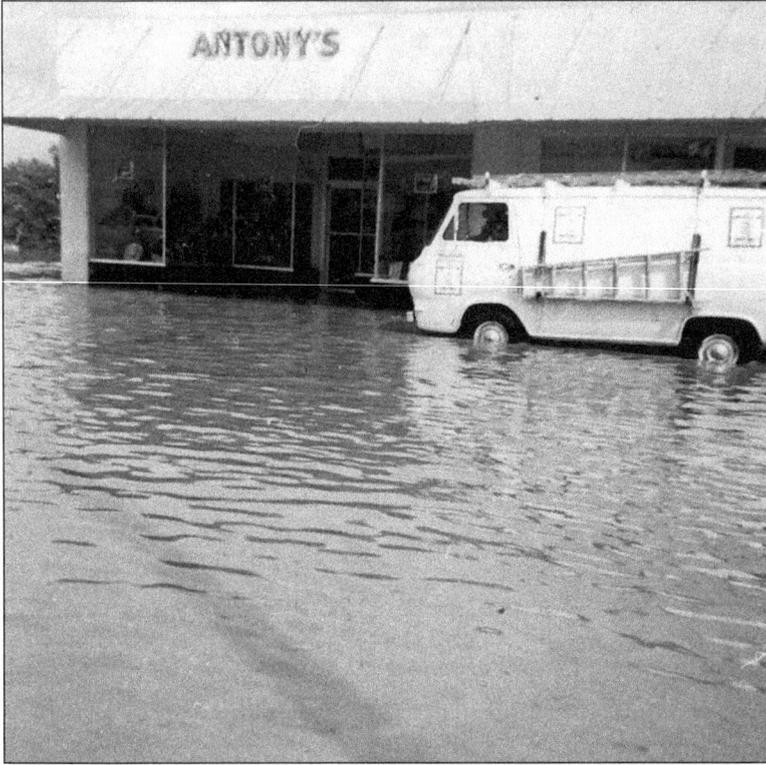

The Tolleson area has not been exempt from tragedy and turmoil. Manmade catastrophes and natural calamities have challenged citizens. Heavy rains and a broken lateral in 1966 inundated the city with one to two feet of water in many places. Homes and business were flooded, some receiving severe damage. From awe-inspiring fires to untimely deaths, the people of Tolleson have always helped one another. (Joy Burton.)

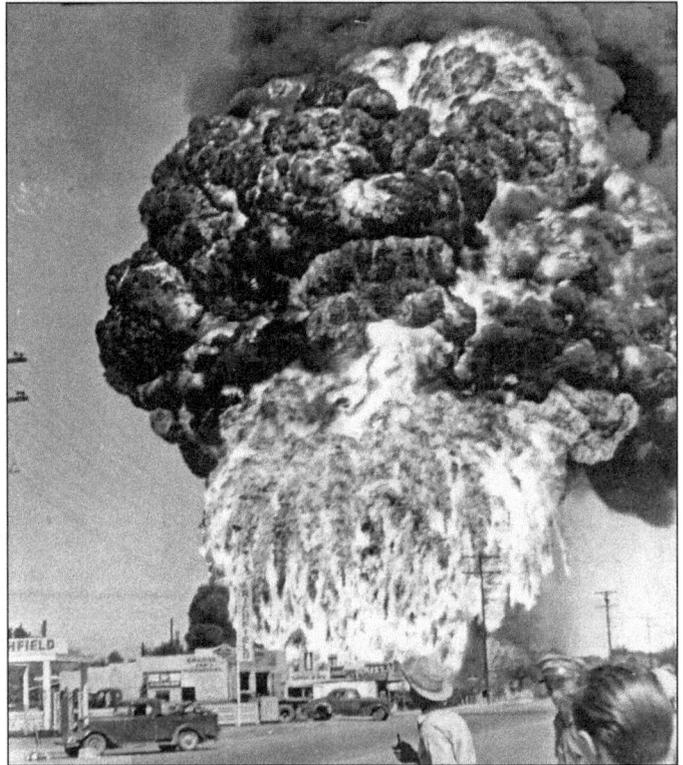

The most notable catastrophe in the community's history was the fire at Farmers' Oil and Supply Company on Van Buren Street in April 1948. A spark from a pump sent fire raging through the spilled fuel of a tanker truck driven by John Bass. In only a few seconds, tanks were aflame, resulting in a horrendous explosion. Taken by Fred Buck, this photograph graced the cover of *Life* magazine.

The town's volunteer fire department attempted to fight the inferno but proved no match for the roaring flames. The smoke could be seen all the way from Williams Field east of Phoenix, a community which, along with neighboring cities and military bases, dispatched fire equipment. Sandoval's Grocery and Buck Byrne's station were losses in the estimated $100,000 in damages.

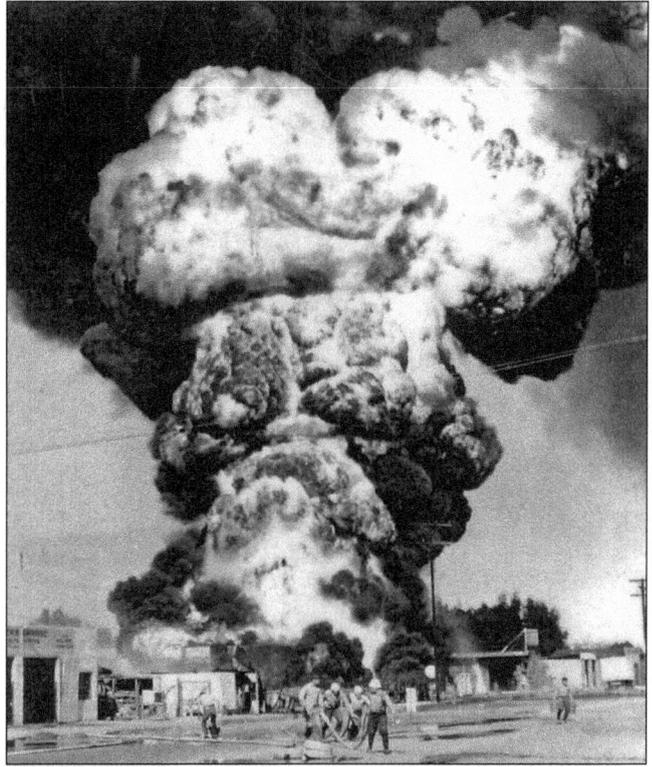

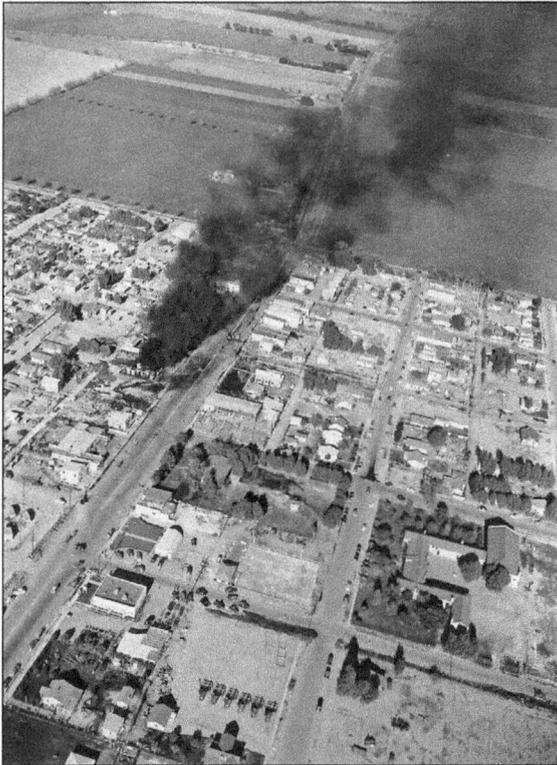

According to the *Arizona Times* of April 20, 1948, "Residents of this blast-stricken community moved back into their singed, smoke-filled homes this morning after a day of holocaust and a night of danger and fear. . . . Smoke rose from the ruins to remind the community of the bomb-like blasts of 54,000 gallons of gasoline fuel which yesterday came within a hair of wiping the town off the map."

Viet Nam

Ralph Ruiz	9412 W Taylor
Manuel Gonzales	
Benny Castenada	9303 W Jackson
Danny Villa	9167 W Polk
Jess Berumen	9111 W Garfield
Frank Guimenez	Rt 1 Box 187
Peter Ledesma	9156 W Garfield
Johnny Ruiz	9251 W Pierce
William Gomez	9255 W Baden
Ruben Nogales	9105 W Garfield
Ralph Rojas	9252 W Baden
Richard Ponce	9157 W Roosevelt
Luis Villalobos	9111 W. Washington
Johnny Villalobos	9111 W. Washington
Jr Ledesma	9156 W Garfield
Robert Peña	9258 W McKinley
Juan Sanou	9203 W McKinley
Frank Contreras	9252 W Pierce
David Angulo	9105 W Pierce
Ruben Arnetta	9257 W Pierce
Benny Gallardo	9109 W. Fullmore
Manuel Sepeda	9159 W. Fullmore
Jackie Martinez	9412 W Jackson
David Victor	9903 W Fullmore
Don Ballard	507 Tracy Lane
Joe Ordonez	9258 W Fullmore
Ruben Galindo	9152 W Taylor
Arthur O'Brien +	9355 W Taylor
Joe Cortina	9260 W Taylor
Ernie Lopez	9257 W Polk
Mike Ybarra	9255 W Polk
Stanley Funchael	9411 W Polk
Ray Aranda	9405 W Polk
David Lopez	9113 W Monroe
Manuel Callas	9167 W Adams
Jimmy Messer +	9360 W Adams

War for any small community is devastating. This photograph is a record of some young men who left to serve their country in the military. The special pluses beside the names tell, unfortunately, of losses. Arthur "Corky" O'Brien's and Jimmy Messer's names have received the mark of a community's tears. Santiago Ruiz's cash book is a stark reminder of the price paid by Tolleson's citizens.

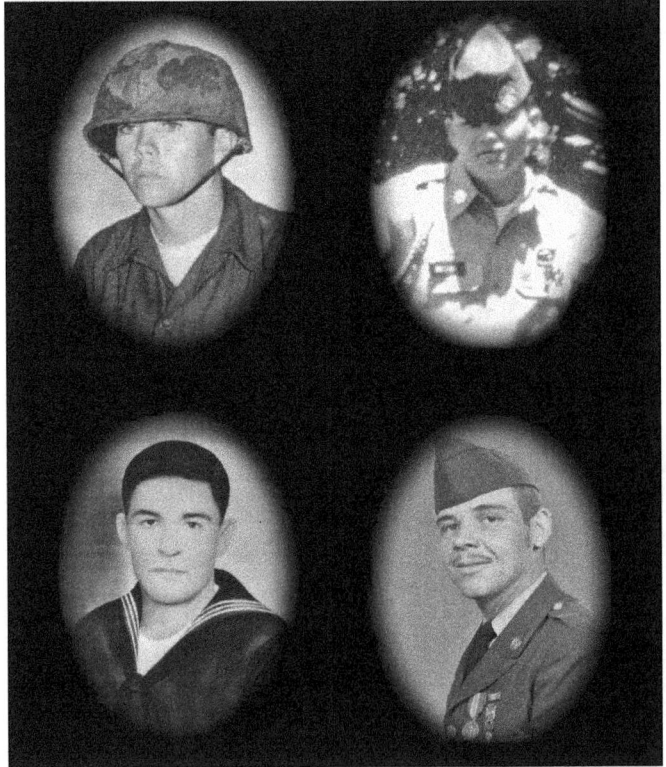

City fathers chose to name streets in a modern housing development after each lost soldier. If a person drives the streets of Villa Rica north of Van Buren in the city of Tolleson, he will surely recognize roads named Jimmy D. Messer, Corky O'Brien, Bobby Lopez, and Stanley A. Goff—four young men who made the ultimate sacrifice for their country. (Patti Sygeel.)

Five

THE WAR YEARS
HEROES ALL

No greater love has any man than he who is willing to lay down his life for another. The history of the Tolleson area in times of war, sacrifice, and patriotic devotion is a story of such love: love for family, for country, and for community. For nearly a century, Tolleson residents have answered the call for military service. Most recently, the City of Tolleson dedicated the new Tolleson Veterans' Park to its native soldiers.

Tolleson's own Keith Hintz enlisted in the U.S. Navy as an underage sailor, serving honorably during World War I. L. M. "Bill" Hunt witnessed the raising of the American flag on Iwo Jima, while Silvestre Herrera became the only Arizonan to be awarded the Congressional Medal of Honor during World War II. Herbert Penny, a medic, was a recipient of the Silver Star in the Korean conflict. Approximately 45 former Tolleson Union High students served in the Persian Gulf War. Former Tolleson Union High student Alysea De La Cruz worked as a medic in Operation Iraqi Freedom.

Jackie Ellis died in Korea. Stanley A. Goff, Bobby O. Lopez, Jimmy D. Messer, Corky O'Brien, Fernando Mesquite, and Bobby F. Lopez of Santa Maria all gave their lives in the Vietnam War, as did John Thornton of Fowler in Iraq. Unfortunately, this chapter cannot recognize Tolleson's complete military history. It simply underlines the heroic contributions made by the men and women who nobly served their country.

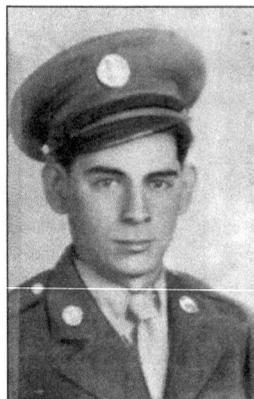

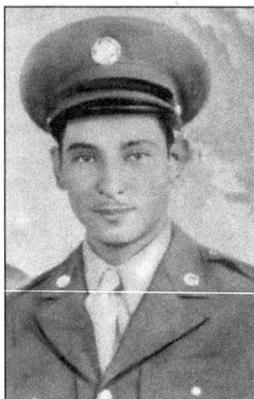

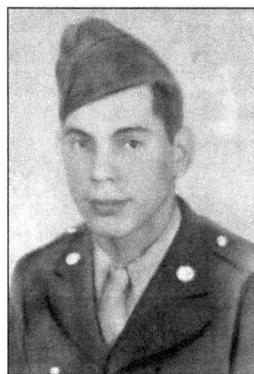

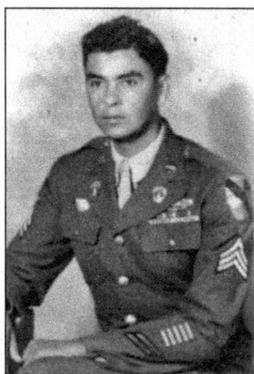

Frank Moreno (top left) and brothers Mike (top right) and Manuel (bottom left) served in the army during World II; another brother, Jose, is not pictured here. Maria, their mother, died at age 95; her descendents number 435. The brothers' cousin Frank Moreno (bottom right) was stationed throughout the Philippines. Frank was on the islands when General MacArthur left and welcomed the general to shore upon his return.

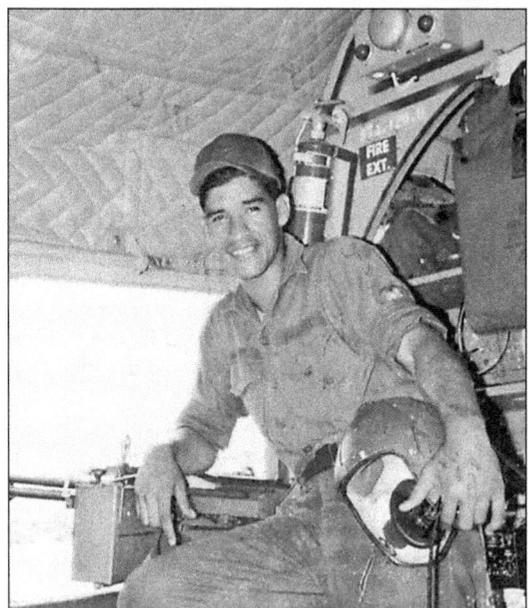

Joe Ordonez (left), a decorated Vietnam flight engineer and Persian Gulf veteran, is the nephew of Sylvestre Herrera (page 92, bottom right), a World War II Congressional Medal of Honor recipient from the Tolleson area. During the military conflict in Europe, Candelario Medrano (right) served as a scout for the army. His team was one of the first to enter and liberate the concentration camps in Germany.

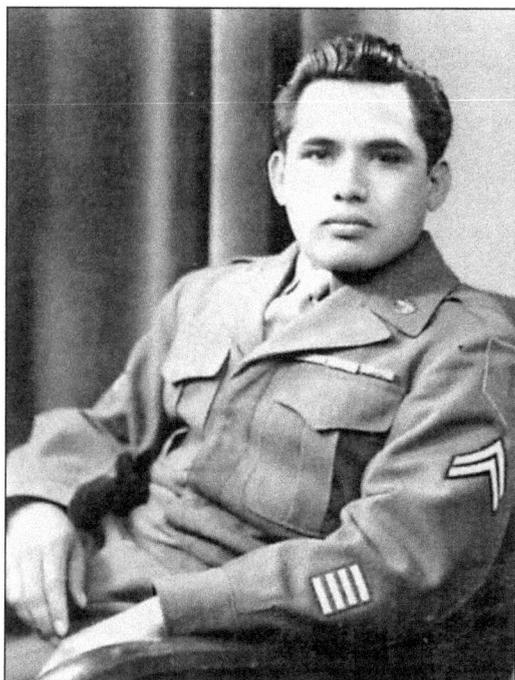

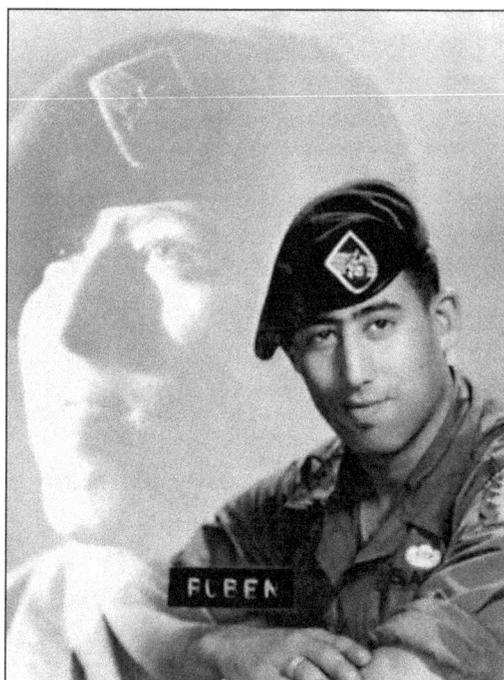

Joe "Pepe" Ramirez (left) was at Omaha Beach on June 6, 1944, with the Big Red One, a U.S. Army division. Pepe was awarded the Bronze Star for his bravery. Today Pepe's Lounge is a landmark in downtown Tolleson, the backroom of which serves as the location for VFW meetings. Ruben Nogales (right) did two tours, seeing action in Vietnam with the Green Berets and with the 173rd Air Borne.

At the Battle of the Bulge, David "Tivo" Angulo (left) fought valiantly under Gen. George Patton in his 3rd Army. Tivo is pictured with his wife, Esther, who worked for many years as Tolleson city clerk and whose name adorns the senior center. The couple's son David Angulo Jr. (right) served in Vietnam as a medic.

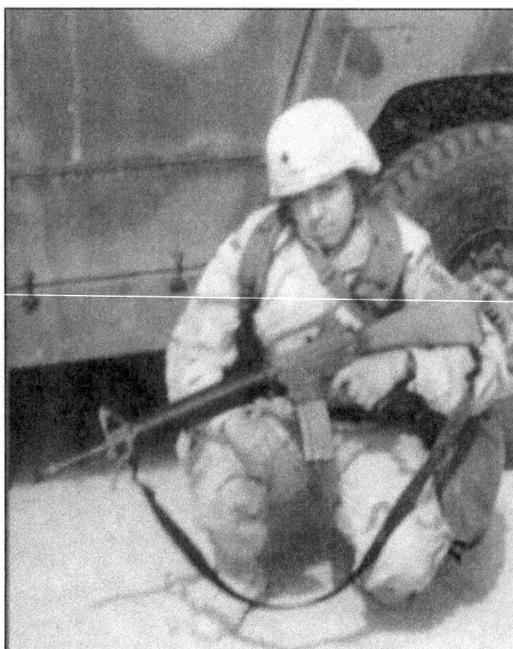

Erik Chavira Cole (left), a former Tolleson High student, as a military policeman trained Iraqi soldiers. Alysea De La Cruz (right), whose father, Roberto, fought in Vietnam, served as a medic in Operation Iraqi Freedom. She was one of the first Tolleson Union High School students to participate in the war.

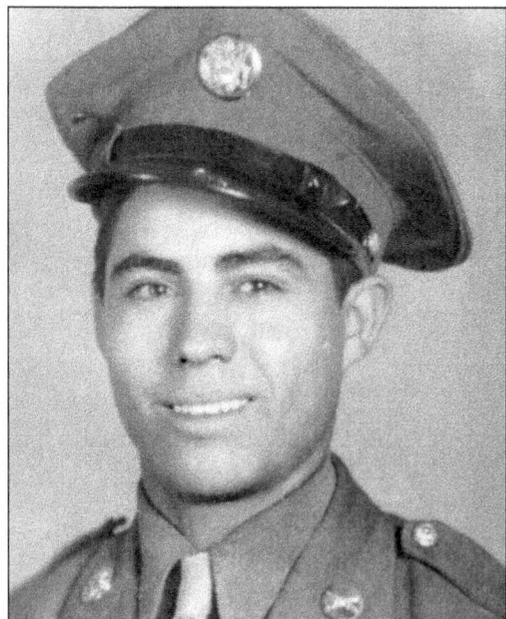

Carlos Rodriquez (left) served both during World War II and the Korean conflict. Fighting in one of the first battles, he was severely wounded and permanently lost his eyesight. John "J. B." Berumen (right) was a part of the 25th Infantry Division in Vietnam. The Berumen family came to Tolleson in the 1920s. At age 104, J. B.'s father was the oldest living city resident until his death in 2008.

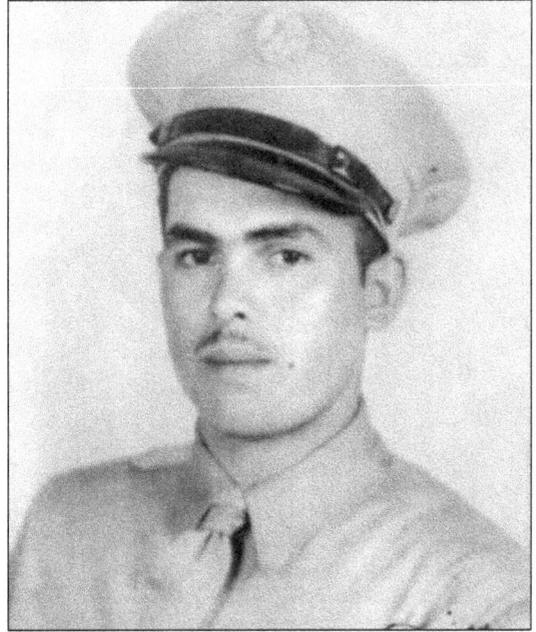

U.S. Army soldier Gilbert White (left) was awarded a Silver Star for gallantry in World War II. During the same conflict, Antonio Hidalgo (right) was killed in action in Germany, along with his Tolleson neighbor Guillermo "Memo" Cabrales (not pictured). Nellie Lara (not pictured), a longtime Tolleson resident, is Tony's sister.

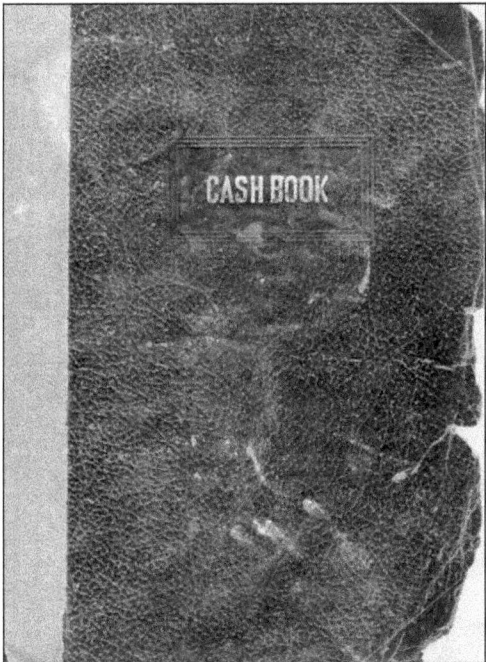

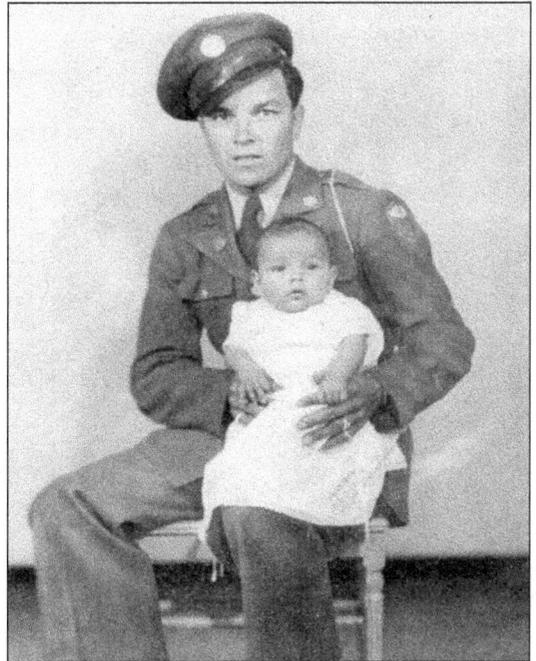

Santiago Ruiz's World War II ledger (left, see page 82) of young men from the Tolleson area stands as a hallmark of commitment from these community families. The first name on the list is Ruiz's brother-in-law Rodolfo "Rudy" Chavira (right), who served in the army in the South Pacific. Here Ruiz's son Jimmy sits in Rudy's lap at one year old.

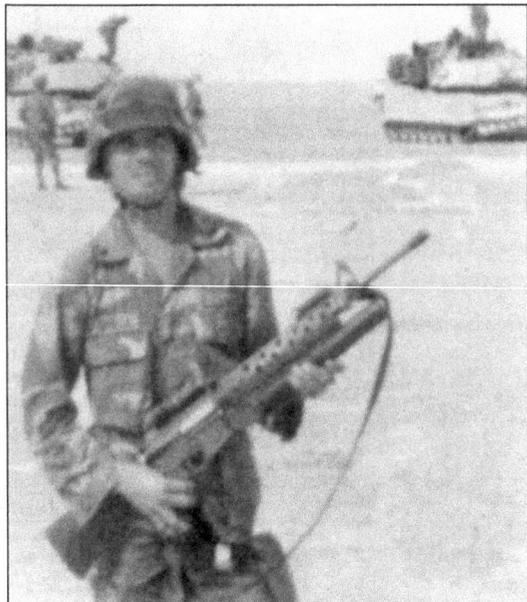

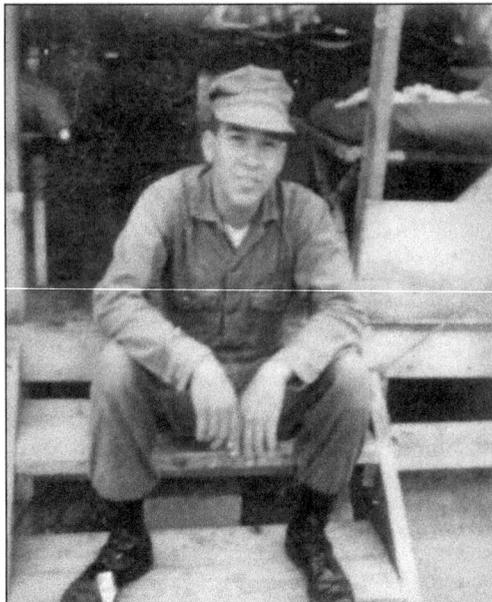

While in the U.S. Army Reserve, Gerald Arrieta (left) saw action in the Persian Gulf War. Gerald's older brother Ruben (right) served with the marines in Vietnam. Gerald and Ruben are brothers to Maria Arrieta Ruiz, to whom this book is dedicated.

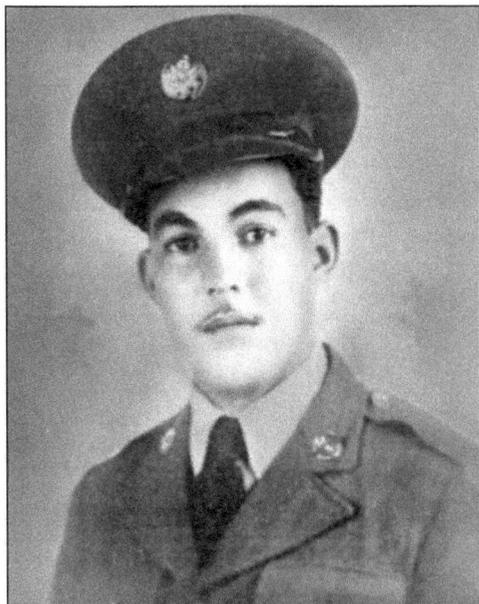

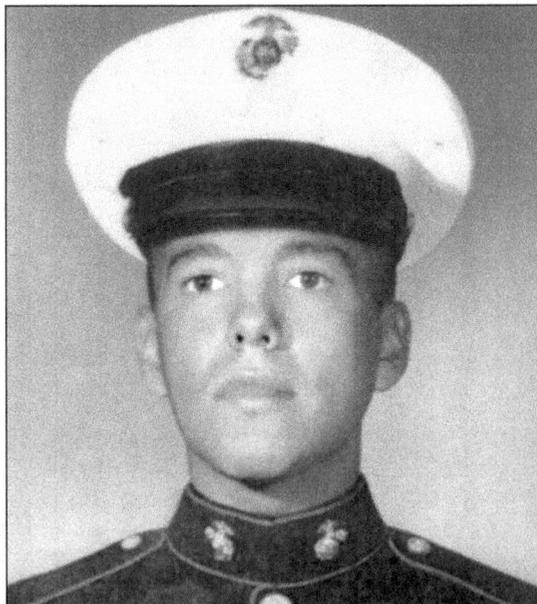

Cornelio Bustamante (left) performed his military duties in the Pacific theater, seeing action at Guadalcanal. Manuel Bustamante (right), Cornelio's nephew, was a marine who served in Vietnam. Manny's family came to the Tolleson area in the 1930s, and he continues to live on Washington Street.

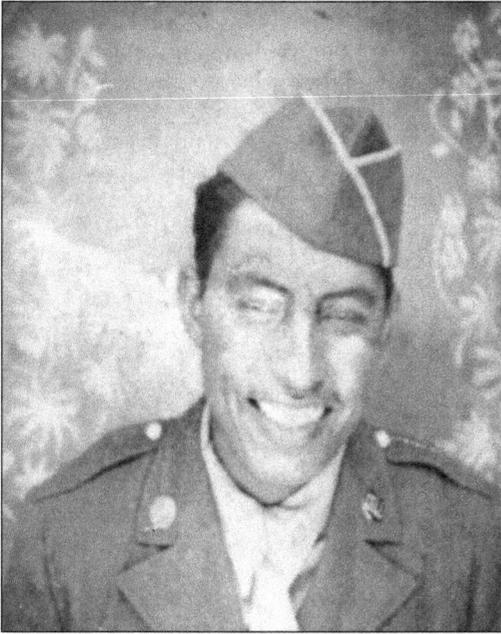

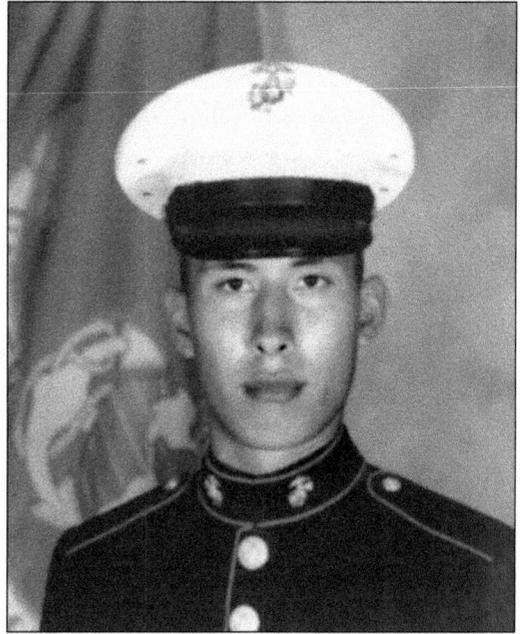

Guillermo "Memo" Cabrales (left) was killed while serving in Germany during World War II. Named after his uncle, Guillermo A. Cabrales (right) graduated from Tolleson Union High School and is currently a commercial airline pilot. He fought in the Persian Gulf War. Memo's eldest brother, Antonio, also served in World War II.

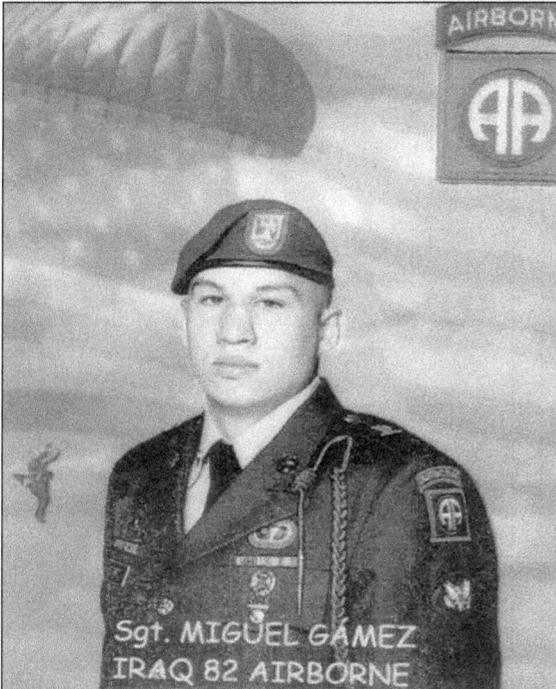

Miguel Gamez (left) served with the 82nd Airborne in Iraq. Miguel's father, Alfredo, is Tolleson district constable, and his uncle Adolfo is Tolleson city mayor. After his tour with the U.S. Army Infantry in Vietnam, Miguel's uncle William (right) received his citizenship.

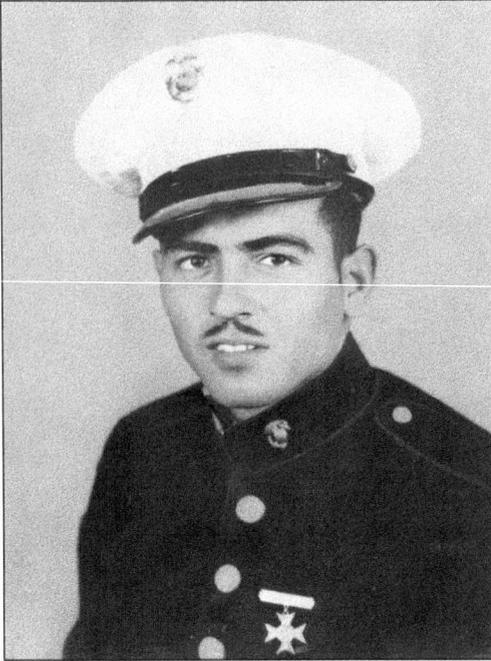

During World War II, U.S. Marine Virginio Fimbres (left) fought in the Battle of Okinawa. His brother Juan received a Purple Heart for his bravery during the same war. Ricardo Silvas, Virginia's nephew, served in Germany, while Ricardo's brother Jose (nosaw battle with the navy. The Silvas brothers are nephews to the Fimbres brothers.

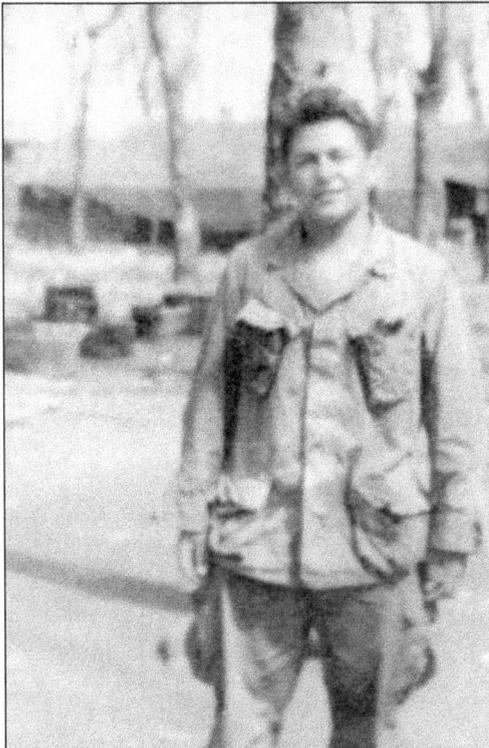

Demencio "Scotty" Ledesma (left), born in Tolleson, served with the 1st and 7th Cavalry, 5th Battalion, in Vietnam in 1968 and 1969. He received the Combat Infantry Badge and the Bronze Star. Peter Ledesma (right), Scotty's older brother, was one of the first Tolleson citizens to go to Vietnam. For his service, Peter was awarded the Vietnam and National Defense Medals.

90

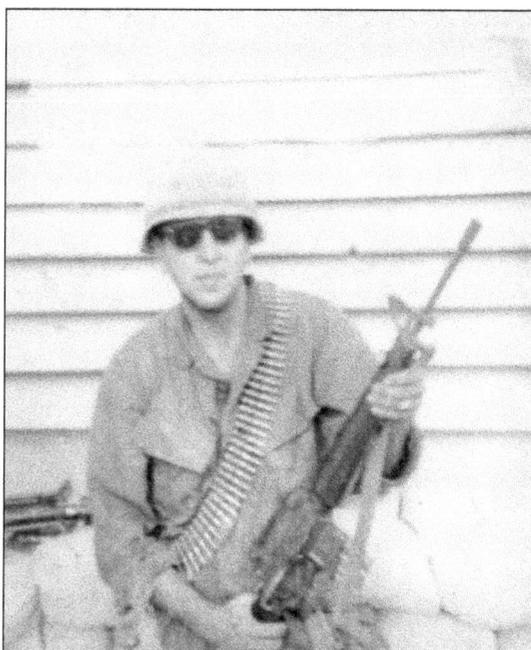

George Ruiz (left) was stationed in Germany for 18 months defending the Berlin Wall during the Cold War. Ralph Ruiz (right) served with the 3rd 22nd Infantry Unit, 25th Infantry Division in Vietnam in 1968. Twice, Ralph received wounds that merited him the Purple Heart. His division inspired the Oliver Stone movie *Platoon*.

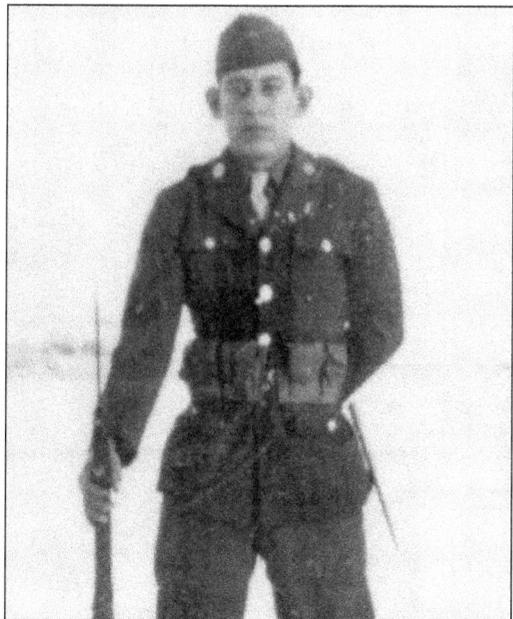

Entering the army in 1942, Benito Pina (left) served as a mortar gunner and combat infantryman until 1945. He earned an EAME Campaign Medal with four Bronze Stars for battles in Germany and northern France. During the Vietnam War, Benito's son Robert (right) worked as a specialist 4 wireman in communications. Robert later became a post commander in the Tolleson Bobby Diaz Lopez VFW Post.

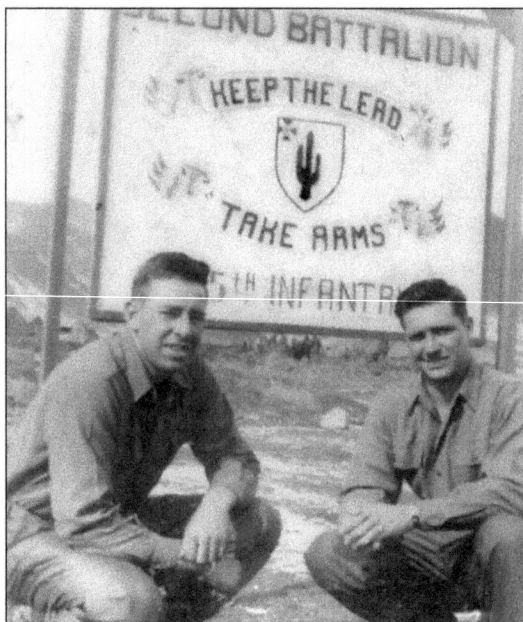

Victor Pina (left)served with the Big Red One and with the 1st Infantry Bravo Troop in Vietnam with both tanks and infantry. A significant athlete, Victor played college baseball after his discharge. In 1951 and 1952, Charles Schmidt (right image, on the left) performed intelligence and reconnaissance duties with the 25th Infantry Division in Korea. His father, Ralph, served as Tolleson postmaster from 1955 to 1972.

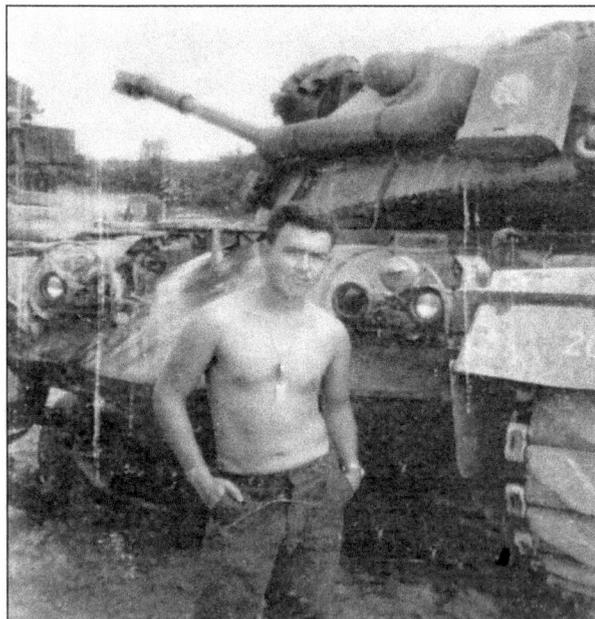

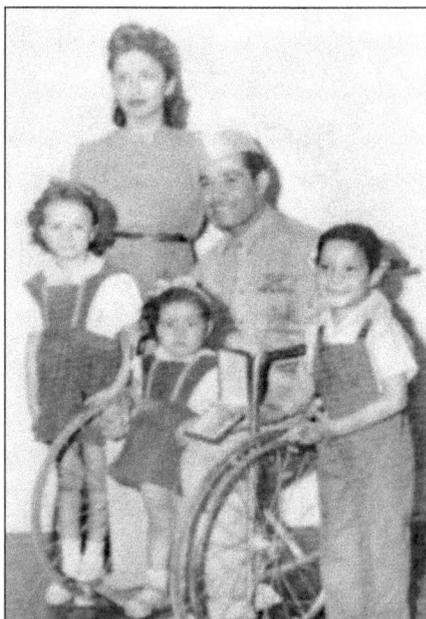

Childhood injuries should have kept Benny Gallardo (left) from military service; however, he became a marine and went to Vietnam anyway. As a youth in the Tolleson area, Congressional Medal of Honor recipient Silvestre Herrera (right, in wheelchair) lived at 107th Avenue and Camelback and attended Pendergast Elementary School. Both the residence and the school received rural delivery out of the Tolleson Post Office.

These pages from Santiago Ruiz's cash book reflect the names of those who served. The first page (left) lists some World War II veterans who were working for Santiago in the produce fields when they were drafted. While employed by the Tolleson Post Office, Jimmy Ruiz continued his father's historical record by documenting those who served in Vietnam (right).

On the left, from left to right, three Tolleson soldiers—Fidel Serrata, Jesus "Pelin" Hernandez, and Sal Gutierrez —have their photograph taken at the 38th Parallel in Korea by a fourth Tolleson soldier: Martin Sapien (not pictured). Alvin Clark (right) served in Bastogne at the Battle of the Bulge with Gen. George Patton. The famous response to a request to surrender was "Nuts" from Brigadier General McAuliffe before General Patton's 3rd Army arrived to help.

Frank Contreras (left) was one of the first Tolleson residents called to Vietnam in 1965, serving with the U.S. Army in transportation. Alvaro Morado (right) worked with the 566th Transportation Company attached to the 101st Airborne Long Haul Convoy to get supplies in and out of the various fire bases. Morado's family has provided automobile service in the community since the 1950s.

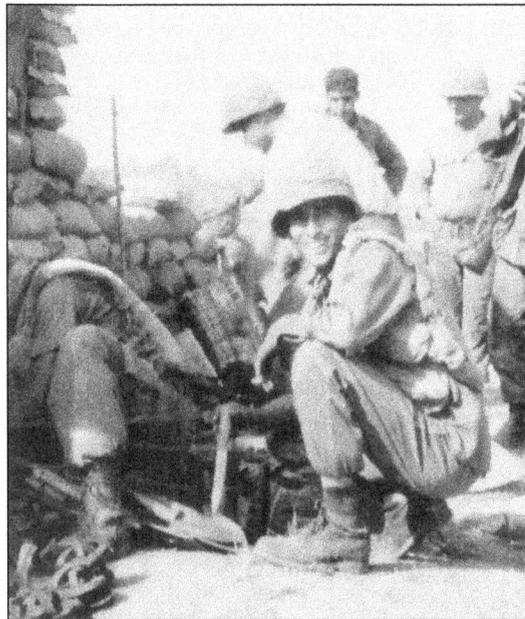

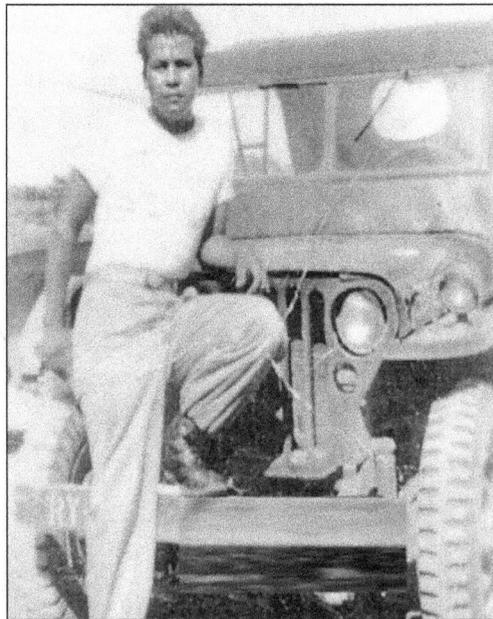

Manuel Elias (left, center), a tank driver and gunner in the 34th Armor 4th Infantry Division, was awarded the Bronze Star for his service in Vietnam. Fedrico "Lico" Lopez (right) saw duty in Korea. Lico's family came to the southwest valley in the 1920s and became prominent business owners. Several of his brothers were important in the produce business as supervisors for the J. A. Wood Company and other firms.

Rudy Berumen's family migrated to the valley in the 1920s, and Rudy (left) married Vickie Alcocer, thus becoming part of the historic Alcocer clan. Rudy's father, Alvino (not pictured), served in World War I. Decades later, during World War II, both Rudy and his brother-in-law Luis Alcocer (right) saw action in the U.S. Army.

During the Vietnam conflict from 1968 to 1969, David Lopez (left) was stationed on a naval hospital ship, the USS *Sanctuary*—the only hospital ship at the time. David's dad, Marcos (not pictured), also served in the navy during World War II. Donald "Butch" Leonard (right) spent the Vietnam War aboard the USS *Wiltsie*. He also performed service craft duty out of Cam Ranh Bay.

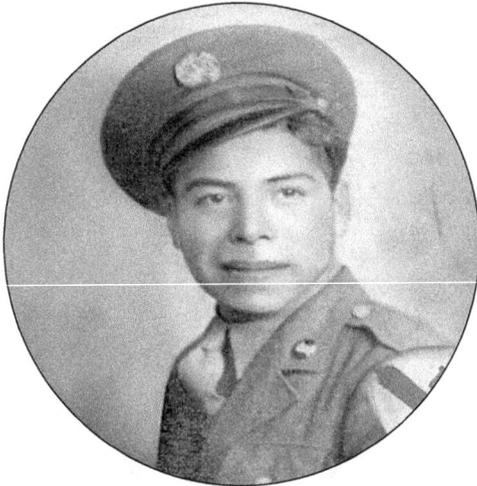

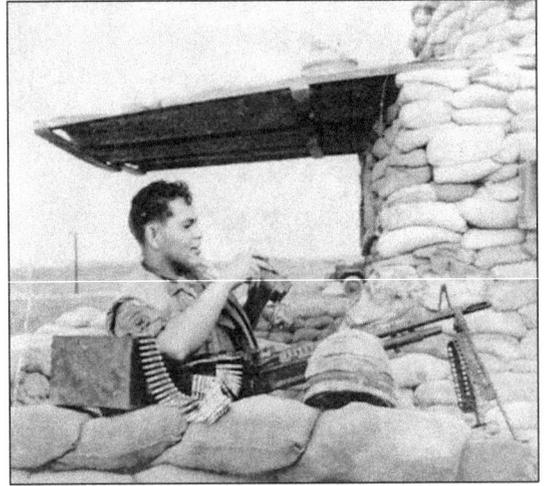

During World War II, Joe Ruben Duran (left) served with the U.S. Army as a member of the 8th Engineers attached to the 1st Cavalry Division in the South Pacific. In 1944, he married longtime Tolleson resident Margarita Berumen. Ernie Lopez (right) served in Vietnam with B Battery 6th/56th Artillery in 1966 and 1967. The Lopez family was one of the original property owners when Charles Baden subdivided north of Van Buren Street (see page 18).

ORIEN FIFER

Jimmy, Corky Robert, Stan

One morning not long ago a mother sat down and wrote a poem.

She was not a professional, but what she lacked in slick paper style she made up in feeling.

She had good reason.

Four Tolleson young men, all friends, had lost their lives in combat in Vietnam — and the last was her son, Stanley Goff, who was killed in September of this year.

This is Mrs. William Goff's heartfelt contribution:

FIFER

"There was Jimmy and Corky and Robert and Stan—
They all went to fight in an unfriendly land,
Each one left his home and his loved ones behind
And went to the war to serve out his time.

Can America imagine what a price they have paid
For our freedom of worship our forefathers laid,
For a place to feel safe through the day and the night,
For a country to stand and uphold all that's right?

And safety at home for their families to dwell.
They appreciated life as much as the rest
And so they were sent, some of Tolleson's best.

Now to us who are left may we take a firm stand
For God and for right, and pray for our land.
There are many more boys, yes .. more than our four
Who will lay down their lives; let's pray for them more.

Let's not let one say they have all died in vain
But each in our hearts let freedom now reign.
Then some day we too can offer our all
To the one who chose our four boys to call.

To Jimmy and Corky and Robert and Stan
We shall come up to meet you and be in your land.
There's no fighting, no trouble, no sickness or sin,
It will all be glorious in the land you are in.

Now please America and the people who care
Just think of the sacrifice and toil they did bear.
Let's get back to God, let His word be our guide,
Fight a good fight of faith, and join side by side.

One day this turmoil and sin will be o'er . . .
These mothers of four will meet on that shore.
We will join hands again with the son whom we love,
And be happy forever in the mansions above."

Those killed in addition to the Goff boy were Jimmy Messer, Corky O'Brian and Robert Lopez. Tolleson has a population of 3,625.

In September 1970, a young private 1st class army soldier who lived in Tolleson was killed in action. Along with three of his high school buddies, he made the ultimate sacrifice for freedom. Through pain and sorrow, Stanley Goff's mother penned a poem to her son and his fallen friends. Orien Fifer of the *Arizona Republic* chose to share a mother's heartfelt thoughts in his weekly column.

Six

THE CITY

PROGRESS, SERVICE,
"THE OPPORTUNITY CITY"

Walter Gist Tolleson died at Phoenix's Good Samaritan Hospital on October 13, 1940, at 8:43 a.m. Tolleson doctor Martin C. Flohr was the attending physician. Walter did not live to see his town change into subdivisions with country-style ranches, single-family homes, and multilevel apartments, or to witness its status change to city in 1956.

Produce packing sheds and small family businesses have been upgraded to manufacturing plants, warehouses, and distribution centers. Over 20 Tolleson Fortune 500 core businesses have located north and south of Van Buren Street to the city limits between Seventy-fifth and 107th Avenues. McKesson Pharmaceutical Company, PepsiCo, Bose, Nabisco, Weyerhauser, McKelvey Trucking, Con Agra, Fry's Food and Drug, Albertson's Distribution Centers, and Holsum highlight the community's offerings. Interstate 10, the Union Pacific Railroad, and State Route 85 connect with the city within a one-mile grid, providing ideal shipping resources for all kinds and sizes of products.

Tolleson's wastewater treatment plant was remodeled in 1967–1968 to service over 100,000 people, becoming the third largest facility in the state by the 1980s. This capacity allowed Tolleson to enter into intergovernmental agreements with neighboring cities. Well over 15,000 potential jobs lie within a city populated by just over 5,000 residents—one of the most impressive ratios in the nation. New businesses, parks, shopping malls, churches, and schools emerging within the scope of an environmentally sound vision have helped carry the spirit of Walter Gist Tolleson from 1912 into the 21st century.

"I believe this would be a good location for a town," Walter Gist said to his brother Leon and his friend Arthur Finley one day at the Ten Mile Store. And so it was.

The Dreamland Dancehall, seen under construction on the corner of Lateral 22 and Polk Street, served as the center of social activity for Tolleson citizens. Weddings, *quinceaneras*, birthdays, and weekly celebrations of all kinds filled the ceremonial hall for some three generations. In the 1960s, the building became a large secondhand store operated by Thelmer Goff. Today the property is part of the Circle K strip mall complex.

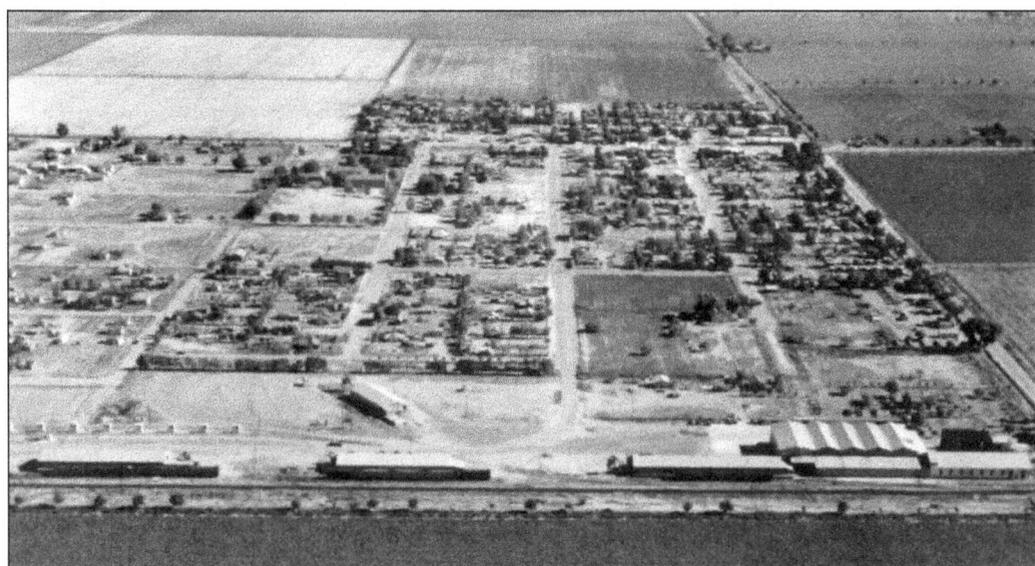

This aerial photograph of the town, taken in 1939, shows the first acreages subdivided by Walter Gist Tolleson and Charles Baden. The Isabell Addition, Tolsun Farms, and north-side lots from Taylor Street to Roosevelt were developed years later. At this time, several packing sheds were in full operation, moving the community toward the Vegetable Center of the World.

Streets were generally a mess in the early days. Residents knew that if it rained, automobiles would have to be left on Yuma Road (Van Buren Street) and they would have to walk to their destination. Through the WPA, some main roads received two-lane concrete strips in the 1930s. Here laborers pave the town's main street in the 1940s.

In the 1930s and 1940s, the Tolleson Town Hall complex consisted of three buildings: the court, the offices, and the jail. Some time later, an addition was constructed onto the jail, making it a two-story building. Then Valley Nation Bank donated a Quonset hut that had been the town's bank. This complex served the town until the current complex was built in 1968. (Jarrie Holliday.)

The home of Warren Smith, U.S. postmaster from 1953 to 1955, stood on Monroe Street between the city court and a local business. This 1940s photograph shows the city air raid/fire whistle behind the city court building. For years, this whistle blew night or day each time a fire was reported to the authorities. Today a similar alarm sounds nightly, but only at the 10:00 p.m. curfew.

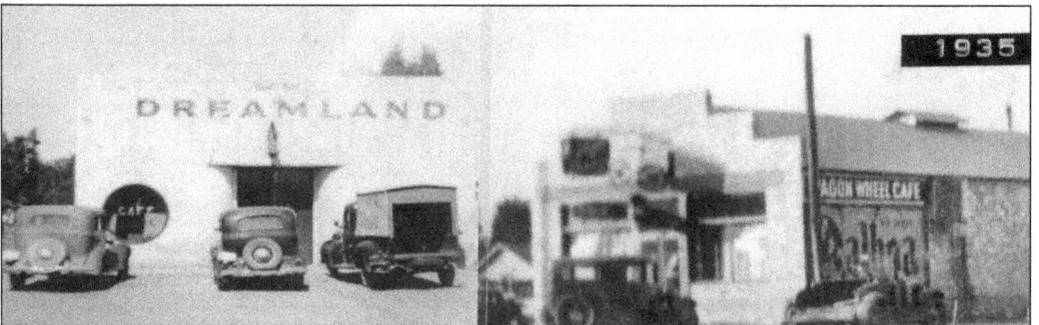

Two buildings have remained on Van Buren as historic sites longer than most others. The Dreamland Café and Bar and the Wagon Wheel Bar have identified themselves with the main street since the 1930s. The Dreamland is now Pepe's, owned by the Joe Ramirez family, and the Wagon Wheel is a modern Mexican food restaurant called Fuego Bar and Grill, owned and operated by Diego Espinoza.

Another longtime landmark in Tolleson's heyday was the collection of establishments north on Van Buren Street where today's Circle K sits. From left to right are Norman Anderson's A and G Hardware, Leonard's Clothing, George's Market, Livingood's Jewelry, Paul's Barber Shop, and Elias's Shoe Repair provided services through the 1940s and 1950s. During this period, over 75 local businesses were available to citizens.

Bert Clark and Son service station, located next to Bill Waller's Valley Drug, was one of the town's service stations in 1950. Bert, Alvin, and Kelly Clark ran their full-service station, while James Arnette owned the Gulf station. The other businesses were Swetman's, Blakely's, Doc Stover's, Byrne's 76, Grady McBride's, and Harold Bowman's rock station and store, later owned by Carlos Gutierrez. The Beasleys and Charlie Tyree also owned stations.

Joe Elias offered shoe service on the back of a lot at Ninety-first Avenue and Van Buren Street. The entrance faced the alley for years, but Joe later moved it to Ninety-first. Joe was an expert at resoles, half-soles, new heels, and taps. Never was a shoe too old.

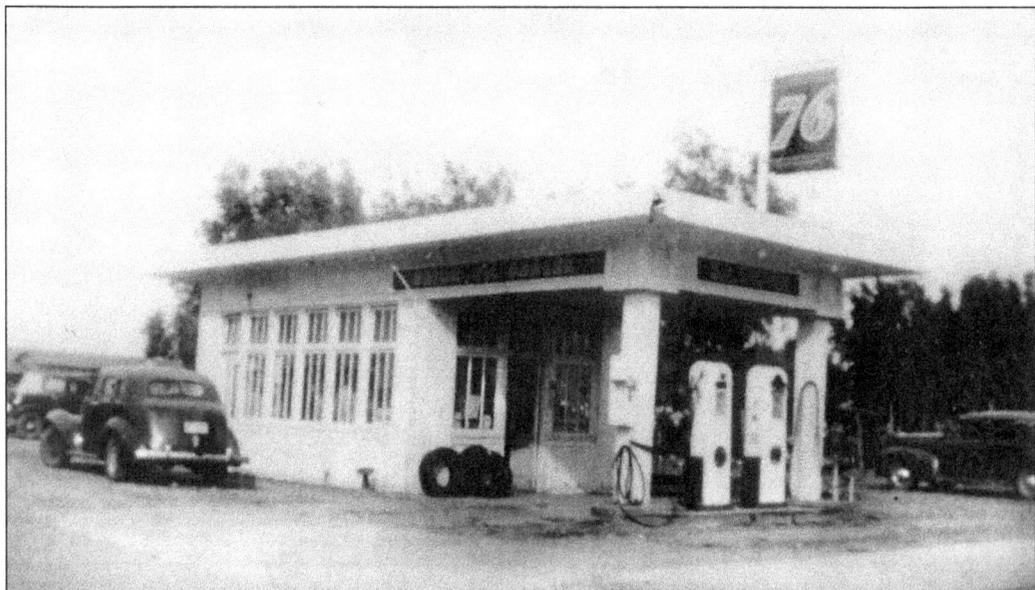

Buck Byrne and Sons Union 76 station burned during the Farmers' Oil fire of 1948. Buck later moved west next to Floyd Bole's Garage and franchised for Richfield Oil. In the 1960s, Buck and Sons purchased property on the corner of Ninety-fourth Avenue and Van Buren to build a station and garage. Today the area is occupied by Joe Chyzy and his B and M Muffler shop.

In 1946, the Green brothers operated the Second Avenue Grocery and Market at Second Avenue and Jefferson Street. In 1952, they joined the number of gasoline station owners in Tolleson with the purchase of this Van Buren Street service station, along with the bulk oil plant in the back. Gasoline sold for 27¢ a gallon; for a 10-gallon fill up, a customer would be awarded coupons or prizes.

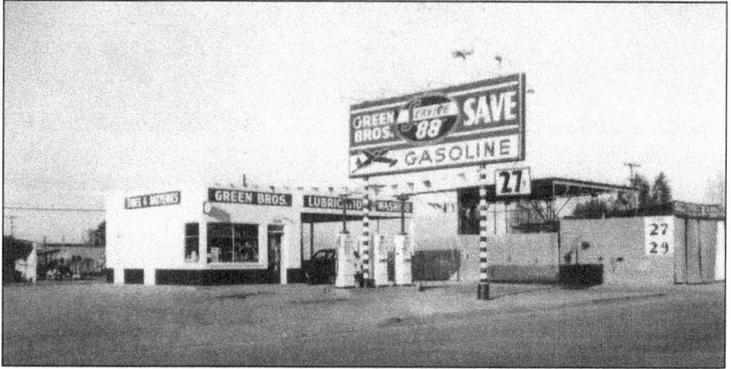

Lester Wishert owned one of two barbershops in town in the 1940s and 1950s. His front chair was manned by Harold Jeisey, always loud and full of colorful jokes. Lester became city manager in the late 1950s and early 1960s. The building that housed his barbershop continues to serve Tolleson residents today as a flower shop. Paul Tovar owned the second barbershop.

In 1959, city fathers decided that because of the city's wide roads, emphasis could be placed on aesthetics to help beautify Van Buren Street. Decorative islands with streetlights were added from Ninety-first Avenue to the western city limits. In this photograph, a sign in the distance shows gasoline at 29¢ a gallon.

Earl and Emmiline Hoctor owned the Hoctor Lumber Company, which supplied building materials to the southwest valley. Emmiline's mother, Rose Balz, was also a business proprietor in the city. In the 1970s, the Hoctor Company expanded into Avondale with a store located on Western Avenue.

By the 1970s, the main street of Tolleson had begun to decline. Full-service gasoline stations disappeared, mom and pop grocery stores left, and the theater and variety stores closed. Pepe's Lounge and the Wagon Wheel Bar remained.

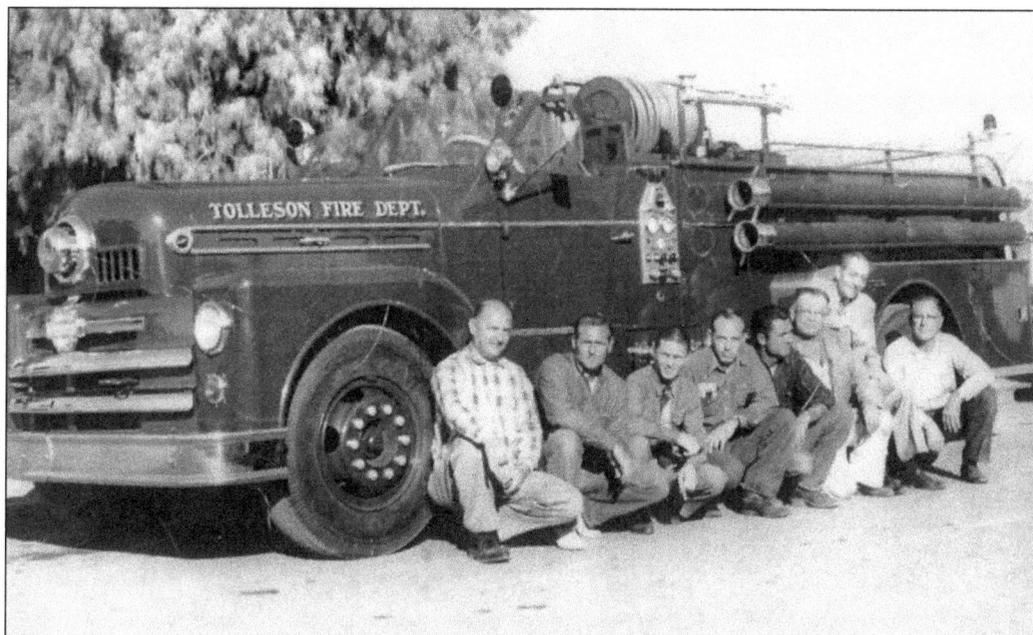

The Tolleson Volunteer Fire Department was officially organized in 1946. Today the city has one of the most sophisticated and modern fire departments in the Southwest. Here eight of the early city volunteers have just taken Pump Truck One out for inspection. Pictured from left to right are Lester Wishert, Henry Chapman, Walter Pillar, Gene Babcock, Dick Beasley, Floyd Boles, Joe Paxton, and Royce McDaniel—all active community leaders. (Elsie Busse.)

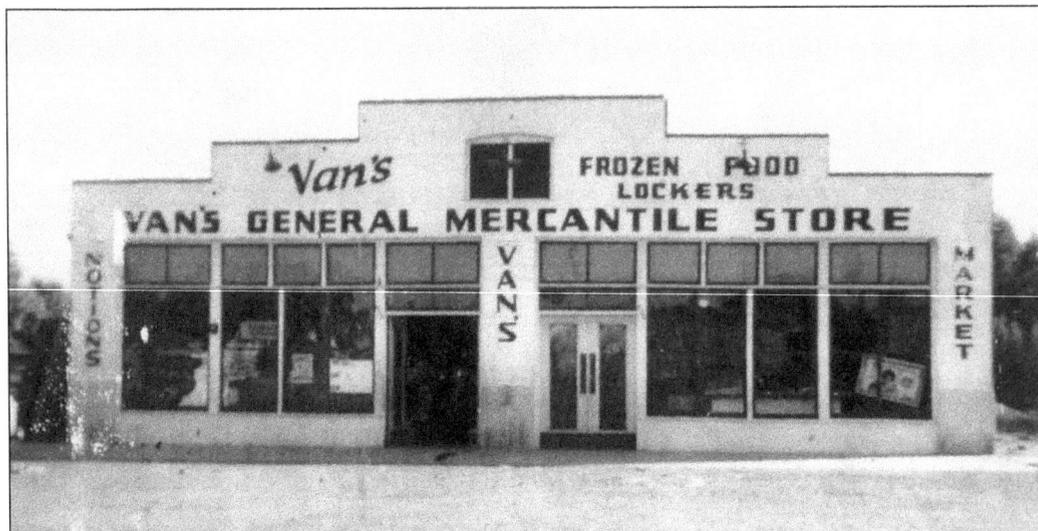

Van's General Mercantile was built on the corner of First Drive and Monroe Street in the 1930s. One of 13 grocery stores in Tolleson, it provided the town's only frozen locker storage to the public. Gene Babcock managed the establishment for many years. He and his slaughter crew prepared local hunters' game and farmers' beef for deep-freeze storage.

The Woodruff family's Tolleson Blacksmith Shop, established in 1923, advertises its business services in 1929. Standing on the corner of Second Avenue and Van Buren Street, the establishment served farmers and businesses alike throughout the west side. By 1979, Henry had changed the name to Tolleson Steel, expanded, and offered modern services throughout the state. Lecil Albright, another longtime resident, managed Tolleson Steel.

In 1950, the Salt River Project put the final touches on installing streetlights to illuminate every road in town. Pictured from left to right, Sy Slaughter, a Salt River project worker, Norman Anderson, and John Collins discuss the new streetlights. Tolleson was one of the first cities in the state with paved streets and lights on every corner, creating in its citizens a sense of pride.

Goetz's ice plant, at the corner of Ninety-first Avenue and the Southern Pacific Railroad tracks, caught fire in June 1961. Plant manager Clyde Shelton lost his life as a result of severe burns in the initial explosion. The ice plant and Joe Palmacino's adjacent packing shed were destroyed. In this photograph, several volunteer firemen wait for their truck.

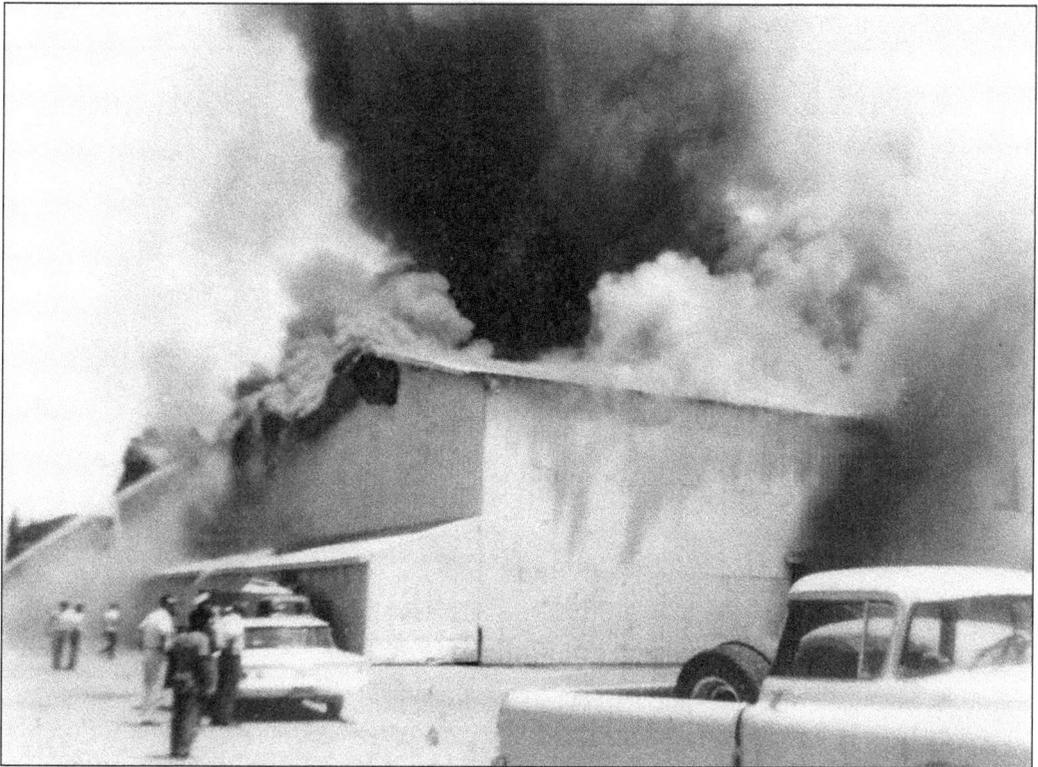

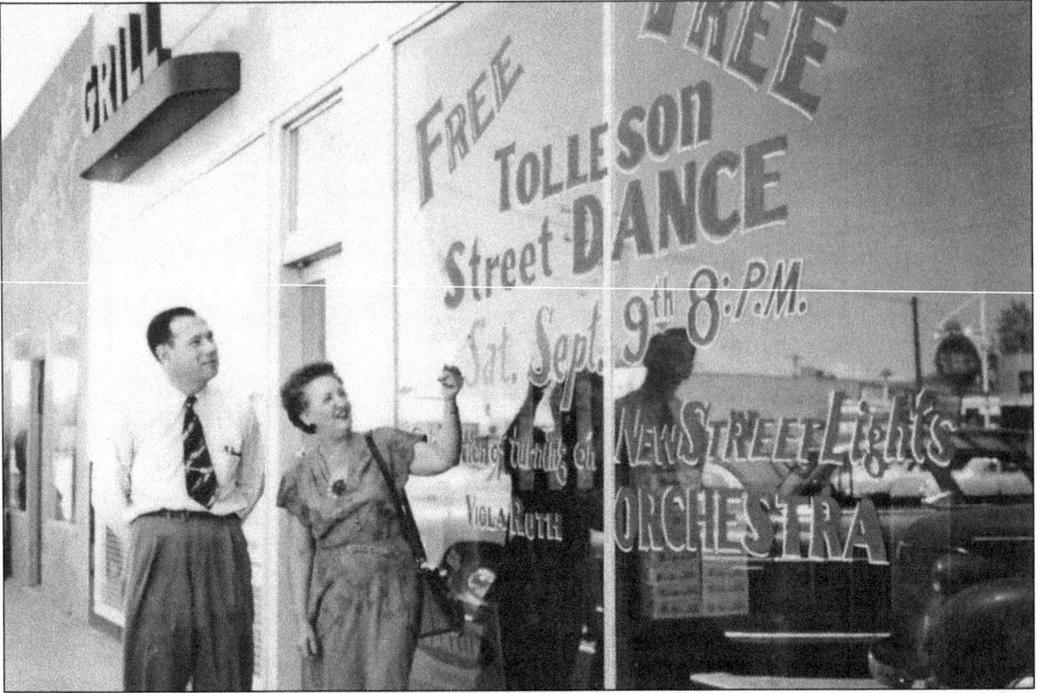

To celebrate the city receiving streetlights in the 1950s, residents were invited to a street dance with music provided by the orchestra of a prominent valley musician. Mayor John Collins and Lucy Tolleson Whyman, Walter's daughter, admire the event advertisement painted on the front window of Collins' Drug.

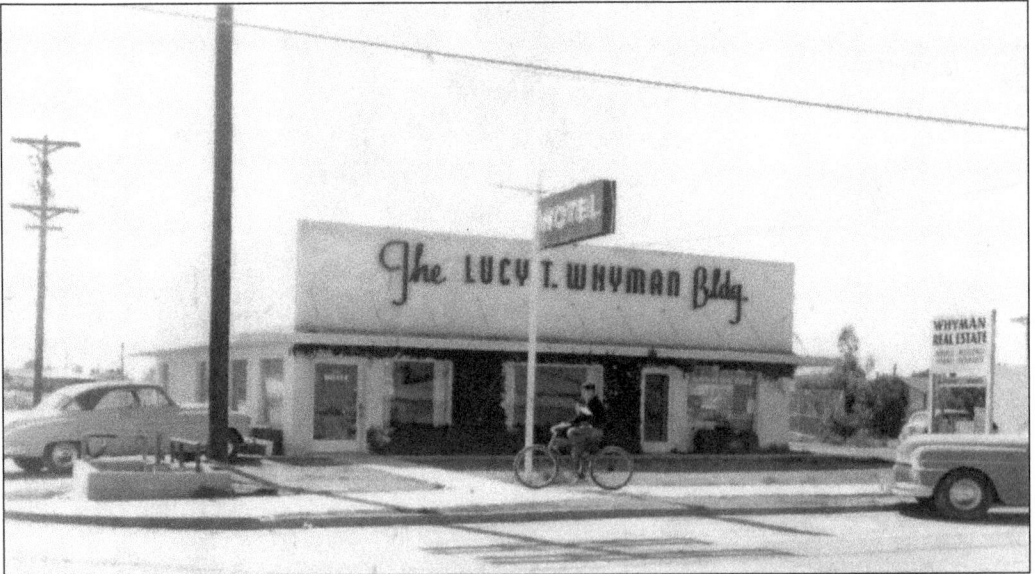

The Lucy T. Whyman Building stood on the corner of Ninety-third Avenue and Van Buren Street. Lucy was a lifelong fighter for Tolleson. While serving on the city council, she supported countless community facilities and improvements. In 1969, the Whoopee Daze diverged from the norm, naming Lucy parade queen. During the city's 50th year of incorporation in 1979, she fittingly acted as Whoopee Daze Parade grand marshal.

Martin C. Flohr came to Tolleson in 1938 and set up his medical practice. The family home served as living accommodations and a medical office. In addition to providing health services, Dr. Flohr was a volunteer fireman, a member of the Tolleson Lions Club, and an active community supporter. In 1952, he moved to Williams, Arizona. As a member of the Bill Williams Mountain Men, Dr. Flohr appeared in numerous parades across the country.

One of the most popular fast-food establishments in Tolleson is Pete's Fish and Chips, located on Van Buren Street. Opened in 1949, the business was first managed by Bill and Mable Dowden. Food was served at a counter inside or at the front window. Hamburgers and fish sandwiches went two for a quarter. Today a person can still get a quick seafood meal or burger at the drive-through or at the front window.

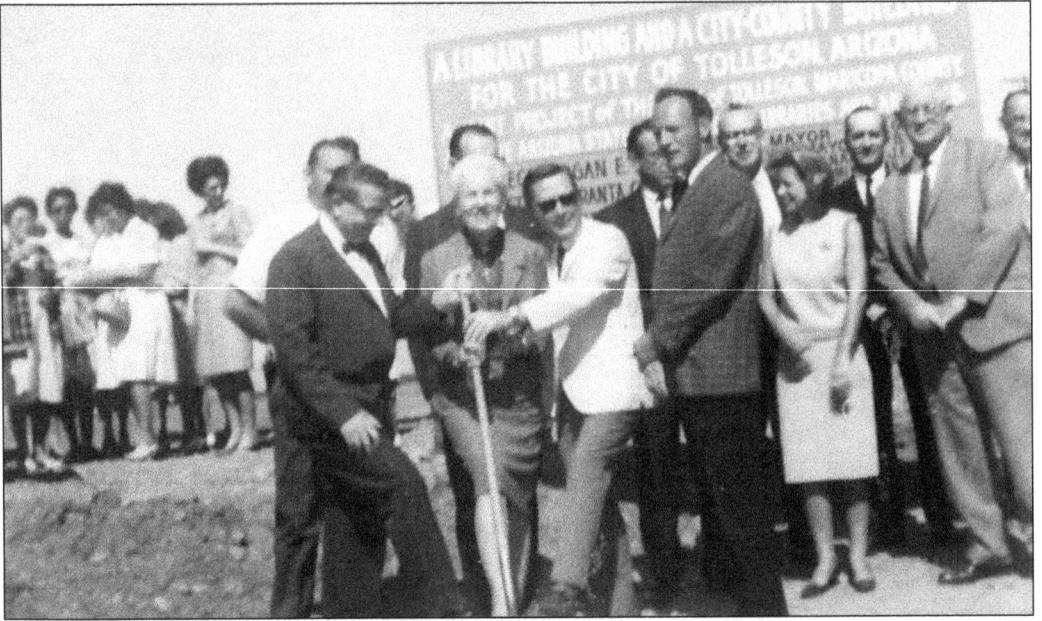

The pinnacle of community development in the 1960s was the completion of a new city library and city-county complex in 1967. From a military Quonset hut donated by Valley National Bank to a multi-building facility, the library, jail, court, and city chamber complex had become a source of pride. This 1966 photograph shows the ground-breaking ceremonies, which included the participation of local, county, and state officials.

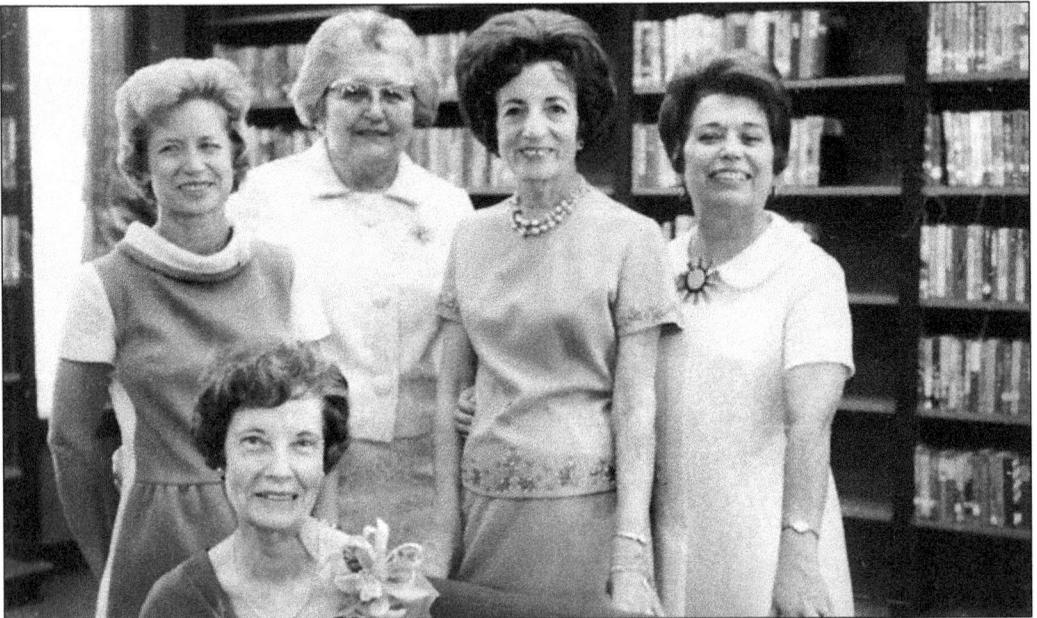

Members of the Tolleson Women's Club celebrate the new city library and the securing of completion funds. The club's members, standing from left to right, included Virginia Vanlandingham, Wilimina Lindsey, Dominica Jenkins, and Phyllis Slaughter. The city's official librarian was Louise Lamar (seated). The original library had opened in a small room at the Community Building on Washington Street with Edna Davis as its first librarian.

The Burger Freeze, owned by P. J. and Ivan Green, was a popular sandwich shop in the 1950s and 1960s. Standing across the street from the high school, the business became the go-to place at lunchtime and after school events. The property later served as a commercial laundry, a secondhand store, a beauty salon, a dry cleaner, and a mortuary. It is now El Cobre, a business center owned by Alex Munoz.

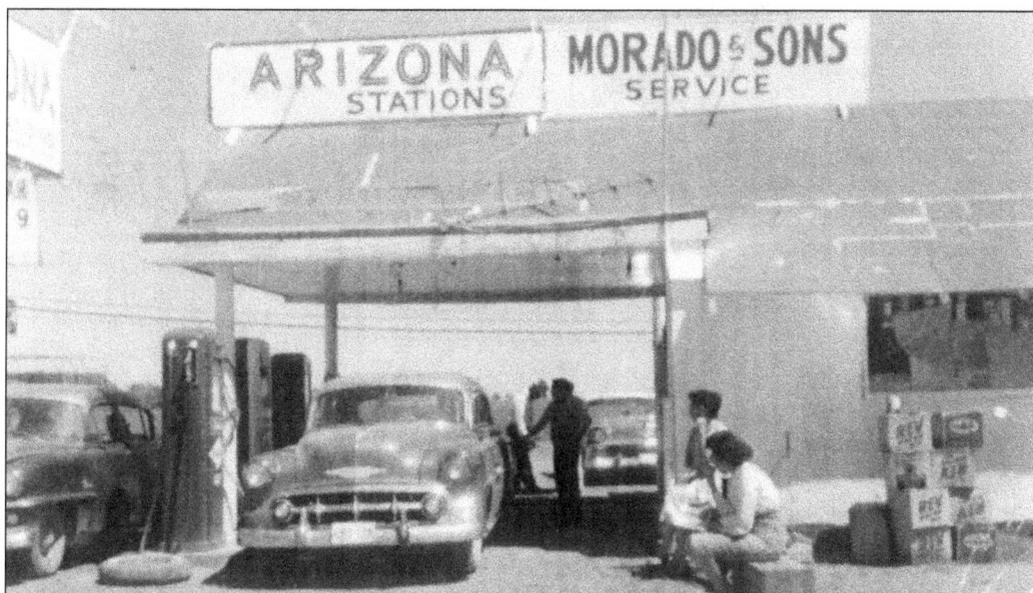

One of the nine full-service stations in the community was owned and operated by the Morados. It stood on the southwest corner of Monroe and Ninety-first Avenue. Arriving in Tolleson in the 1950s, the family became prominent in business, education, and social activities. Today Morado's Auto Body is situated on the corner of Jefferson Street and Ninety-first Drive.

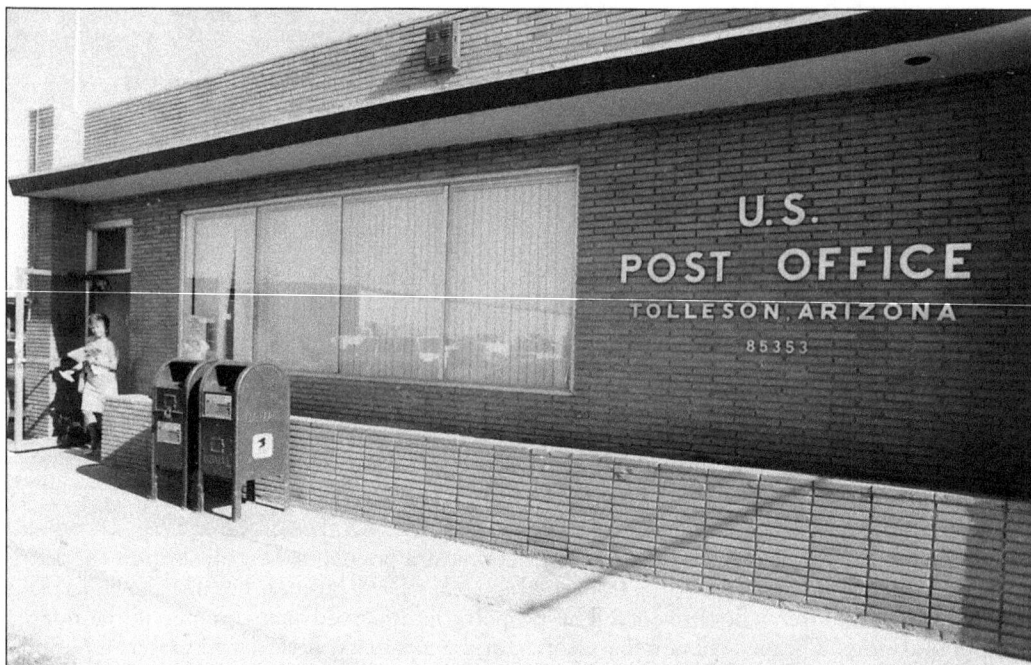

The third location for the Tolleson Post Office was at 9205 West Van Buren Street. Built in the early 1950s, it became the center of town activities at its location between the Circle K and Hoctor Lumber. The city outgrew the accommodations, and in 1996, the post office was moved to its present site at 8805 West Van Buren. (Joy Burton.)

TOLLESON POST OFFICE
MARICOPA COUNTY, ARIZONA

Name	Title	Date Appointed
Leon H. Tolleson	Postmaster	07/14/1913
Homer H. McNeil	Postmaster	07/08/1916
Samuel W. Pescay	Acting Postmaster	02/01/1923
Samuel W. Pescay	Postmaster	04/24/1923
Edward M. Schmidt	Acting Postmaster	03/24/1925
Edward M. Schmidt	Postmaster	12/21/1925
Carl W. Schmidt	Acting Postmaster	12/15/1952
Warren D. Smith	Acting Postmaster	05/31/1953
Theodore Ralph Schmidt	Postmaster	03/09/1955
Mrs. Betty Barton	Officer-In-Charge	06/27/1972
James C. Ruiz	Officer-In-Charge	08/18/1972
James C. Ruiz	Postmaster	06/30/1973
Kenneth Kirkman	Officer-In-Charge	11/28/2000
Ricardo S. Gutierrez	Postmaster	03/10/2001
Michael K. Quintana	Officer-In-Charge	02/28/2002
Terry J. Misenhimer	Officer-In-Charge	05/31/2002
Gene E. Reilly	Postmaster	08/24/2002
Michael Roderick	Officer-In-Charge	10/18/2006
Michelle L. Gardner	Postmaster	02/03/2007

Since Leon Tolleson's appointment in 1913, the post office has had nine different postmasters plus several acting postmasters and officers in charge. The post office has served the community from four locations, the most recent being a modern facility for the growing city.

This 1952 view of downtown Tolleson, looking east from Ninety-third Avenue, highlights the wide main drag of Van Buren Street. Only a few additional businesses were west of Ninety-third. Fae Papin Veronin recalled selling tickets at the Tolsun Theater in the late 1930s and early 1940s. "I also remember [in later years] Tolleson farmers taking a break at a certain time everyday and having coffee at Collins' Drugstore," she wrote.

The Patterson family turned the Tolleson Roller Rink into a drive-in sandwich shop in the 1950s. Constable Reg Brummel and his wife, Winnie, acquired the business and then sold it to the Charles Marriott family. It later became part of Tolleson Elementary School. The building was razed along with the old first-grade classes to make way for the new elementary district offices.

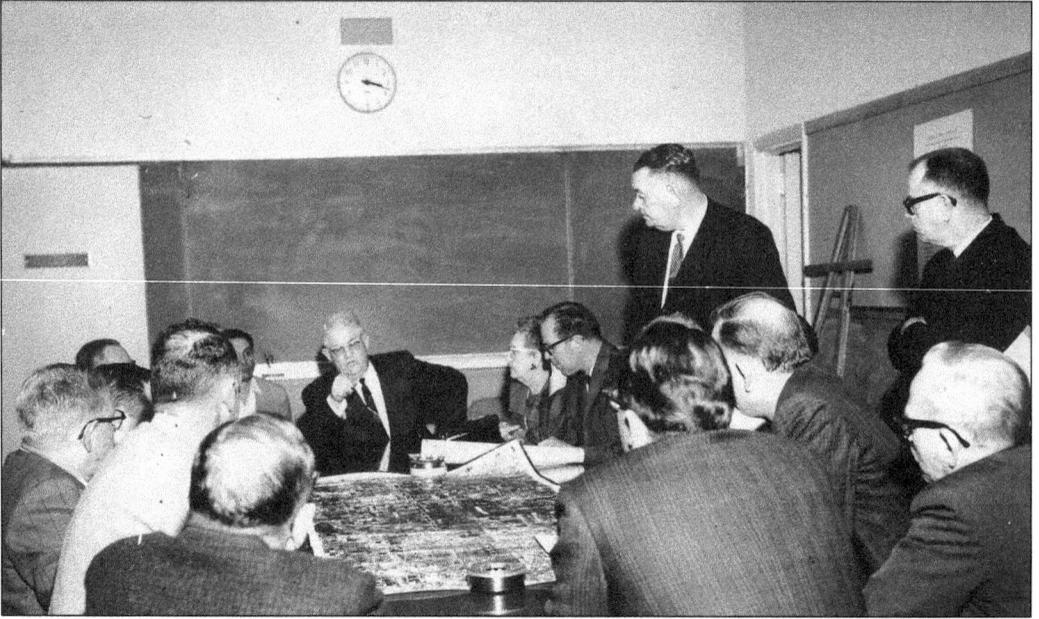

With progress comes compromise. In the early 1970s, Tolleson's city fathers had to make decisions concerning the construction of Interstate 10 through the northern city limits. Here Arizona Department of Transportation personnel offer proposals to the city council and a group of citizen advisors. Mayor P. J. Green (center) makes his point, as Lucy T. Whyman (left of Green) and others look on.

Wayne Watson (center) and Peter Falbo (right) attend a city function with an unidentified dignitary in 1973. Pete was longtime branch manager for the city's Valley National Bank, and Wayne served 20 years as Tolleson chief of police. Pete officiated at basketball games for the Arizona Interscholastic Athletic Association, while Wayne and his wife, Mary, stayed active in the community.

114

In 1968, the Swift meatpacking plant came to the area, building a $5 million facility on South Ninety-first Avenue. Sewage treatment had to be improved. During this time, $2 million was spent on the city's facility to handle all sewage needs into the distant future. The foresight of the city fathers gave Tolleson a great advantage going into the 21st century in terms of wastewater needs. (Thelma Green.)

Opening on April 8, 1968, the Swift plant employed 200 workers and could process 5,000 head of cattle in a normal workweek. The facility is now owned by Sunland Beef. Today over 20 major businesses make up the Fortune 500 core within Tolleson's six-and-a-half-square-mile limits. That brings the city's job totals to more than 15,000 positions.

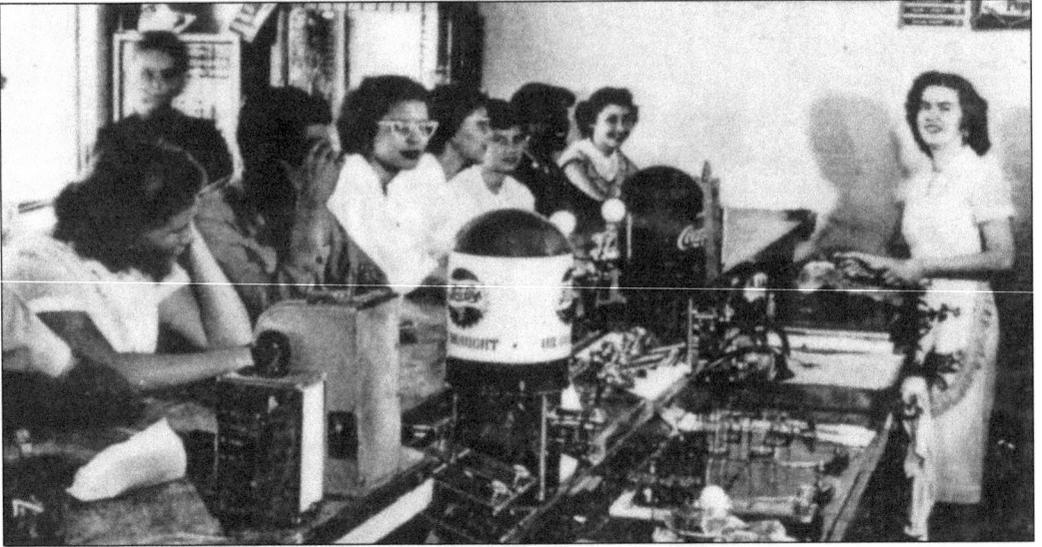

One of Tolleson's teenage hangouts in the 1940s, 1950s, and 1960s was Mary Ellen's, just a block from the high school. A Coke and a burger or a Pepsi and pie served by Alice Ballard went well for lunch or after school. Two pinball machines and a jukebox took lots of nickels while the crowd socialized.

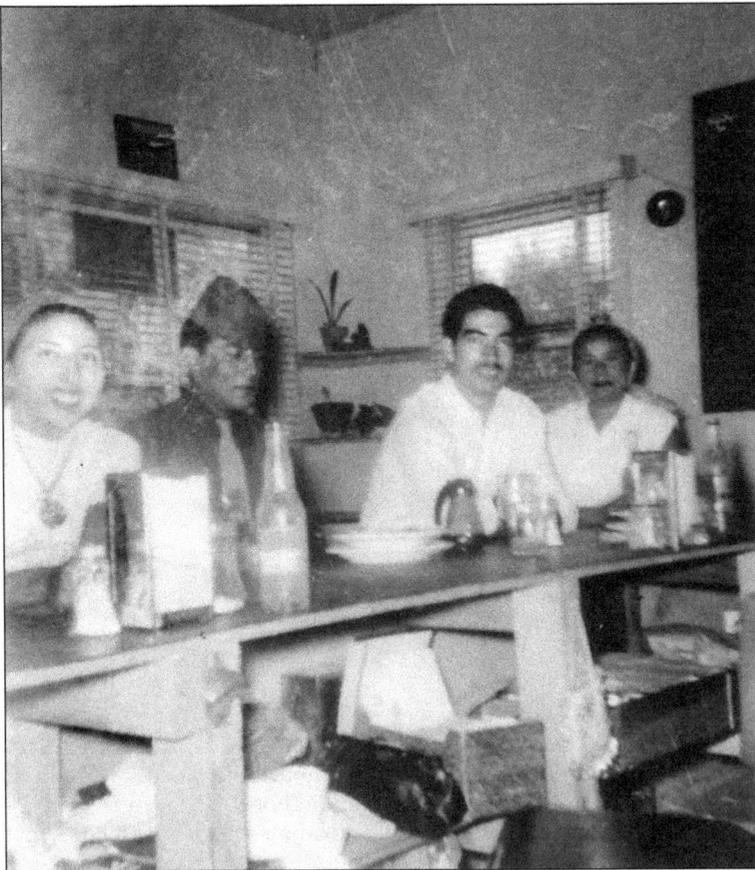

No one who has lived in Tolleson during the early years could forget the Sahuaro Café. People would come from all parts of the valley to eat the original Mexican food. Some other important restaurants that served the community were the Tolleson Tamale Shop, the Evans' Stagecoach, Hope's Punch and Judy's, Collins' Grill, Gouchers', the Tastee Freeze, Lyle Crew's King Cole, and Jose's Fierro's Mexican Food, to name a few.

Seven

SHARING WITH GREATNESS
PEOPLE WHO MADE A DIFFERENCE

Jack Swilling was one of the first individuals with renowned status to visit Tolleson. The city's history mentions the following as well: Cesar Chavez; Tommy Nunez; Leo Durocher and his Hollywood wife, Loraine Day; Michael Carbajal; Lou King; Wallace and Ladmo; the Harlem Globetrotters; Sam Steiger; Barry Goldwater; Govs. Ernest W. McFarland, Bruce Babbitt, Sam Goddard, and Jack Williams; Ed Pastor; Mary Rose Wilcox; Richard Miranda; Wayne Newton; Paul Rodriquez; Lattie Coor; Janet Napolitano; Tom Horne; the Phoenix Suns gorilla; and Dennis Johnson.

Tolleson has its own prominence in numbers: literally hundreds of service medals and awards have honored these valiant citizens. Prominent west valley residents have included Bob Stump, a U.S. congressman and local farmer; Sylvestre Herrera, a Congressional Medal of Honor recipient; Nick Hysong, an Olympic gold medal winner; Greg Medrano, a Small College All-American; Donnie Waldon, the home run record holder for slow-pitch softball; Mike Bell, a professional football player; Cecil Miller, the longtime president of the Arizona Farm Bureau; Manuel Pena, a state legislator; William G. McNeel and Ross Sotelo, coaches of the girls' softball state champions; Tod Nelson, coach of the high school girls' basketball state champions; and the Tolleson Little League and Babe Ruth League state champions. Numerous students at all levels have been winners of prestigious academic, personal achievement, and scholastic awards.

Could Walter Gist Tolleson have imagined the city of today? His legacy of creating a lasting township is perhaps the greatest of all. Like family, the community has life and meaning, and because of Walter's determined spirit, this legacy shall endure.

Clifford Armstrong began farming in the Tolleson area in the 1920s. His first farm sat on Christy Road between Lateral 23 and Lateral 24. He later purchased a ranch adjacent to Littleton School. In the 1940s, after his retirement, Armstrong became a member of the Arizona state legislature, representing the Tolleson region for six terms. (Barbara Hudson.)

In the 2000 Olympics in Sydney, Australia, Nick Hysong went 5.90 meters to bring home the Olympic gold medal in pole vaulting. Nick is a graduate of Tolleson Union High School and Arizona State University. His parents, Sue and Cranston Hysong, are award-winning coaches and educators from the Tolleson High District. (Sue Hysong.)

Rose Mofford (at podium), Arizona's secretary of state in 1977, 1978, 1982, and 1986, and governor from 1988 to 1991, helped Tolleson citizens open the city's new branch of the Valley National Bank. Some of the community members sharing in the event were, to the right of Mofford in the first row, Rod Rodriquez, city councilman; Jess Stump, justice of the peace; unidentified, Pete Falbo, branch manager; Virginia Vanlandingham; and Jack Muir, director of Tolleson Public Works. (Bank of the West, Tolleson.)

Sam Steiger, a U.S. representative from Arizona, visited the Tolleson community to assist with federal planning. Always available for community events, Steiger served the Tolleson area in Congress from 1967 to 1977. Pictured in 1969 from left to right are councilman Frank Rivera, Mayor P. J. Green, Steiger, and councilman Charles Gray.

119

In 1953, the New York Giants baseball team came to town to celebrate Tolleson's first little league success. Community activist P. J. Green contacted manager Leo Durocher at the old Phoenix Municipal Stadium, where the Giants held spring training. Durocher accepted the invitation. From left to right, Wink Van Zanten, Leo Durocher, Jim Green, and P. J. Green stop for a group photograph. The author still has his baseball signed by the team.

Arizona's senior senator Barry Goldwater (left) often visited Tolleson, where he had acquaintances he counted as friends. Goldwater served five terms as an Arizona senator and ran as the Republican presidential candidate in 1964. One of his dear friends was Rod Rodriquez (right), a longtime Tolleson resident, businessman, politician, and community activist. Here Goldwater attends a VFW function with Rodriquez in 1981. (Rod Rodriquez.)

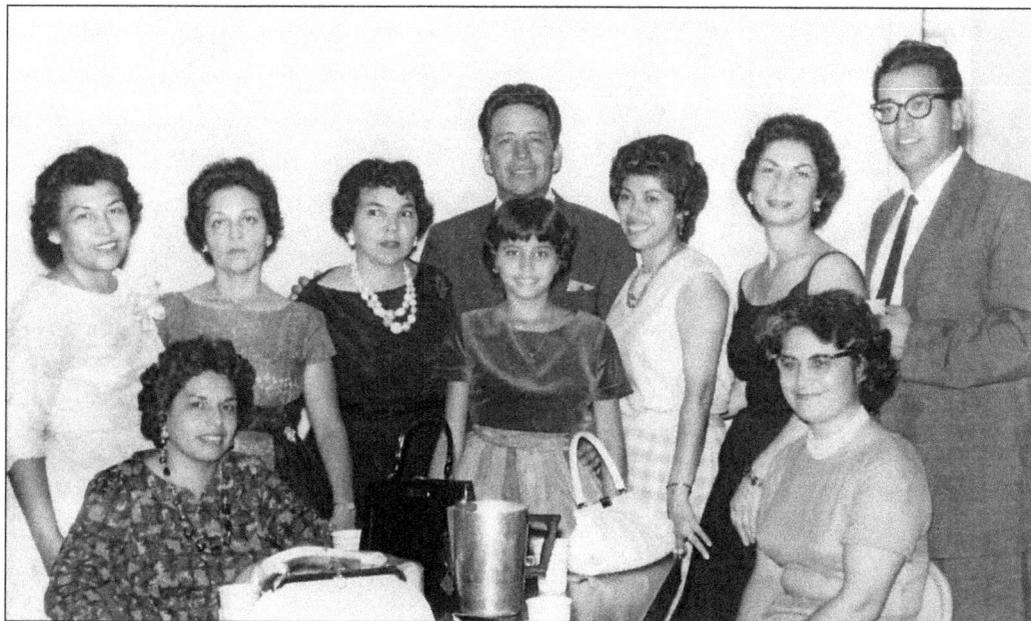

Manuel "Lito" Pena's family members were Tolleson merchants in the 1940s and 1950s before Lito moved to Phoenix to enter politics. Over the years, he has been an advocate for community causes. These Tolleson friends sharing a moment in the 1950s are, from left to right, (first row, seated) Pat Saiz and Aurora Pena; (second row) Nellie Rodriguez, Eloisa Mendevil, Mary Ruiz, Virginia Sotelo, Annie Sotelo, Virginia Moreno Mendevil, Manel "Lito" Pena; and (third row) Ross Sotelo.

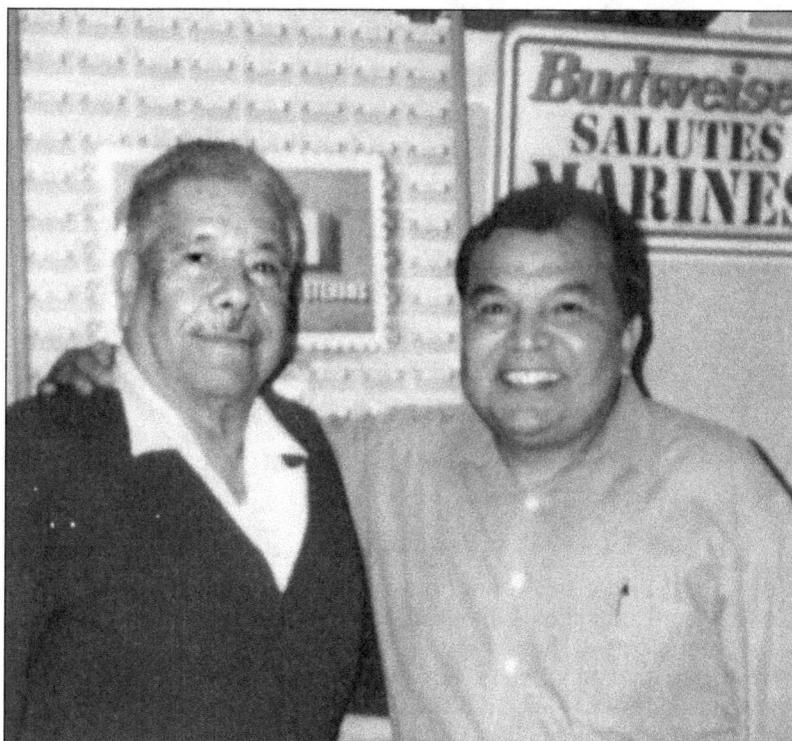

At a special VFW meeting, Silvestre Herrera (left) spends time with author Jimmy Ruiz. As a Congressional Medal of Honor recipient, Herrera's presence was always respected, and he never passed on the opportunity to share with his Tolleson friends.

Gov. Ernest W. McFarland (left) and his wife, Edna (far right), visited the area many times. Here the governor and first lady attend author Jim Green's wedding at the Southern Baptist Church on Jefferson Street in 1961. Ernest McFarland served Arizona as a senator, governor, and chief justice of the Arizona Supreme Court. (Jerri Green.)

In 1975 and 1976, Larry Clark (in car) won the National Sprint Car Championship, racing in Iowa, Nebraska, Indiana, Ohio, and Colorado. Larry's parents, Alvin (left) and Doris Thrasher Clark (not pictured), helped sponsor his endeavors through their Tolleson service station and garage. Here Larry and Alvin show off their car. Doris's family, the Thrashers, included Norma, Bill, Bud, and Conley, who ran the West End Store, the hub of the Pendergast community. Bill and Bud were prominent area residents. (Alvin and Doris Clark.)

Rev. Joseph M. Gamm began his service to the Catholic missions at Tolleson, Buckeye, and Avondale in July 1949. Father Gamm assisted Fr. Augustine Leal, pastor of the Spanish national parish of the Immaculate Heart of Mary. Gamm began as assistant pastor for Blessed Sacrament Church when it was built in 1949. He also organized the renowned Tolleson Crusaders softball team.

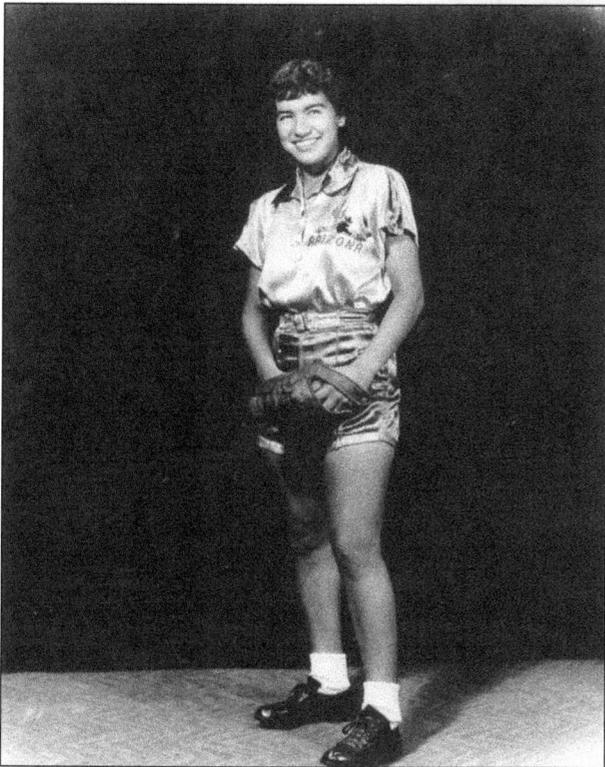

One outstanding Tolleson athlete was Eloisa LoCha Diaz. She not only played with the state champion Tolleson Rockettes in 1949, but went on to play in 1951 for the famous PBSW Ramblers, a professional women's softball team that won several world championships. Diaz is a member of the Arizona Hispanic Sports Hall of Fame. (Rebecca Diaz.)

While in New York City, Bill and Lois Hunt managed to get on a popular television program called *Beat the Clock*, and the Hunts did just that. They won a new Mercury station wagon and $21,000—quite a prize for the 1960s. Bill and Lois became Tolleson's celebrities for an entire week as residents gathered daily around their television sets to watch the local stars. (Joy Hunt.)

Robert M. Korte moved to Tolleson in the early 1950s and became everybody's favorite high school teacher and coach. An outstanding college athlete at Kearney, Nebraska, he signed with the Chicago Cubs but experienced arm problems along the way. Arizona was the place to heal. In time, Korte was recognized as one of the Southwest's most prominent basketball officials for his state and Western Athletic Conference work.

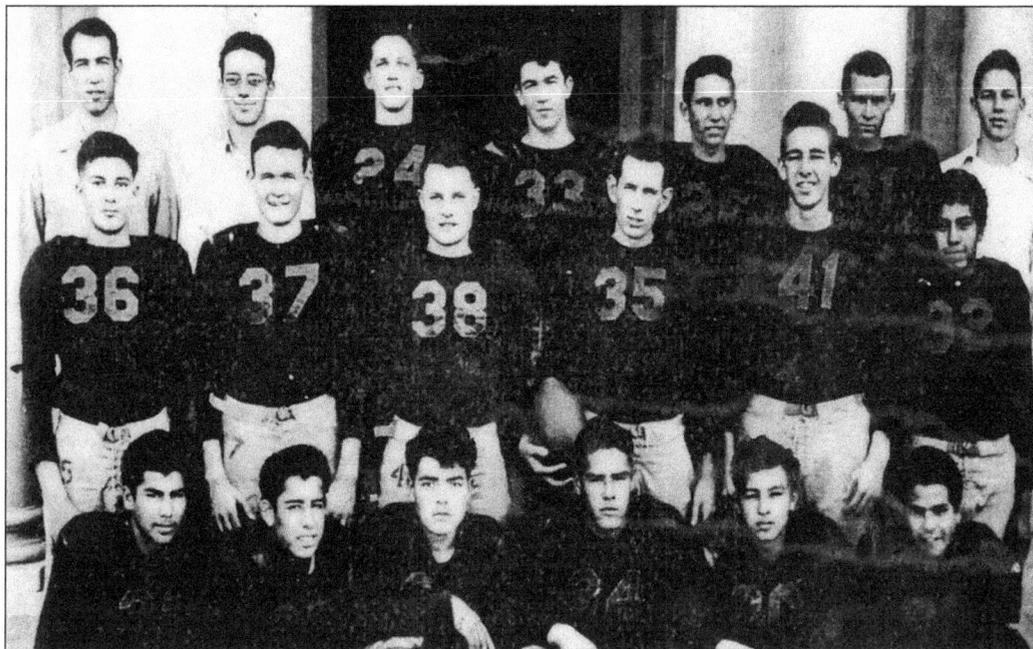

The 1946 Tolleson High football team included Robert Stump (third row, sixth from left), who went on to serve 26 years in the U.S. Congress from Arizona's Third District. Stump left school as a sophomore to join the navy in 1943. He returned to Tolleson High, played football, and graduated in 1947.

Michael Carbajal (left), a four-time world boxing champion in the flyweight division, came to Tolleson on numerous occasions to help the community. He was called "Little Hands of Stone" after his favorite boxer, the legendary Roberto Duran. Here Carbajal poses with Jimmy Ruiz during a 1990 visit at Blessed Sacrament Hall.

Tolleson's own Sabina Ruiz (left) and Debbie Serna take a photograph with Roberto Duran during a visit to the Tolleson community. Duran, identified by *Ring* magazine as one of the five greatest boxers of the 1980s, came to town to promote the union at Sunland Beef. The Panamanian is the only boxer to have fought in five different decades.

One of the most prominent sports personalities to come from the area is the defensive coordinator for the Arizona Cardinals, Clancy Pendergast, who graduated from Tolleson High School in the early 1980s. He is the great-grandson of Charles Pendergast, for whom Pendergast School is named. The University of Phoenix's stadium, the Cardinals' home field, lies only a stone's throw from Charles's original homestead on Avenue K and Lateral 22. (Bonnie Pendergast.)

Authors Jim Green (above) and Jimmy Ruiz (below) have lived in the Tolleson area for a combined total of more than 130 years. Green is an educator and writer who has served the community in many capacities. In 2004, the Tolleson Union High School District named the continuing education academy in his honor. Green has published eight books, as well as several stories and poems over the years, and continues to function as program director for the James A. Green Continuing Education Academy. He has also won eight world championships in senior softball. Ruiz served the U.S. Postal Service for more than 37 years, with 28 as official postmaster out of the Tolleson office. He has coached the city's youth for years and has become the community's unofficial historian, his personal collection providing much of the artifacts and photographs for this volume.

Visit us at
arcadiapublishing.com